EXPLORING
NOTTINGHAMSHIRE

EXPLORING NOTTINGHAMSHIRE

KEITH TAYLOR

AMBERLEY

First published 2010

Amberley Publishing
Cirencester Road, Chalford,
Stroud, Gloucestershire, GL6 8PE

www.amberleybooks.com

British Library Cataloguing in Publication Data.
A catalogue record for this book is available from the British Library.

ISBN 978-1-4456-0150-2

Typesetting and Origination by Amberley Publishing.
Printed in Great Britain.

CONTENTS

ACKNOWLEDGEMENTS

While exploring and attempting to learn something about my natal county, I came into contact with and befriended people who were generous with their time and enthusiastic about the project I had set myself.

Besides the never-failing staff of the Nottingham Local Studies Library, I gained the support of such stalwarts as the late Bernard Harling and his wife Joan, Jim and June Bark of Deerdale, Eric and Margaret Spafford of Rufford, and Monty Carter of Perlethorpe.

Friends closer to home have journeyed with me from time to time, thus providing backing and genial company. Thanks then go to Andrew Smith, Keith Woodvine, the late Phyl and Ed Crowther, and Anita Sutton, who with her sons along introduced me to Wilf Wild.

Farmers, poachers, gamekeepers, pub landlords and bar staff provided sources of information along the way and I am particularly grateful to the Mettam family of Ollerton from whom I was given information on their restored water mill and its history while learning of other types of mills scattered throughout the county.

Special thanks are also extended to Liz Weston, Curator of the Mansfield Museum, who gave me permission to photograph the Egyptian Nightjar, which is still displayed as part of the Joseph Whitaker collection.

Mention should also be made of Richard, who drives for Nottingham City Transport and described my book *Old Nottinghamshire Remembered* as 'fascinating'. May this book prove the same.

Over the years my son Stuart and friends Denis Astle and Tony Stevenson have been good companions, as has, when time allowed, Pete Dawson.

My grateful thanks to you all.

PROLOGUE

The attractive young woman proprietor of the seafront café in Lyme Regis, Dorset, had, I felt, misjudged my native county.

Several years earlier she and her husband had travelled the central roads of England from north to south and in Nottinghamshire had expected to see something of the once vast Sherwood Forest. What they saw was acre upon acre of farmland, intersected by woods and villages. As I contemplated a second helping of her home-made cherry pie, I explained to the woman that what they saw was the historic but outer face of Nottinghamshire, the immediate visual portrait. The inner core they had still to discover.

I was not making excuses. Nottinghamshire to the untrained eye can appear, like tracts of West Yorkshire, sombre, repetitive and uninteresting. Consequently, what one has to do is search for the hidden landscape or riverside and probe into the individual histories of each village, ancient hill fort, country house, farmstead and town.

The very ditch sides and hedgerows fringing the roadsides speak of the past. And traces of the old field boundaries can daily be picked out by the amateur historian, along with the trees planted specifically for boundary recognition.

The county, like most, can be read as a book, but of the land. Yet there are names and characters to be assembled into the storylines of that book. The various orders of architects, builders, craftsmen, yeoman farmers, monks and abbots. The hunt-conscious kings and earls. The Byrons, land-owning Royalists whose family tree eventually produced a world-famous poet. D. H. Lawrence, son of a miner, who in distinguished forms of art recorded aspects of the world immediately and then well beyond

his everyday doorstep. Shaping and characterising the county have been people in their hundreds, often wrongly regarded as minor characters and now no more than unsought names recorded in parish records. Yet they have probably left behind more than the present generations, who seem at loss with the land, and the future generations who will inherit the legacy but perhaps never know or contemplate the hardships, and to some extent the bloodshed and self-sacrifice, that took place across the acres of what may yet become little more than a misinterpreted museum and weekenders' theme parks.

Probably then it was due to the gentle bantering of the woman in Lyme Regis that I psychologically collected the themes and aspects of the Nottinghamshire that, due to the combined senses of exploration and need for employment, I came to know.

Admittedly I could not alter the varied landscapes. But I did delve into situations of social, industrial and natural history, enough in fact to gain and create my own impressions of the land book while realising that there is still much out there waiting to be read.

NOTTINGHAMSHIRE – AN INTRODUCTION

Covering an area of 834 square miles, Nottinghamshire is situated ninety or so miles inland from the Wash and bordered to the east by Lincolnshire. Its southern borders are fringed by Leicestershire. On the west side, Derbyshire offers many contrasts in landscape and character, while the relatively flat country of North Lincolnshire begins immediately beyond Nottinghamshire's northern boundary.

Topographically, Nottinghamshire is regarded as a greater part of the lowland country extending east from the southern Pennines. Around the Leicestershire and Lincolnshire borders the wolds suggest hills and noticeable contours within Nottinghamshire itself, but although the county contains vast acres of rich agricultural land, it is also relatively flat and, despite extensive prevention schemes, several riverine locations are still prone to flooding.

Nottinghamshire's hill country is to be found in the west around the ancient market town of Mansfield and nearby Kirkby-in-Ashfield, where the highest point rises to 591 feet. Elsewhere the land contours vary between 98 and 427 feet above sea level.

Since the Enclosures Act of 1760, livestock farming has provided a consistent income for many landowners, but the cattle and sheep breeds have changed according to personal whim and commercial value.

Cereal crops such as wheat and barley are still grown, along with potatoes and sugar beet. There are still market gardening businesses extending throughout the region, although the once-plentiful orchard farms are today recognised because they remain as green islands and are unique within the land mass, earmarked for crops, dairy produce and 'set aside'.

Nottinghamshire's principal river is the Trent, the third longest in England. It extends from the Cheshire-Staffordshire border, recognised today as part of the south Pennines, at the intriguingly named Norton-in-the-Moors.

The embryo course of the Trent strikes southwards. In Derbyshire there is a gradual swing to the north-east where, but for tracts of water meadows and gravel extraction lakes, the Trent almost converges with the Leicestershire Soar ahead of the terminal decided upon and engineered by the canal companies of bygone times.

On its course through Nottinghamshire the Trent has become a social and psychological dividing line, particularly among people living in the southern part of the county. Not infrequently, in the pubs and restaurants thereabouts, one hears them mentioning having travelled 'south [or north] of the river today'.

Still navigable for 100 miles, the Trent extends for 171 miles and is used for leisure and narrowboat traffic, in comparison to the streams of barges carrying coal, grain and night soil that were part of the river valley some 100 or so years ago.

Throughout the Nottinghamshire section of the Trent Valley, extensive gravel extraction works are still very much in evidence, whereas the electric power stations are fewer.

The city of Nottingham and the historic town of Newark are the principal locations along the Trent but there are many attractive villages, nature reserves, unusual features, and leisure centres situated throughout the county.

There are several tributary rivers such as the Leen, Dover Beck, Smite and Devon winding between the varied contours of the county, as well as the boundary-dividing River Erewash to the west and the River Idle in the north. Nor should one forget the rivers Whitewater, Ryton, Medan and Maun, each threading through or around the Sherwood Forest country.

The villages of Eakring and Maplebeck are considered to be in the middle of Nottinghamshire, whereas when one hears mention of Ranskill or Barneby Moor one thinks immediately of the north, with the Isle of Axholme, the Lincolnshire Wash lands, and tidal Trent wide open to the uncertain skies beyond.

* * * *

Nottinghamshire in Saxon times served as a portion of the kingdom known as Mercia. Following the Danish invasions, it was included within the extensive region of Danelaw that stretched from the River Thames to the River Tees. Here, as in the days of Mercia, the language, customs and laws administered by the conquerors were maintained.

No fewer than sixteen prominent places of worship were listed for Nottinghamshire during the Dissolution of the Monasteries. The atmospheric Newstead Abbey reminds one of this fact. Prompted by events and concert brochures, coffee table volumes and free newspapers, the twenty-first century visitor explores Southwell and its minster (constructed by the Normans), the remains of Sherwood Forest, Edwinstowe (which unbelievably, compared to modern times, extended for twenty miles and was seven miles wide) and the literary famed D. H. Lawrence country.

Cresswell Crags, close to the Derbyshire boundary and 'The Dukeries' estates such as Welbeck, Clumber, Thoresby and Rufford, are also rightly featured as tourist attractions that interpret the history of each and its importance and position as a squirearchical haven. Whether living in the county suburbs or city, the present day residents not employed in computer technology, shops or offices will probably work or know someone who works in engineering, cigarette manufacturing, the pharmaceutical industries and textiles, or the production of sandstone, gravel, gypsum and perhaps oil.

Late in the eighteenth century, the hosiery and lace industries rapidly expanded. This resulted in many people leaving the land and the farms, and moving into the city or suburbs because work was so readily available.

Although I have failed as yet to confirm, I would not in the least be surprised if I discovered that my ancestors, particularly on my father's side, were among those many people who made this move because throughout his life, and later in mine, he and I have turned back to the fields whenever time and chance has allowed.

Nor were we alone. My late wife Jean recalled being in a pushchair by the porch of 21 Somersby Road, Mapperley Plains, on an evening of low summer sunlight, watching the dairy cows from a nearby farm looking over the front garden gate. As a toddler, she also loved gathering 'posies' of bird's-foot trefoil from the fields of Lambley Dumbles.

My friend of the then future Jim Bark, terrier by his side, cycled from his home village of Blidworth and, partially screened by unchecked stands

of bamboo, swam the lengthy and intriguing chain of lakes dominated by Rainworth Water until he was sent on his way by the gamekeeper.

Another friend, Robert Wheatcroft, has in modern times only to glimpse, from a bus seat, a reeded tract of the Grantham Canal near Cotgrave or Cropwell Bishop and he's transported those fifty or sixty years back and fishing with his father along the same canal, at the much vaunted anglers' resort of Redmile Bridge.

Almost everyone carries memories of fleeting times spent in their natal county. And we Nottinghamians are no exception.

My father was, as I am today, an inveterate wanderer. Each Sunday of my school years, when he and I were out in the lanes or on the footpaths, we met men of a similar calling. Men who throughout their five- or six-day working week hungered for the freedom and the fresher air that is today celebrated in paintings, photographs, prose and poetry.

My father and I did not so much walk a lane as *explore* it, so that, as he put it, 'we would know what to look for the next time we came and see the changes that had occurred due perhaps to the weather but definitely the season'. The following chapters explain something of our way of life and the mode of wanderlust that in my free time I have still frequently to exercise.

BILL SMITH'S RECOLLECTIONS

Born in April 1938, I was around the age of three or four when I became aware of my address, which was smuggled into the daily round of stories and nursery rhymes by the doting aunt in whose house we lived. The reason the family decided upon this tactic had, no doubt, to do with the probability of the house being bombed and should I have been the only survivor then I could at least give my name and address to whichever group of rescuers chanced upon me first. However small, with a name and address I, like most people, had an identity and the city, or rather the western suburbs of Nottingham, I regarded already as my home.

Daily forays into the pages of the *Daily Sketch* newspaper and regular visits to the cinema heightened my awareness of other towns and cities. But I was unaware that Nottingham was surrounded on four sides by countryside, hamlets and villages that collectively and administratively were embraced within a large tract of land known as a shire.

Within this shire had for centuries lived a distinctive people. Hardworking and mostly, but not always, at one with the land and its hardships, crafts, crops and animals.

When I eventually discovered that the world existed before I was born, aside from being piqued, the seeds of social research were already being sown.

On the country walks with my family I wanted to know who lived in a certain cottage and why. The staircase of lock gates and pounds, taking miles of a canal route up the gradual but undeniably steep gradient from Lenton to Wollaton, who had built those? And for what purpose? If there had been narrowboats and people who worked them along that particular waterway, then where were they now?

Gradually, there evolved within my mind the picture of an unattainable past, like a canvas with a background of green-foliaged dusk light. In the foreground, people walked silently and to some extent contentedly. Some were alone, others together. In the future years I was to meet some of these people who inhabited this canvas within my mind and who were building, or had built and were capitalising upon, fabrics of their lives when I was being guided, wide-eyed and questioning, along the summer lanes.

* * * *

One man whom I would have placed in the foreground of that canvas was Bill Smith, who lived in a cottage at Trowell, opposite the Lenton to Langley Mill diversion of the Nottingham Canal.

The main road extending between Nottingham and nearby Ilkeston, the third largest town in Derbyshire, winds downhill at a lower level than both the canal and the three or four detached cottages opposite.

On a warm evening in the summer of 1969, Bill Smith and I each walked alone and in opposite directions along the canal towpath where the hilly fields of the Trowell Hall estate slope down to a reeded and thicketed bay that in the days of the canal lengthmen, and for several decades after, was known as Trowell Basin. Here the barges were loaded and unloaded, the cargoes being consignments of house bricks, night soil, coal, fruit and vegetables, intended for the Nottingham and Ilkeston markets.

On that summer evening in 1969 I had photography in mind. A pair of mute swans had as usual nested in the extensive reed bed of Trowell Basin. Bill Smith, about six feet three inches tall, wearing a grey suit and trilby, and partially supported by a walking stick, was out for a stroll.

We met, exchanged pleasantries, then leaned on the post and rail fence with our backs to the waterway and watched the lines of traffic racing – for Bill agreed that there was no other word to describe it – along the M1. Between the ridge bank, through which the waterway in 1792-94 had been cut, a hilly field sloped down to the stock-proofed hedgerows bordering the motorway embankment. In the field, two white horses raced, manes flaring and tails lifted as if attempting to out-manoeuvre their own shadows. Lifting his trilby and scratching the side of his head before resetting the hat, Bill admitted that he never thought he would live to see the day six lanes of motorway traffic attained speeds of 50, 60

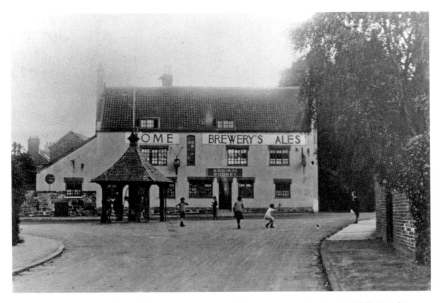

Children playing in the village street were a foregone conclusion in Bill Smith's time.

or 70 mph within several hundred yards of the cottage in which he was born and, with his wife, still lived.

Bill was, he volunteered, born in 1877. On noticing my surprise due to his obvious health and stature, he confirmed that he was into his ninety-first year. He remembered the fields of golden harvest, the stooks arranged 'like Native American villages' in line from hedgerow to hedgerow.

As a child he had helped with the harvest, been taught how to arrange and shape stooks, and ridden at sunset with his brothers and sisters on top of the hay wagon. As a youth he had loaded the stooks onto the wagon and until he was drafted as a soldier in the First World War, he picnicked on each of the harvesting days out in the fields. Carrying bags of sandwiches, cake and lemonade, Bill's mother and sisters crossed the fields and frequently joined the men, boys and youths for the early evening meal.

Those were hard times. Days of aching shoulders, backs and biceps. After the harvest the ploughmen walked between eleven and sixteen miles a day as they ploughed the fields six days a week for several weeks, weather permitting.

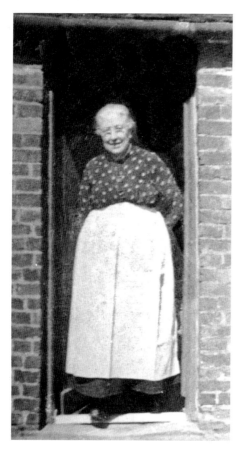

A villager at her cottage door at the turn of the century.

Red and white liveried Dairy Shorthorn cattle, along with the imposing Ayrshires, grazed the fields and milk was delivered direct from the farmyard dairy by pony and gig, compared to modern times the postman and woman had a really extensive round, most of which they walked, although occasionally a bicycle was supplied. That or they used their own.

When, in Bill's boyhood, a member of the family went to town, it was usually to Ilkeston with its hilltop market, although one could catch a train at Trowell station or from Ilkeston Junction and within half an hour alight in Nottingham.

Smiling as he gazed into the distance of his yesterdays, Bill mentioned the first coach – a single-decker – travelling on its inaugural run between Ilkeston and Nottingham.

'Even the company's proprietor wasn't sure if it would get the passengers there and back without a mishap,' chuckled Bill. Gesturing towards Wollaton Village, Bill recalled seeing the family from Trowell Hall, whose names he never learned, being driven to and from Nottingham in their liveried horse-drawn coach.

Together we then discussed the pleasant landscaping of Trowell Hall, which I studied on the few occasions I walked from Balloon crossroads to Swansea Bridge, situated about thirty yards from Bill's cottage.

The estate had been economically planned right from the time of the Enclosures Act, Bill and I decided. The fences were post-and-rail, interwoven with hedgerows of haw and blackthorn. The pastures, grazed usually by sheep, were pleasantly undulating.

Coverts, perhaps with artificial brick-lined fox earths, had been planted every few hundred yards across the parklands where oaks, lime, elm and black poplar trees were nurtured with shelter and field boundary markings in mind.

Pheasants and partridges were once reared for the autumn and winter shooting parties, and small ponds inset within the coverts and plantations to attract flying mallards and teal.

On the opposite side of the road, the land tract known as Trowell Moor was open but agricultural, and the two farmsteads set well back into the field. There were, I told Bill, some interesting winter tree-scapes following the field boundaries across Trowell Moor. Bill then confirmed he had harvested, picked potatoes, and spent back-aching days raking up stones in those fields.

'I didn't get much time to look at the trees,' he mused, then added, 'if the farmer or his wife looked through their field-glasses from the farmyard and saw that you weren't working, they stopped your pay. There were no two ways about that.'

He remembered in particular a woman who lived alone in one of the turnpike cottages at Balloon crossroads. She was locally known as Grannie Simmonds. Remembered for her Victorian skirts and smart blouses, Grannie Simmonds was a countrywoman in every sense of the word. She was often to be seen in one of the four woods on the Balloon crossroad corners collecting kindling, winter and summer alike. Or returning across the fields, her basket filled with mushrooms and blue buttons.

The few people who knew her well recall Grannie Simmonds' recipe book. She had, I understand, a recipe for just about everything, including

curing warts. But her recipe for pickling walnuts she gave to no one. Perhaps, understandably for those times, she was superstitious. A build up of cloud or the shape of the moon were reasons enough for Grannie Simmonds to make preparations accordingly.

Gamekeepers, poachers and farm labourers called in to her cottage with rabbits or braces of pheasant and partridge. In return she gave them apples, pears and blackberries from her orchard. She also had an arrangement with the narrowboat families travelling the lovely wooded tract of canal within three hundred yards of her home. Filling a bucket with home-grown fruit and vegetables, she carried it weekly to the canal bridge and left it in a thicket. A day or so later she returned to the bridge and saw the bucket in its place but filled with coal, which she carried back to the cottage. When during springtime Grannie Simmonds saw a group of children in the woods, she assumed they were either bird-nesting or collecting bluebells. In an always successful bid to ward them off, she donned a black shoulder cloak and conical hat, took up her walking stick and wove between the trees and through the glades until she was within sight of the children, who mistook her for a witch and fled as she intended.

Bill then recalled the summer evenings spent walking and courting his sweetheart, as he put it, in the woods and fields. His future wife I think came from Cossall, the village where Louise Burrows, whose dusky beauty caught the attention of D. H. Lawrence, lived in a cottage near the church.

'I might have passed D. H. Lawrence but I wouldn't have known who he was, of course,' Bill admitted.

On his walks to Cossall, Bill loved to see, 'the white owl [barn owl] hovering like a displaced star over the fields and along the hedgerows. In the deep green dusk it would come quite close to you sometimes.'

Gradually reverting back to the times in which he lived, Bill reminisced about sleeping on hot summer nights with the cottage windows open and waking at daybreak to the dawn chorus, the woodland and hedgerow birds proclaiming the whereabouts of their territorial boundaries. He and his family heard the corncrakes during those long summer days.

But now that the M1 passed over the road within 100 yards of the cottage, Bill and his wife slept with the windows closed due to the consistent roar, day and night, of motorway traffic.

I next saw Bill on a Saturday morning the following April, for with a calendar photograph in mind I was on the canal towpath and returning

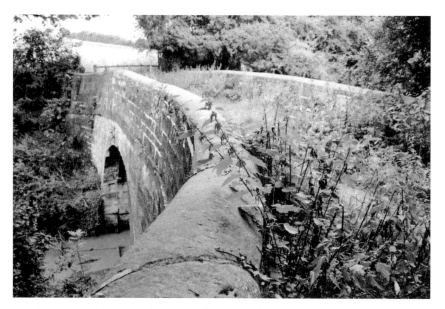

The forgotten bridge over the Nottingham Canal, built *c.* 1793-94. Here the author used to converse with cottagers Bill Smith and Albert Thornhill on summer evenings.

to Trowell Basin. The photograph, I decided, would include the willow and hazel catkins growing by the waterside and the swan pair – the pen incubating the clutch of eggs in the high mound of dead reed stems serving as the nest and the cob sailing arch winged in the foreground. But it was not to be. And this I learned from Bill, who as before approached me smiling along the towpath. He had with him several grandchildren or great-grandchildren, I couldn't be sure. One of the children carried a swan's egg. Bill carried a second. Earlier that morning, Bill told me, the swan pair had been stoned by louts until the pen left the nest to which the louts then waded and removed all nine eggs.

'They couldn't manage to carry nine, so they left these two in the grass at the side of the path,' said Bill. He invited me back to the cottage and introduced me to his wife, the children and family dog around us.

The cottage path was paved with red tiles. The couple still grew their own vegetables in the back garden, but were grateful for the fact that there was, by this time, a regular bus service to Ilkeston or Nottingham.

All the cottages interior activities, with the exception of the television, were centred around the kitchen and the black cooking range or 'hob',

which was still intact with its fireplace, 'for heating up the hot water', and ovens. The spacious hearth was used as a place where wet socks, scarves or gloves were dried.

Before leaving Bill and his wife, I photographed a swan's egg alongside that of a domestic hen to illustrate the difference in size. Then I left, with Bill, his wife and the children waving at the gate and telling me to call round at any time. But regretfully, although I kept their invitation in mind, I never called back to Bill's cottage which today has, I notice, been renovated according to modern times, along with the acceptance and drone of the motorway traffic that has sadly become part of the everyday scene.

CHAPTER TWO

A WORLD BEYOND THE CITY

The Nottinghamshire of my boyhood comprised of two or three villages south of the Trent – at least during my formative years. Throughout the Second World War my father was employed as an airframe fitter at Langar aerodrome, to which he travelled daily by bus from Nottingham. As part of the War Effort, he and my mother decided to keep poultry. The first dozen day-old chicks I went with my father to buy one Saturday morning at Nottingham Central Market. But as the home and garden poultry-keeping experience progressed, my father bought in hens or pullets that were 'on the point of lay'. These he collected from his work colleagues, who were also employed at Langar and kept poultry. But such men lived in villages like Cotgrave, Colston Bassett or Cropwell Bishop. Three villages, I mused, whose names all began with a letter C.

Exciting for me then were the Saturday mornings when my father and I journeyed by bus out to one or other of the villages.

As my father conferred with his colleague, I studied the cottages, many inset with pantile roofs. Others were set back a little off the road and fronted by orchards. Even the cottage chimneys differed, I noticed, as often I gazed at trails of blue smoke lifting slowly against a background of tree foliage.

There was always a church and a scant few shops, perhaps a High Street post office, but there was also few people about and even fewer buses.

There were homes, I reflected, but save for the twining of skylarks over the nearby fields, there was also silence.

When we returned to the bus stop my father and I were each carrying a hen or pullet 'on the point of lay'. They were usually of the Light

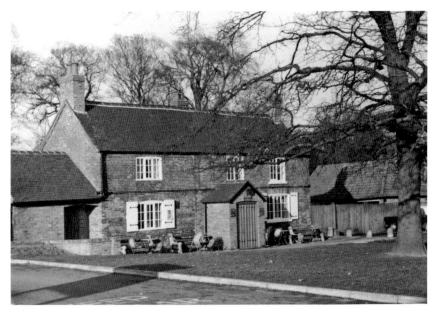

The Broad Oak public house, originally built by the Edge family for the estate workers and their families of Strelley village.

Sussex, Buff Orpington or Rhode Island Red breeds, although my father wanted, one day, to breed Black Leghorns.

Each hen was partially incarcerated in a sack and tied around the body with twine. The heads and crops were free and on the two bus journeys home, each hen sat immobile and never uttered a sound.

Bus passengers smiled, especially when we changed buses in the centre of Nottingham. I felt still small but somehow heroic, able to do a man's thing, which on those occasions was transporting a hen from one place to another.

Most evenings when he came home, I would ask my father what he had seen from the bus windows that day. Usually it was hares, rabbits, pheasants and partridges. He would sometimes describe what they were doing, their modes of behaviour and, due to his descriptions and my ever vivid imagination, I acquired a gradual interest in the mammals and game birds that the countryman refers to as 'ground game'.

When one Sunday morning my father pointed out a 'covey' of partridges huddled within the furrow of a ploughed field situated about 300 yards from the house in which we lived, he also explained that partridges roost together on the ground. They roost in a circle, each with

its head outwards, so that an approaching fox or stoat could be located immediately and a single alarm call set the covey flying.

There was, I realised, something different, if not unique, about the behaviour patterns of each bird and animal. Once or twice on those Sunday morning forays my father pointed out a stoat hunting across the fields or a group of hares circling and leaping over each other.

We also built up a list of collective terms used by the countryman to describe a group or flock. A 'chime' of goldfinches, a 'covey' of partridges, a 'spring' of teal, a 'deceit' of lapwing, a 'muster' of peacocks, a 'wisp' of snipe.

To my delight, as we passed the Dairy Shorthorn cattle cropping the parkland pastures of Aspley Hall one morning, my father told me that eventually we, as a family, would probably own a farm of our own. In order to do it, he and my mother would need to sell the house bequeathed to them by my aunt and father's sister, but he had been looking around. There were holdings and farmsteads in the countryside that my father passed through every day, mostly along and around the Nottinghamshire-Leicestershire border and with intriguing, yet unexplainable, place names like Hose, Hathern and Harby. Three villages all beginning with the letter H, as opposed to the C with which I had first become acquainted. Six Hills, another of my father's favourites, was even at my tender age a little easier to define.

* * * *

The walks I was taken on by my father each rainless Sunday morning usually embraced the north-east side of Wollaton, and Woodyard Lane and the canal in particular. Or Strelley, but as we had to walk a mile along Aspley Lane, which by that time was well built up and bordered by shops and council houses, we rated second best.

Compared to Wollaton, I found Strelley spacious and to some extent less cluttered. Separating the village from the sprawling council estate of Bilborough was Coventry Lane, which, turning in the manner of a dog's inverted hind leg, became Bilborough Road.

How swiftly the countryside can become built up housing estates was interpreted for me by the shape of a solitary farmhouse that stood beside the pavement a few yards beyond Denewood Crescent. When I asked my father why it was called Manor Farm when there was not a barn, stables

or outbuildings in sight, he explained that there had been a farm but the houses of Denewood Crescent now covered the fields. The farmhouse, at that time serving as a wartime community centre, was all that remained.

There were still fields bordering Bilborough Road and the hamlet of St Martin's, clustered around the church of that name, nestling in an inviting pastoral hollow. On the lane corner here, I never ceased to become fascinated with the exterior stonework of 'The Forge', a blacksmith and farrier business positioned, with a cottage alongside, on the higher ridge corner of Bilborough Road.

Where The Rose public house now stands, fields stretched towards the northern horizon. Two or three farmworkers' cottages, detached and with front gardens used for growing fruit and vegetables, faced the roadside. A few yards across the fields, the low white house of Moor Farm, surrounded by a white picket fence, stood within a copse of yew and holly trees.

When we reached Coventry Lane, where a signpost directed the exceptionally few cars south towards Bramcote and Stapleford, a ballast hole filled with water and surrounded by tall oaks mirrored the sky on the nearside of the field. Here we continued along the narrow country road with cottages of character set back from the pavement and trees rising from almost every available corner and parklands beyond and either side. This was, my father explained, our destination – Strelley Village.

The front gates, each positioned within a hedgerow comprising of haw or blackthorn, were singular. A narrow, paved path led directly by the vegetable and flower plots to the front door. At first glance, the village retained an air of uniformity. But a longer look interpreted the reverse, because each tract of post-and-rail fence differed from the one we had just passed and every stand of hedge, thicket and roadside ditch differed slightly.

On each of the gates was printed neatly the location and occupation of the cottager and his family, such as *The Woodsman's Cottage, The Stonemason's Cottage,* and further along, *The Head Gardener's Cottage.* They were, my father explained, tied cottages belonging to the Edge family, who were the current owners of the Strelley estate.

In retrospect, I believe The Gables, a half-timber-fronted house, may well have been the residence of the estate land agent or steward. Someone whose occupation involved him directly with the squirearchical family.

Horses for all purposes were to be seen in the fields and stable yards of the 1940s.

I was intrigued by the schoolhouse, which was fronted by a low wall inset with a water pump and drinking fountain. The windows were high and the building surrounded by sky, clouds and trees. I saw myself daydreaming and sky watching, while at the same time pretending I was listening to the teacher. Laurie Lee was already writing of such dreams.

Two cottages up from the school house, Grange Farm, complete with its grand Dutch Barn, overlooked the fields sweeping south to Trowell Moor.

On the right side of the road next to a paddock where the Grange Farm calves were kept, The Broad Oak pub, fronted by the tree after which it was named, replaced the traditional village green.

There was more stone-walling, pinkish-yellow in colour and locally quarried. More holly, ground ivy, tree trunks of varying pattern and texture fronting cottages, again set back off the road. Then across the parklands on a low ridge stood Strelley Hall, while in the roadside corner close to another holding a pond shaped like an inverted letter 'L'. I was forced to slow my pace in a bid to watch the moorhens ferrying or probing into the beds of waterweed as they searched for edible plants and insects.

In the early months of the year and almost into each summer, the usual blackbirds, song thrushes, chaffinches, robins and dunnocks could be seen or heard singing. But one Sunday morning as we neared the pond, my father and I heard an unfamiliar and excitable gabbling sound, which my father rightly associated with ducks, and as he uttered the word they came into view: six or seven Khaki Campbells following and heading off one of their number in whichever direction it turned.

Seconds followed, then for us the reason became apparent; that particular Khaki Campbell had clasped in its bill either an outsize frog or normal-size toad. There was little question of the duck being able to swallow its shiny skinned captive. Yet it held onto the frog or toad and all the excitable splashing, gabbling and attempts to ambush the seemingly stricken duck continued throughout the minutes my father and I spent looking from the fence side.

* * * *

I had in those days little sense of history. I knew there had been two world wars and before those the Boer War. But beyond that I knew nothing, except that Sherwood Forest had once harboured a green clad outlaw called Robin Hood.

Strelley Hall and such manorial residences, I decided, had been built just before those three wars. Had I learned that the village and enclosed land tract of Strelley had been owned and farmed since the early eleventh century, I would have been stunned, for I had no idea that such an epoch existed.

Strelley's first owner was William de Stradlegh [Strelley], whose son, Samson, fell into disrepute when Richard I was at the Crusades, because he sided with Prince John. When Richard returned and attempts were made to put the country to rights, Samson was fined, which was to some

extent the medieval equivalent of being blacklisted. Time and good fortune remained on Samson's side and he was awarded the Strelley estates when John succeeded to the throne.

Like most manorial estates, Strelley and the surrounding countryside has its bygone associations with heraldry, hunting, family bigotry and out-and-out rivalries. Fortunes were made and lost. Manors were divided then reacquired.

In the sixteenth century, the Strelleys were profiting from coal mining until, due to family quarrels and the lawsuits that followed, their overall wealth declined considerably. Consequently, the estates were put up for sale and in 1651 bought by a prominent Nottingham lawyer, Ralph Edge. But it was not until 1682 that he managed to acquire the outer portions of the Strelley estates, thus finalising his ownership of a greater proportion of the lands awarded to Samson in medieval times.

※ ※ ※ ※

A narrow road followed the parkland fence of Strelley Hall around a tight corner and directly north. Because it was wartime, pheasant rearing had ceased on the estate and Harold Walton, a gamekeeper born at Wollaton, had left Strelley and enlisted in the armed forces.

But from Strelley he collected several small trophies, one of which was a stoat he trapped – unusual because it was in partial white or 'eclipse' winter coat and partial russet which is the normal coloration. This specimen he had set up by Wollaton Hall taxidermist Leonard Wilde, and displayed it in a glass case, as was often the fashion in those times. The stoat I saw when I had befriended and visited Harold some thirty or so years later. Harold's predecessors, and in particular the gamekeepers of the mid-eighteenth century, had made by a local blacksmith a succession of mantraps intended to catch and hold poachers.

In 1861 the Offences Against the Person Act came into force and the mantraps were withdrawn. Numbering sixteen and stowed in a stable loft of the hall they were considered to have been the largest number of mantraps within private ownership, but were sold at the request of Strelley's last owner, Miss E. M. Edge, at a Retford auction on 20 October 1971.

Besides pheasants, rabbits and hares and the predators associated with them, the parklands of Strelley Hall yielded another interesting occupant.

Thomas Webb Edge (1756-1819) and his wife were, in the summer of 1801, watching a molehill being raised among the tussocky grasses when a large gold ring was suddenly brought to the surface. On picking up the ring, they traced the engraving of a woman in flowing robes. Above her head was a halo. The ring was probably worn by a woman of the fourteenth or fifteenth century, it was later decided, and the two words inscribed probably bore the name 'Saynt Edith'.

On our Sunday explorations, my father and I knew nothing of these incidents. Nor did we see a single person in Strelley Village. If we had, he or she might have told us that our namesakes, the Taylors, had at one time been millers and that the gamekeeping families were named Duffin, Elliot and Collishaw. These families each maintained a long lineage throughout the Strelley estate, as did another family named Falconbridge.

One imagined informant may have mentioned the school having been built in 1840 and then rebuilt with the schoolmaster's house incorporated in 1872.

We might also have learned that The Broad Oak pub was originally a stable block and its first landlords, who opened up the venture, were also tenant farmers.

In 1855 a windmill stood behind the appropriately named Windmill Farm. George Breeze was the best known of the millers. But no one of the twentieth century could say why the mill was dismantled.

By 1929 Strelley was still not connected to the City of Nottingham's water supply. Nor was electricity or gas installed until the mid-1930s. There was not then, and never has been, a village shop.

The outbuildings around the Hall comprised of a laundry, dairy, baker, joiner's shop, brewery, stables, coach house, kennels, gamekeeper's and game hanging rooms and a gun room. Dating from the original hall, there was still in existence a pit that was used for bull baiting and perhaps cockfighting. Both these pastimes, such as they were once known, gained popularity in Staffordshire, which is where Walter Edge, whose son Ralph acquired the Strelley estate in the late seventeenth century, was born. Walter Edge was a lawyer and lived at Horton, Staffordshire, before moving to Nottingham in or around 1620. The baiting pit may have originated, at Walter's bidding perhaps, after that time.

Leaving our imaginary informant, my father and I, on those wartime mornings, continued along the wall on the right which, hid the Strelley

The south-west wing of Strelley Hall and the gate in the wall leading into the foreground churchyard.

Hall gardens from public view. Magnificent Cedars of Lebanon and other ornamental trees rose above the height of the wall as the lane contour lifts to meet the entrance to All Saints' Church with its early perpendicular style and twelfth or thirteenth century base, although the main building work apparently dates from the fourteenth century. The battlements were added a century later. Pevsner described this church as 'the most important on the western outskirts of Nottingham.' The ancestral tombs are inside an ornate chancel. The nearby nave was similarly described as 'the finest rood screen in Nottinghamshire'. The outstanding monument is considered that awarded to Sir Samson de Strelley, the church founder.

The ancestral and family cemetery is situated opposite the church with the undulating fields and varying skyline beyond.

I never ceased on those Sunday morning walks to be fascinated by the buttress-type gate lodges positioned at the entrance to the Hall grounds, the gates of which were always closed, if not locked.

On the few occasions my father and I entered the churchyard to look at the gravestones, we glimpsed the south-west corner of the Hall into which was incorporated a medieval tower. But we knew nothing of the

Hall's occupants, who in later years I learned were two: Miss E. M. Edge, the only surviving family descendant, and her butler, both of whom had moved into the south-west wing.

Even less did we realise that the Hall was rebuilt in 1789, its architect being Thomas Gardner of Uttoxeter.

The interior of the hall consisted of four reception rooms, sixteen 'principal' rooms and bedrooms, and four bathrooms. There was an Adam fireplace. The furniture was of the Queen Ann style, which included a walnut grandfather clock. A Welsh dresser and three Chippendale armchairs blended well into the ornate and historical surroundings.

Had we been allowed inside, I don't doubt that my father and I would have been fascinated by the gun cupboard built into the thickness of the wall.

But as this was not to be, we had always to continue with our walk and as we left the hall and church I became fascinated by the Holme 'evergreen' oaks, providing a bower in the field and family cemetery corner across the road.

Evergreens, such as yew, laurel, rhododendron and the pleasantly prolific holly, screened the cottages and houses well back off the lane.

There was a ballast hole off to the left, kept in check by the low wall on which I frequently leaned while tracing in the carpet of floating leaves the routes made by moorhens, especially in the autumn when these birds would find not only remnants of torpid insect life, but seed heads and beech mast also floating in the leaf litter.

Where the lane turns left towards Oldmoor Wood and Robbinetts, the winter tree traceries and fields, ploughed in those times by Fordson tractor, became apparent. I recall on one occasion my father and I walking the length of the countryside beyond Strelley and winding with the footpath down into seemingly distant Kimberley. From there we caught a Midland General, the cream and blue liveried bus, back to Bobbersmill from where we had only another three-quarters of a mile to walk home.

But it was on the Oldmoor Wood/Robbinetts ridge lane that my father and I met one man and to my surprise he knew my father.

Wearing a three-piece 'Sunday best' navy suit, a cloth cap and horn-rimmed glasses, the man topped a stile in the hedgerow and greeted my father with such warmth I thought the two were going to embrace.

Through their conversations, I learned that they had attended the Bentinck Road School together then been drafted into various army

units throughout the First World War. Moreover, it was from this man that I learned that my father had been captain of a local football team, a left-handed spin bowling cricketer, and a pub pianist. These admissions again surprised me because I knew that my father loved and had for many years worked with horses. He had served as a horse-breaker and stable orderly with a cavalry unit in the Sudan. That much he had told me, along with his main ambition, which was to have been a jockey. But he was a little too heavy and as a man of average height, considered too tall. Of his talents on the cricket and football fields I knew nothing until that morning.

And so the village of Strelley I have long regarded not only as a village conceiving many historical questions, but also as a place of pleasant surprise, 'Why didn't you tell me, Dad?' I remember asking later.

Despite his Sunday best 'city' attire, this friend of my father's was, like most of their generation, also a countryman. He told us that if we took the footpath over the ploughed field across which he had walked, then climbed the next stile, looked to the right and counted the ninth furrow in from the hedge, we would see a hare lying in its 'form'. This we did, after the two men had shaken hands and wished each other well.

Before leaving us, however, the man looked down at me and ventured, 'I bet you don't know the name for a young hare, do you son?'

'Leveret,' I told him.

It was then the man's turn to look surprised. 'Well I never! Well bless me!' he exclaimed and from his pocket took a bag of Dolly Mixtures. 'There you are son, you've won today's big prize,' he announced, while gently ruffling my hair.

THE EVENING 'MYSTERY' TRIPS

In the bookshops and stationers of twenty-first century Nottingham, sepia postcards depicting the city and its surrounds that my parents knew are displayed on racks.

The postcards of the Victoria Embankment interpret a promenade lined with lime trees and lawns – or what can be seen of them, because in the stifling hot days of those bygone summers people of all ages gathered there on fine evenings, particularly at the weekends. Those who chose not to walk or visit the Memorial Gardens sat on the steps watching their friends taking out a rowing boat or selecting a comfortable seat on a pleasure cruiser.

On several weekend evenings during wartime my mother and father took me to the embankment, but if we sat on the steps and, like many, fed bread to the swans, it wasn't for long because all three of us were really out for a walk.

At that time I regarded the Victoria Embankment between Trent Bridge and Wilford Toll Bridge as somewhere special, much as I do in present times. Since those early years I have walked many riversides but, apart from Richmond-on-Thames, have found nothing to compare with the sylvan and aquatic atmosphere nurtured by this man-created walk that follows the natural meanders of the Trent so closely and effectively.

On those evening walks, or strolls, with my parents, I noticed that once we were past the suspension bridge, other strollers became fewer, as did those couples, the man always at the oars, rowing on the river.

One evening I spun round on my heels as a rhythmic clapping sound revealed a swan flying low over the river surface, neck outstretched and wings flogging the water. Like a pale sea plane, the swan crossed the

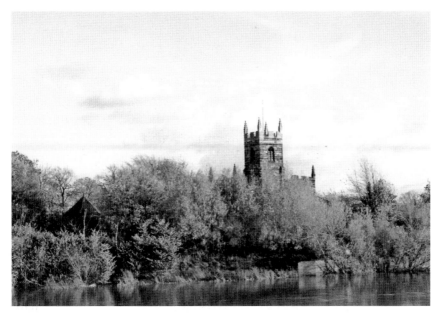

Wilford church from the north bank of the Trent.

tapering path of the river emblazoned sunset and changed from white to pale grey, purple and then to black, in accordance with the position of the clouds, the sun and the play of light. And that, for me, was enough. I had seen an image that in its grace and power excited me. I had also seen the swan change colour, in accordance with the light, as it flew downstream. I asked for nothing more, while knowing that my parents would turn only when we reached Wilford Toll Bridge.

The village of Wilford, I discovered, was situated on the opposite side of the Trent along the south bank. It was a village about which my parents spoke with affection, where around the imposing riverside church there were many picnicking spots and in the village some memorable old cottages. People bought cream teas and sat in the front gardens of one or two of these cottages. Or if the visitors, usually walkers or cyclists, had stowed in their rucksacks wrappings of sugar and tea, the cottagers provided the milk, cup, saucer, teaspoon and flask of hot water.

My mother and father enjoyed their cream tea afternoons at Wilford, after which, not infrequently, they continued upstream of the Trent and through the lanes to Clifton Grove, situated along a ridge of red sandstone gorged out by the last Ice Age and persuading courting

couples of bygone times to walk between the ranks of lime, oak and elm trees to a termination point near the equally pretty Clifton Village, and the church and hall in particular.

Cottagers advertised their cream teas at Clifton much as they did elsewhere. The village green was beautifully maintained. But it was at the opposite end of the village, on the lawns and around the monuments of Clifton Hall, that my parents saw their first peafowl, the peahens pecking at the turf while the peacocks paraded with tails fanned out in full display around them.

On those wartime evenings when I was taken by my parents to Wilford Toll Bridge, they explained that Clifton Grove and the hall were closed, due to the property having been taken over by the War Department. So we had to be content with the stroll to Wilford Toll Bridge, the sandy yet reed-swathed inlets of the Trent, and the water meadows over which swallows and housemartins 'hawked' for flies, blazing yellow due to the profusion of buttercups and celandines.

During the construction of this iron-framed bridge in 1870, many Roman coins were found along with a number of interesting artefacts. From these finds, one can assume that the villages were indeed once ancient settlements, with the connecting trackways now converted to busy roads.

Before this bridge was constructed, a previous bridge had a 'Table of Tolls Act' drawn up by its owners whose days were spent in the tollhouse collecting the tolls. The 1870 bridge was used for the same purpose and the toll rates used accordingly.

In his boyhood my father, and probably both my grandfathers, came here on Saturday mornings to watch the flocks of sheep and herds of cattle being driven from the farms situated between the Trent and Soar valleys to the abattoirs around Daleside Road, London Road and Great Freeman Street in Nottingham.

The herding was taken on by drovers, who hired themselves and their bicycles out to the farmers, most of whom had many seasonal tasks to occupy them around the fields and farmsteads and were therefore grateful for the drovers' services, even though they had to pay for them.

On reaching Wilford Toll Bridge, the drovers, according to the Toll Bridge Act had to pay: 'For every ox, cow, bull or neat cattle one penny, or for a score *6d.*' Charges were also made for sheep, yet on the bridge toll sign still displayed in present times there is no mention of them.

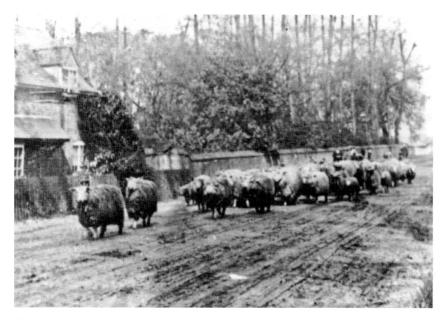

Sheep and cattle were driven by road to Nottingham cattle market.

The drovers were apparently, like many unskilled men of their time, a breed apart. Not all of them were reliable, however those who were worked in teams and divided up the cattle and sheep into manageable herds, flocks or groups. A group was regarded as the responsibility of one drover and his dogs. The name 'Drove' on a map, which admittedly no longer seems to exist among Nottinghamshire place names, indicates the section of a route used by these men. But back in Tudor England, drove roads were a foregone conclusion on any map relating to the inland counties.

At the cattle auctions, markets or abattoirs, each buyer or stockman signed the documents stating how much they had paid for a herd or a solitary beast, and these the drover returned to the farmer or landowner, although not immediately.

After a day or two spent droving, herding and hard bargaining, the drovers headed for certain boisterous pubs in the centre of Nottingham where they drank, gambled and allegedly consorted with prostitutes.

Following the weekend, each Monday the drovers met the prominent city-based butchers, all of whom closed their business at noon, for within the livestock trade hereabout Monday was known as 'Butchers'

Monday' when these tradesmen also headed for the inner-city pubs and the bawdy trappings connected with them.

On Tuesday the butchers opened their businesses as usual, while the drovers went back to their homes if they had them, but more often their stockman-based lodgings, the contracted work having been completed until the following Saturday.

One Sunday evening my parents took me across Wilford Toll Bridge, but I cannot recall whether or not they paid a toll. The bridge was known locally as 'the halfpenny [ha'penny] bridge' because that was the amount charged to a pedestrian for crossing it.

There was, I sensed, a touch of romance, a feeling of togetherness, threading strongly between my parents on that warm, sunlit evening. In retrospect, I believe they were remembering the times they crossed the bridge as a courting couple on their way to Clifton Grove. When we reached Wilford Church, my father pointed out the green turfy routes leading down to the river. Then he and my mother stood on the pavement quietly discussing the individuality of each roadside cottage, some with pink and yellow roses highlighting the porch, others with interesting name plaques attached to the door or brickwork alongside.

We heard the staccato rhythm of an approaching pony – a trotting pony – and presently an elderly couple guiding a pony and gig along the narrow road diverted my gaze as my parents stood smiling, as if transfixed. The trotting pony, specially bred I believe for the task of pulling a gig, was black, its neck, body and flanks gleaming like satin. The pony trotted with blinkered head lowered, neck arched, mane lifting and swaying and legs describing the splendid co ordination of the trotting gait that is so admired, and understandably, by equestrians.

The gig, bearing gold lettering that because I was stunned by the magnificence of the pony I failed to read, was painted black and fitted with black leathery type upholstery. The wheels were painted bright yellow.

Couples and families strolling on the village pavement turned, then stopped and commented. No doubt they, like my parents, wanted to retain this remnant of a fading era; the 'times gone by' element that would in future years be seen only on sepia photographs and to which there would be no return.

* * * *

Further explorations of Nottinghamshire became for me enhanced by our Sunday evening 'mystery trips'. Because so few families owned cars, there was a growing demand for these two-or-three hour excursions into the surrounding countryside and a stop, if not two, at a forest or riverside pub. Such excursions were laid on by three coach companies, Barton, Trent and Skills, throughout the summer months.

In retrospect, one would have thought that boarding a coach five, sometimes six, mornings a week would have been enough for my father. But he never once complained when we travelled again to the Huntingdon Street bus station for his seventh day of journeying out into the countryside and with the awareness that he would be returning to that same bus station nine or so hours later in order to board his usual 'works bus' to the airfield at Langar.

More often than not, the mystery trip described a circular route beginning south of the river and with such regularity that I anticipated the route and looked across at specific farmsteads, folds of land, and lines of trees as we travelled the A52 between Gamston Bridge and the Saxondale island.

These evening trips also filled me with an awareness of a sense of direction, as usually the trip commenced with the 'home' image of north-west Nottingham and its suburbs, psychologically placed at my back or over my right shoulder. I recall seeing fields of wheat and barley slewed to one side and blackened by, my mother explained, the fierce and continual summer rains. The harvest, she told me, was ruined for that year. Consequently, everyone would have to pay more for their produce when buying at the shops.

When we journeyed north into Sherwood Forest country, the 'home' image became transferred within my mind to the left shoulder. Home was in that direction, I told myself. The glades of the little that remained of Sherwood Forest and The Dukeries estates (with which in the then future I became well acquainted) fired my imagination. But I was not fantasising on the theme of Robin Hood. Instead I was hoping for a glimpse of the wild red deer, the true and ancient forest strain that I was told still remained there, although described as being widespread and relatively few in number.

When we stopped at a village pub, I had always to stand in the porch, glass of lemonade in hand, while listening to the baritone cajoling of drinkers packed shoulder to shoulder around the bar, and between

whom my father shouldered his way in his early arrival bid to buy drinks for himself and my mother. The smell of beer, providing it wasn't stale, I loved. The low beamed snugness and ingle-nook comforts that I occasionally glimpsed as I peered between the groups of drinkers, nurtured within me an ache, an impatience connected with growing up and being able to join those drinkers myself.

Occasionally, when we stopped at The Red Lodge on The Fosse Way, or The Unicorn at Gunthorpe, I wondered if Dick Turpin on his legendary mare, Black Bess, had also stopped there, the highwayman still masked, cloaked and winning the landlord's sympathy on his famed ride to York. Of the Roman-era associates with The Fosse Way, by contrast, I knew or learned nothing. Those country pub stops were, I soon realised, the highlights of each trip for those many adult passengers. My father's favourite was, I recall, The Cross Keys, at Epperstone. But I was searching, as I have always searched, for images, the majority of which I found in some way fascinating. Except perhaps the Nissen huts, barbed wire compounds, stacks of sandbags and tanks that usually polluted the outer glades of Sherwood Forest.

It was all to do with 'the war', I was told. Army units, battalions and personnel were established there. 'In residence' until the War Department decided they should be withdrawn. Nevertheless, protective measures though those army compounds interpreted, I regarded each as an eyesore and silently wished them out of the way.

One sun-drenched evening in the springtime of some unrecorded year, the coach driver, instead of deciding to swing south-east along and around the villages like Syston and Fardon, which are linked closely to The Fosse Way, obviously thought that a change wouldn't be amiss and guided the coach south-west while following the long ridge route through Clifton Pastures and Kingston-upon-Soar. This was, for most of the passengers, a less travelled route, and I noticed how keen an interest they took in the countryside, parklands and villages that we passed through.

When eventually we swung north after having crossed the River Soar and the Leicestershire border, I realised the 'home' image was for me in front of the coach and somewhere over to the right. We may have journeyed through Shardlow – I cannot recall – but it would have made sense if we had. Eventually, however, the yellow-flowered water meadows of Sawley held my gaze before the coach travelled over two

bridges: first the hump-backed bridge over the Sawley Cut, then the fast flowing currents of the Trent, where in one glance I took in a weir, two islands and the steeple of Sawley Church, which for me has always contrasted beautifully with the low, fertile yet vulnerable flood plain of the Trent valley.

I was still revelling in those images when the coach turned right and followed the A453, as I now know the road to have been, towards Long Eaton.

Wrongly believing that the rest of the city directed journey would comprise of passing houses with various styles, corner shops, an occasional church or chapel, I settled back in my seat while imbibing those previous images and was unprepared for the next hump-backed bridge.As the coach made its descent I suddenly realised that a stretch of canal flanked the roadside for about four or five hundred yards. Moreover, a swan sailed on its mirrored surface while taking sips of water as, like the flying swan mentioned earlier, it crossed the path of the sunset. Then to my disappointment the canal curved behind a school, a fire station and a library on its northern course. Determined to return to this place when I was older, I asked my parents where we were. They both said they weren't sure, until the sign appeared: 'Long Eaton'.

That name I retained, along with the images, which had again psychologically screened the continuing threat of war and enhanced yet another of our evening mystery trips.

* * * *

The fields of Aspley Hall Farm, situated about a quarter of a mile from home, I walked occasionally on summer evenings with my father. They were parkland fields inset, probably since the Enclosure Act, with spinneys and grazed by a herd of dairy cattle. I had learned to identify a Dairy Shorthorn, Ayrshire, Jersey or Blue Albion cow and before I attended school I could confidently master the twelve times table. Maths, or sums as they were known in the infant school, mattered little to me, except those connected to adding, subtracting or dividing money, because I was convinced that one day my father and I would become farmers – dairy farmers most probably. Therefore it was, I thought, essential that I could identify the cattle breeds apart, and one day learn the rudiments of the dairy or milking shed.

On our way across the fields to Shepherds Wood we bypassed these heavy and lethargic grazers, heard them breathing or coughing between their mouthfuls of lush grass, and smelt the sweet aromas of digested buttercups and glandular controlled milk that would be persuaded into buckets at daybreak. I studied their weights, body contours, and pelt colouration and was always aware of their swinging tails and udders against a background of singing larks or cuckoos calling from the woods that beckoned us on.

I felt at home, at one, with the Aspley Hall herd.

When one Sunday morning my father took me further afield across the Exmoor-like wilderness of Bramcote Hills to Moor Farm and Coventry Lane, I become by contrast apprehensive. With Coventry Lane at our backs and Moor Farm on our right, we faced the noonday heat and home. But my father was in no hurry. Wearing his trilby hat, good suit, polished shoes, waistcoat and pocket watch to remind us of the time in respect of Sunday lunch, he strolled while attempting to answer my constant flow of questions.

Then it occurred to me that the herd of Lincoln Red bullocks were, as one body, heading in the same direction as my father and I. And like us they were in no particular hurry. One or two seemed to turn sideways, tails swinging, and side-stepping in an attempt to move in closer. Comparing the size and weight of each bullock with that of my father, I voiced my concern: that we should quicken our pace and attempted to ward off my sudden fear of being trampled underfoot.

My father? He chuckled. So they might follow us? So what? They were only cattle. He had, as a young man, handled unbroken stallions standing at sixteen and a half hands. 'And stallions can be really dangerous,' he smiled.

To my continuing alarm, as he and I walked, the bullocks slowly yet intentionally closed in on us. But my father would have none of it. With one hand stuck into his trouser pocket, he strolled. So what, he murmured again, they were only bullocks. Yet despite my father being present, I had never until that time experienced such relief as that which swept over me when we climbed the stile that took us over onto Moor Lane, Bramcote.

Thirty or more years elapsed before I discovered, due to local history research, that Moor Lane, insignificant though it now appears, was the oldest road connecting Wollaton to Bramcote and the adjacent lanes or

An intimidating stance. Red polled bullock, curious and on the defensive.

trackways. This lane, or nearby Coventry Lane, may have been used by Romans travelling from Attenborough to their fort at Broxtowe. Known in the Middleton times as 'Brickyard Lane', the still narrow route was overlaid with clay, cobbles and bricks. Such substances provided a secure footing for the horses that pulled the carts to Lord Middleton's brickyard, which was situated alongside the canal. This canal Lord Middleton partly owned, along with the colliery, situated a mile or so away.

The bricks not used by the Middletons were sold by the ton to the Nottingham and District building contractors but the problem was, for many years, the steep sides of Bramcote Hills, up which the brickyard carts had to be pulled in order to reach the hamlets and villages of the Trent Valley on the other side.

The kindly owner of the white cottage built on the corner of Deddington Lane explained in recent years that his grandfather and great grandfather had known those times and the hardships associated with them. He recalled horses sustaining injuries while attempting to pull cart-loads of bricks to the crest of Bramcote Hills and the times when both a horse and cart overturned.

If the Middleton family negotiated for a route with their estate neighbours the Sherwins, who owned Bramcote Hall, those negotiations

were never recorded for posterity. However, negotiations with the owners of Moor Farm allowed for extra horses to be grazed and stabled there. These were in turn harnessed to the existing team pulling cart-loads of bricks from the brickyard. In this way the horsepower was doubled or trebled and the loads conveyed over the hill brow without mishap.

Today no such hill brow exists because eventually the Middletons used dynamite to cut a satisfactory route through the terrain. This in present times makes for an interesting three or four hundred yards of the walk – from Moor Farm to the nearby houses and sports fields of Bramcote College.

Returning then to the morning my father and I walked Moor Lane, we were without realising it exploring an old, perhaps ancient, and once well-used trackway.

Another track that I walked just once was that which struck west from Cinderhill Road, near Bulwell, and wound directly up or downhill by the Northern Cemetery and Snape Wood to or from Bulwell Hall Park. So far as I can ascertain, the track was named after the farm beside which it passed – Crabtree Farm. Eventually, the tall hedgerows of haw and blackthorn on either side eased into low scrub thickets. On the left, as we walked uphill, the farm came into sight. The fronting wall was made from locally quarried stone. The cart and cowsheds were situated way back from the house, which looked out onto the track. There was an orchard and the crab apple trees from which the farm was so named. A mixed group of Buff Orpington and Rhode Island Red hens ranged freely throughout the yards and hedgerows, but our attention was immediately diverted by the first-cross mongrel dog, which barked and strained at the end of a chain.

The dog was, we discovered, held fast by its chain to a kennel, which was no more than a barrel turned onto its side.

The lane wound between the two woods, Snape and Sellers, then petered into a green road near Barkers Wood, through which we walked before meeting with and crossing the cricket field and football pitches of Bulwell Hall Park.

To my delight there were two lakes fed by a woodland stream, which surged down from Hucknall and perhaps the higher tracts of countryside beyond.

On one of the lakes, yet another lone cob swan rooted deeply for weed, and I was puzzled by how the swan had found these lakes. What I failed

to realise was that the River Leen, with its many attractive backwaters and millponds, had gauged a long winding course through the fields less than a mile away.

We were that Sunday about six miles from home and so being by mid-morning tired, I was also relieved when my father guided me across further tracts of parkland and along another dirt track lane, which brought us out onto Hucknall Road, near Forge Mills, Bestwood. Here we boarded a bus that returned us to the more familiar climes of Bobbersmill.

AN ATMOSPHERIC PLACE

Due to these early days and the trips associated with them, I found myself not only comparing fields, woods and the varying meanders one glimpsed in the Trent and Soar valleys but also villages.

Strelley village was, for instance, different from Wilford and our often visited Radcliffe-on-Trent. Wollaton village could hardly be described as similar to Bingham, to which my father took me on Boxing Day 1944. There we attended a meet of the South Notts Hunt with Bingham village and its centralised square in the background.

The houses and cottages nurtured a sense of solidarity. The feeling of family lineage closely associated with that one place which to many, who remained unseen and chose not to turn out for the hounds, was unquestionably home.

Each of the trips I was taken on by my parents proved to have been more than a coach trip, or 'a ride in the country' as people described such trips. Each direction or stretch of road along which one travelled retained, like a person, its own personality but which, unlike a person, was formed according to the eventual destination, the weather, cloud formations and changing or relatively static landscapes.

There was, I discovered on one Sunday afternoon trip, more belts of woodland, spinneys and coverts beyond Arnold and Redhill, north of the Trent, than in the rising and the dipping wolds-like country to the south. That Sunday after the war had ended, we and our fellow passengers were going 'somewhere really special', or at least to the single oak tree fronting the formal entrance of that place. We were going, I was told, to Newstead Abbey, once home to a poet called Lord Byron. I knew little about poetry, even less about Newstead Abbey.

When one gazes at the countryside from the windows of a vehicle, one is looking at history, the past. The farmsteads have been built, the fields allocated, and the field boundaries planted and aligned, in this part of the world, with haw, blackthorn, oak, field maple and black poplar. One is looking at what might be described as a living museum.

That much, as a boy attending infant school, I had gradually become aware. On that and subsequent trips I learned also that many of the woods and coverts were intentionally planted. But I was not aware in terms of time how far the countryside, let alone the world, reached back. For me the afternoon trip began when the coach reached the Leapool Roundabout and swung gently left onto the A60. Beyond the hilly fields to the left the trees of Big Wood (or Bestwood) pleasantly blocked the skyline. This southerly tip of Sherwood Forest is said to have once been owned by Nell Gwynne. It is a climbing wood with steep slopes and much ground shelving, which in the reign of Henry VIII was where no less than 114 red deer and 691 fallow were kept, both to grace the royal table in respect of venison joints and also for hunting. The word 'park', which in Norman French was spelt 'parke', denoted 'the place at which the deer are kept' and in Henry's reign Bestwood Park, within which Big Wood was enclosed, certainly lived up to its name.

Why Leapool Roundabout? I wondered in later years. The roundabout refers to the traffic island. The word 'Lea' suggests that the field slopes as we see them today were at one time wooded, because the word in Old English denotes 'a glade or stretch of open land situated within a wood'. But the pool?

I discovered that there was water nearby when an acquaintance from Calverton mentioned in the 1980s that as he journeyed into Nottingham each morning a heron stood preening on the grass of the traffic island, regardless of the lines of traffic and the associated sounds. I explained that herons frequent certain pools at night or the small hours of morning. Therefore, after a bout of hunting, or 'fishing' ,as some refer to the heron's manner of securing food, a heron needs to regurgitate all the indigestible fish bones and such matter before it settles to preen and oil. Quite often the heron will walk a few yards from the pool and begin its toiletry rituals there, which is why herons are sometimes to be seen standing in fields. If a man happens to be ploughing with a tractor, the heron will not associate him as a source of danger and will remain. But if a man is working or walking nearby, the heron will take to the wing.

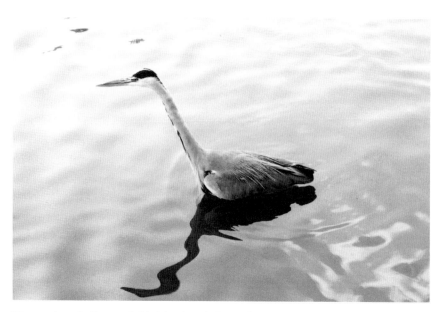

Heron alerted. One such bird intrigued the early morning commuters travelling to Nottingham from Claverton and Mansfield by preening in the centre of Leapool roundabout.

So far as the Leapool Roundabout heron was concerned, it looked as if the bird had been disturbed from a field where perhaps close by a man or group of men were hedging and ditching. That said, neither my Calverton acquaintance or I could recollect there being a pool in the area. Years later I discovered that we were wrong, as on looking at the winter hedgerows while in the passenger seat of a car I saw the silver gleam of water: a small fishpond inset into the road or ditchside corner of the field. There may indeed have been a large pool in the long wooded glade when Leapool was so named.

Just over the horizon, and following the ridge line from Daybrook to Big Wood, is a lane along which I have walked but once. Pausing at a farm gate to look across the fields, I was joined by an Arnold man. He enquired if I was looking at anything in particular. I told him that I was attempting to make something of the landscape, while adding that it looked a likely place for barn owls to be hunting over.

Returning to the afternoon of our trip, I was surprised when, not far along the A60, we passed a group of ornate-looking buildings fronted by evergreen shrubberies, trees and a small foliage reflected lake. Was that

Newstead Abbey? Smiling, my father explained it was 'the waterworks'. In later years the building and its environs became officially known as the Bestwood Pumping Station.

Built from 1871-73 the pumping station was designed by Thomas Hawksley, who designed around 150 pumping stations throughout Britain. Hawksley was, however, born in Nottingham. The site and pumping station were managed by the Nottingham Waterworks Company, who were forever aware of water sources becoming polluted and served to eradicate such problems.

The company leased the site from the Duke of St Albans, who owned the historic estate of Bestwood. The Duke, residing across the hills at Bestwood Lodge, insisted that the design resembled that of his residential home, thus arched Gothic-type windows, balustrade stairs and ornamental carvings were strongly featured.

The Bestwood pumping station chimney, extending 172 feet, was designed in the manner of an Italian bell tower.

To retain the same atmosphere of lavishness, the chimney extending to 172 feet was designed in the manner of a campanile or Italian bell tower. When the station was completed the grounds were fitted with gas lamps.

Because the two wells, at 176 feet deep, became over-pumped, similar pumping stations were built at Papplewick (1884) and Boughton (1901). Harry Clements, the superintendent, lived in the gate cottage with his family and retired from the Waterworks Company after serving for twenty-four years. He retired in 1939 and moved with his wife to Mapperley.

To some extent the Clements family lived off the land and no doubt bought their milk at nearby Lamins Farm, for attached to the house was an allotment and fuel bunker. The buses between Nottingham and Mansfield stopped conveniently outside of the waterworks and so Mrs Clements, if not her husband, had the choice of a city or a town in which to do the extra shopping.

Next to the Pumping Station the stockyards, outbuildings and house of Lamins Farm front the A60. This farm, situated below the east slopes of Big Wood, was once owned by the Duke of St Albans. It is called Bottom House Farm. By taking the lane left and walking between the hedgerows towards Big Wood, one passes Top House Farm, named probably because of its situation about halfway up the back-sloping hill. This lane and the one I once walked from Daybrook converge by the equestrian centre on the edge of Big Wood. From there one can walk downhill through Big Wood to Bestwood Colliery village, or take the track on the left and fronting the equestrian centre. This leads to the Bestwood Hotel and the adjacent housing estates on the urban fringe of Nottingham.

The fields around and between the two farms were managed by John and William Lamin, respectively. In 1915, when Nottinghamshire hosted the Royal Agricultural Show, both brothers won prizes for having maintained the best arable farms in the East Midlands. In the post-war years they received further recognition for being the first Nottinghamshire farmers to have grown sugar beet.

None of these facts, of course, came to light when I was bypassing in the Newstead-bound coach with my parents. In later years I heard the A60 being referred to as 'the Mansfield Ramper'. Yet to this day, none of its regular users, with whom I have spoken, can tell me why. Belts

of silver birch woodland flank the east side of the A60 as one travels north. Farms, holdings and game coverts are maintained throughout the varying types of land beyond the trees. For a further three or so miles the road winds between the fields until it meets with the B6011, Linby and Papplewick Lane, the large spacious detached houses surrounded by belts of woodland and individual in style, screen the estate woodlands of the Newstead estate.

The woodland gardens hereabout play host to all three species of woodpecker which visit the bird tables, jays, pheasants, an occasional brace of wintering woodcock and sparrow hawks.

When on the day of our trip we stepped from the coach at 'The Pilgrim Oak' and lodge gates of Newstead Abbey, I became all too sadly aware of how close my parents, sister and I lived to the boundaries of a busy city, until I remembered our future farm.

At 'The Pilgrim Oak' people reassembled after leaving their buses and the trek began along the winding centralised drive connecting the main road to the Abbey.

I mused quietly on the fact that everyone was walking or strolling in the same direction, the majority carrying picnic baskets. Thick rhododendron coverts overlooked by stands of mature silver birch fringed the roadside then gradually heathland merged in. There were oaks, pines and maples rising monumentally against the low hills or background sky. But the silver birches continued, having long gained a foothold.

Inch-high grasses eventually flanked the drive and pleasant slopes of unchecked bracken. Rabbit droppings or 'tods' were profuse and completed with the mole heaps.

The park, my father observed, appeared to be overrun with rabbits, while adding that the estate probably lacked gamekeepers and a mole catcher due to the men of these professions having enlisted for service with the Armed Forces during wartime. I then asked my father what would happen if the rabbit numbers continued and he pointed to a patch of bare earth. 'That. And the rabbits would die out because there will be nothing left for them to feed on,' he explained.

On each undulating bend of the Newstead Abbey drive I expected the Abbey, or some aspect of our destination, to ease into view in the way that our close-to-home Elizabethan eminence of Wollaton Hall came into view when one had spent but a matter of minutes walking the formal drives. I also envisaged the Abbey situated on a hill in the

manner of Wollaton Hall and was, therefore, after a walk of two or so miles pleasantly surprised to see it rising comparatively low, compared to other country seats, from within a wide valley backed by parklands and woodland.

To the right, and divided from the Abbey and its frontal lawns, the lake for me held equal prominence. And so like many, I expect, we picked up our pace, forgot our weariness and proceeded down the gentle grassy slopes. There was, I emphasise, no car park in those days. And perhaps no plans for a car park, for the idea of parks, be they in cities, suburbs or the countryside, was to provide somewhere away from what were then considered to have been the stresses of everyday living.

Lured like most people by the sight of water, we went first to the lake alongside which families picnicked to such an extent that the majority were within conversing range of each other. Among the picnickers padded a cob swan, to the alarm of some families, who rose and moved aside, while attempting to ward off the bread-demanding swan who helped himself from their equally white tablecloths. By the lakeside in the nearest corner to the cob, the pen rooted for weed and scattered it on the water surface for the large brood of eleven cygnets to feed on.

To my further delight there was a waterfall and a pump house over which the water descended as one stood mesmerised before the glassless windows. The waterfall fed the lower lake, partially surrounded by shrubberies and ornamental trees. So far as I was concerned, there were two lakes centralised within the grounds of Newstead Abbey. In those tender years, I surmised that the lakes had been dug out by teams of men and over a long period of time filled with rainwater. Some fifteen or twenty years passed before I discovered that the lakes are part of the descent gorged out by the River Leen on its journey from the second highest point in Nottinghamshire at Hollinwell in the parish of Kirkby-in-Ashfield.

I was unaware that these lakes, said to have originated due to the Byron family having paid to have dams constructed, were part of the long aquatic staircase that descended into the mill-dominated villages of Papplewick and Bestwood before continuing down into the less scenic districts of Bulwell, Basford and Radford.

Whether manmade or not, these are lakes in every sense of the word, along with the chains of outlying private lakes that enhance a number of residential properties, and Newstead is the wealthier for hosting them.

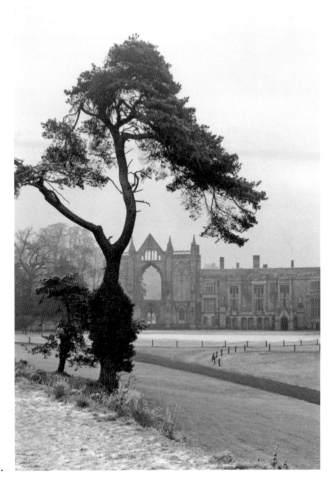

Newstead has remained the most atmospheric of the houses around which I have been shown. It seemed incredible that someone had chosen to live there.

After our brief exploration of the lake and waterfall, we visited the gardens. Here I saw my first peacock, perched on the outer roof of a wallside aviary. There were, I was told, several.

The yews and cedars projected a landscaped sombreness, which again I associated with the ornamental gardens at the rear of Wollaton Hall.

The Abbey, or Priory, as Newstead's famous residence was formerly known, was for me a first experience of cloisters, floors laid with broad paving stones, echoes, and dark, sinister corners. I was aware of eyes other than those of my parents and the party we had joined as part of the guided tour. Newstead has remained the most atmospheric of the houses around which I have been shown.

It seemed incredible that someone should have chosen to live there. Yet live there they had, as was proven when we were shown into each of the rooms. One that I remember particularly well featured a glass-topped case in which a lock of Byron's hair was displayed. There was also a small but beautifully crafted model of a leopard. Byron's boxing gloves, about which contemporary poems have been written, were similarly displayed.

Eventually we stopped at a door. Before unlocking it, the guide explained that in the room we were about to enter Byron claimed to have seen the apparition of a Black Abbot, after which my imagination ran riot ... supposing the Black Abbot happened to be in the room when the guide opened the door to admit us? Suppose I glimpsed him leering from a dark corner? I was holding my mother's hand tightly. If, however, she was aware of this, my mother gave no indication. The Black Abbot apart, the room appeared light and airy. None of my swiftly anticipated dark corners existed. But minutes later I was secretly glad when the guided tour ended and we stepped again into the sunlight.

* * * *

Built as a twelfth century monastery, Newstead in 1540 became the family seat of the Byron family. Although historically and romantically overshadowed by the poet George Gordon Byron, who resided at Newstead from around 1808-1814, the sixteenth-century Byrons were outstanding as wielders of the sword, and devout Royalists.

There were seven brothers, all of whom, along with their uncle, held the rank of officer. The eldest brother was John. He was born around 1600. Awarded the distinction of becoming the 1st Lord Byron, Sir John had by 1634 acquired the civic role of High Sheriff of Nottingham.

With his uncle, Sir Nicholas Byron, he fought at Edgehill in Warwickshire, which is recognised as being the first direct battle of the English Civil War. Although Sir Nicholas was wounded, Sir John, as part of Prince Rupert's cavalry charge, turned the Parliamentarians in all directions at the expense of the Royalist foot soldiers, who were routed by troops commandeered by Sir William Balfour. In this battle, the Royalist standard bearer, Sir Edmund Verney, was killed.

For Sir John Byron and his brothers, 1642 proved to be a year of challenging incidents. This was the year that Newstead Abbey was

garrisoned for the King, although only for a short time. But Royal garrison or not, in the Byrons' absence the Abbey was targeted by a group of Roundheads travelling from Mansfield to Nottingham. Their mission was to collect money, food and various saleable items along the way. Moreover, they had with them a convoy of carts intended for transporting the bounty.

It was in a Bestwood Lane, perhaps one of the connecting lanes near Lamins Farm which I have previously mentioned, that these Parliamentarians were routed by a column of Derbyshire Royalist troops led by Colonel John Freschevile. In the affray that followed, the colonel suffered a severely cut hand and seven of the Royalist troops were killed.

Sir John Byron [on New Year's Eve 1642] was garrisoned at Reading and forced to face a 'Cirencester mob' whose collective intention was to have him killed. Facing his assailants, Sir John received a facial wound that became a 'noble scar' and the small but decisive battle did not end until he and his men had killed twenty of the mob and dispersed the rest.

Sir John was, it seems, quite proud of the 'battle scar' he carried on his right cheek and when posing for the Oxford artist, William Dobson, who specialised in Cavalier portraiture, stressed that the scar be included.

By December 1642, Sir John with his brother Thomas had arrived at the estate of lawyer Bulstrode Whitelock. Situated near Henley-on-Thames, the house was called Fawley Court.

Sir John's orders that the house itself remain clear of Royalist intervention were, however, ignored. When chances arose, his men looted the house, consumed food and drink, stole horses as 'fresh mounts' for themselves and killed and roasted portions of the Fawley Court deer herd. Sir Thomas, who had lost two sons prematurely, took the Whitelock children under his personal protection.

In July 1643, Sir John led a cavalry charge at Roundway Down, near Bristol, to such an extent that the opposing troops led by Sir Arthur Hazelrigg turned their horses and fled. That Sir John meant business when he descended upon the enemy was never without doubt. He had arrived to fight for 'the cause' and not to parley. By all accounts he was merciless and possessed by a barbarous streak, although murderous streak may better describe his treatment of the villagers he terrorised at Barthomly in Cheshire.

Understandably for the time, these villagers were making for the Church, but Sir John was having none of it. He had his men smoke them out, and then slaughtered them. In a letter to William Cavendish, Sir John explained that, 'I find it is the best way to proceed with these kind of people for mercy is cruelty.'

However, at Nantwich, and facing troops commandeered by Sir Thomas Fairfax, Sir John lost all his guns and some 1,500 prisoners of war.

Commandeering the right-wing defensive of Prince Rupert at Marston Moor, Sir John lost many troops when the Royalist army was opposed by Sir William Brereton. By comparison, in 1646 he held strong to the defensive position at Chester and was later commander of Caernarfon until after surrendering at Kelham, near Newark. King Charles ordered the Royalists to surrender themselves, and the garrisons and strongholds they were holding accordingly.

After the Civil War, Sir John did not return to Nottinghamshire but chose exile on the continent where he died around 1652-53.

Sir Thomas Byron, way back on 7 December 1643, was accosted and attacked in an Oxford street. His assailant was an officer of his own regiment, Captain Hurst. The violent quarrel arose over pay. Presumably swords were drawn, because Sir Thomas was mortally wounded. He died in February 1644 and was buried at Oxford in the Christchurch Cathedral.

As for the other Byrons, Sir Richard in October 1643 became Governor of Newark, having a year earlier won battlefield acclaim when he led troops into Nottingham and held the town for five days. He was knighted by Charles I in 1642.

At Newark, holding a defence position, Sir Richard surpassed as commander until Prince Rupert arrived with reinforcements. By 1644, however, Sir Richard made plain his disagreement with the idylls of the King's Commissioner and in the October of that year the troops under his command were defeated at Denton in the Belvoir Castle country. Consequently, Prince Rupert had Sir Richard replaced by Sir Willys, who was known to have been a good friend of Prince Rupert.

In 1652, Sir Richard succeeded to the title of 2nd Lord Byron and returned to Newstead Abbey. Here he lived until his death in 1679. In the family vault in nearby Hucknall he is commemorated by a marble memorial.

Of the four remaining brothers, Sir Robert was in command of a regiment at Naseby before serving in Ireland. Sir William remained the enigma. He is recorded as having fought in the Civil War but may have drowned when his ship went down at sea. Sir Philip, during the 1644 siege, was killed while holding a defensive position at York where he was buried in the Minster. Historically Gilbert was recorded as the black sheep of the family, because he was the one Byron brother who failed to receive a knighthood. He was for a time Governor of Rhuddlan Castle in North Wales. Following the Royalist defeat at Willoughby Field, Gilbert was imprisoned at nearby Belvoir Castle. He died in 1654.

A STONE FOR BESSIE SHEPPARD

Returning now to the 610 Nottingham-Mansfield road, the oaks rising prominently from within the long or wide belts of woodland are probably self-regenerated or were planted after the Civil War. Therefore, those bygone people travelling between the two towns may have seen different tree patterns and branch traceries than those the many commuters pass five days of the week in modern times.

Silver birch now predominates the broken-up tracts of woodland interspersed among ancient forest glades along Newstead's walled boundaries and into the gently undulating coverts and plantations of Thieves Wood.

Today ample car parks, each to my eyes a scar on the landscape, are sited alongside the Thieves Wood tree belts. From these car parks people walk their dogs, jog, undertake a spot of orienteering, and bird-watch.

In March, local naturalists record in their notebooks the first 'drummings' of greater- and lesser-spotted woodpeckers, while listening for the 'yaffles' of the green. Flocks of finches and titmice pass through, particularly during the autumn and winter, and the bracken-swathed runnels attract breeding pairs of pheasants and woodcock. At dawn and dusk, a fox may be glimpsed and hares flushed from the fieldsides in the evening, creating a startling crash as they bound through the vegetation.

While the passing motorist is obviously aware of relatively isolated houses and cottages positioned among the trees, many of the younger generation appear surprised when one mentions the Bessie Sheppard Stone.

I first read about the stone when one evening my father arrived home with a soft covered yellow book entitled *Rambles Around*

Nottinghamshire. The author was a local man, Jack Hellier, who was employed as an organist at the prestigious Elite cinema, situated on Parliament Street in the centre of Nottingham. We had on several occasions studied what would rightly be described as the back of Jack Hellier when we visited the cinema and I think that in their younger days my father might have known Jack, for both men nurtured a respect and love for the countryside.

The publication of his book also interpreted Jack Hellier as an acute observer who possessed the ability to map out a route using words, although there were, I recall, also maps in the book. Browsing the pages within seconds of my father having put the book into my hands that evening, I was surprised to learn that there was a stone in the roadside woods almost opposite the Harlow Wood Hospital erected to the memory of a girl called Bessie Sheppard. But why? And who was Bessie Sheppard? Why had she had a stone named after her?

I read through the brief explanation written by Jack Hellier and over the years learned more, but I did not visit the stone until the mid-1970s, when a friend and I shared a car early one morning and travelled to Mansfield.

As we neared the Harlow Wood Hospital, I remembered the stone and the name Bessie Sheppard. Then when the chance arose we pulled into a lay-by and had a look around. Sure enough, there among the bracken fronds was the stone, still intact.

Seventeen-year-old Bessie was the daughter of a Papplewick woman. On 7 July 1817 she walked from Papplewick to Mansfield looking for work and retraced her steps in the evening. As she passed the place where the memorial or 'murder' stone is now positioned like a gravestone beside the road, Bessie was attacked by a Sheffield man, an itinerant knife grinder and an ex-soldier called Charles Rotherham.

By all accounts, Rotherham beat Bessie to death with a hedge stake, removed her new shoes and cotton umbrella, then lowered her body into the ditch. He then walked to The Hutt Tavern, had a drink, and proceeded along the road known today as the 610 to Redhill. At The Three Crowns Inn where he stayed the night Rotherham attempted to sell Bessie's umbrella and shoes, but without success.

Around 7 a.m. the following day, Rotherham left the Three Crowns and walked, presumably, through Nottingham, crossed the Trent and headed for Bradmore and Bunny. In the village of Bunny he sold the

To the right of this roadside glade in Thieves Wood was erected a stone marking the spot where Bessie Sheppard was murdered by Charles Rotherham in 1817.

shoes and umbrella but by this time Bessie's body had been discovered and the law were onto his trail.

In Loughborough they closed in on Rotherham and arrested him. He was taken to Nottingham and on Monday 28 July, a mere three weeks after murdering Bessie, he was hanged. For the period in which I am describing, I think the law enforcement did exceptionally well in apprehending Charles Rotherham.

As for 'little Bessie Sheppard', as she was known, there have over the years been many reports of people travelling the 610 and seeing 'a young girl wearing the clothes of a hundred or so years ago' walking in the woods opposite the Harlow Wood Hospital. Some claim to have seen the apparition in and around the hospital grounds.

What I find interesting are the sightings recorded by the youngsters of today, their noses pierced and the girls each doing their best to look like Britney Spears, of a strangely dressed girl crossing the road 'in front of their car headlights' during the small hours, while travelling home from the late partying pubs and clubs in Nottingham and Mansfield. These young people have never heard of Bessie Sheppard, the murder or the

stone, which they have failed to notice or if they have, they forgot about instantly as opposed to querying its existence.

One woman, a spiritualist, convalescing at the Harlow Wood Hospital, recently told a local newspaper reporter that she believed Bessie's spirit to have long been in a state of confusion.

'She doesn't know where she is, poor girl. Or where she is supposed to be. Her body is buried – yes – but her spirit is still out there in the woods. And I think she crosses the road and comes to the hospital because she wanted to make contact with someone. She is probably still wanting to go home to her mother, bless her. She might even be looking for her shoes and umbrella.'

* * * *

Beyond Thieves Wood Lane and the traffic lights, the road dips and winds into the suburbs of Mansfield. One passes tree lined pavements and glimpses a house or two with a half timbered front. Road signs direct the motorist south-west to Sutton-in-Ashfield and south-east to Blidworth.

Then one notices the inevitable garages and car sales businesses, and the long-closed cinema one sees today in almost every Midlands town, which reverted with the times to a bingo hall or a disco but which is now a well-patronised Italian restaurant. There are warehouses, pubs, business parks, trees, houses and near the football stadium the modern frontage of MFI divided from the road by ranks of parked cars and people stowing packages into rear seats and car boots. The people here exchange comments about football, locally staged gymkhanas and the bargains to be found at a car boot sale, much as they do in similar locations.

Titchfield Park adds a touch of greenery to the scene, a small but well-kept park intersected by the glistening and usually clear waters of the narrow River Maun.

Some of the side streets, cobblestoned and built on rising ground between the park and the busy bus station, I find austere. The bus station is bustling due to the atmosphere created by people travelling in many directions and with a specified time in mind. It is not a modern bus station but friendly, yet at its most depressing when with feet aching due to a Sunday morning walk one returns, studies the bus timetable and finds, while being silently flayed by February's east wind, that there is an hour to wait before the next bus is due.

The arches of the Midlands Railway provide a viaduct over Mansfield. The structure is estimated to be around 25 feet high.

Mansfield, once an 'ancient forest settlement', is to my mind essentially a shopper's town. Some streets are still cobbled. Many buildings are built of grey stone and remind one of the mill towns of the north. There is now an excellent shopping centre, The Four Seasons, a first-rate library, and on Leeming Street an interesting museum. In 1823 the town gained recognition when it was listed for the Parliament's Improvement Act, after which forty commissioners were elected to establish the town as a business centre. Seventy years later, around 1891, Mansfield gained borough status.

The Swan Hotel, long recognised as the oldest building in Church Street, served as a hostelry for the coach and four in the eighteenth century. From here eight coaches a day linked Mansfield with such destinations as Leeds, Halifax, Lincoln, York, Gainsborough, Nottingham, Chesterfield and Derby. It was a town of wheelwrights, saddlers, blacksmiths, farmers, cotton and flour mill employees, colliers, general shopkeepers, and pub landlords.

Besides the Horse Fair started by the Mansfield Carters' Association, the town council hosted on the water meadows, now much overlaid by Titchfield Park, the annual Gooseberry Pork Pie Fair, where everybody

The River Maun
passes through
Titchfield Park,
Mansfield.

ate sizeable proportions of the sweetmeat. In the evening, if they were
well enough, the revellers queued for the music hall evening held at the
Victoria Hall Theatre on Leeming Street.

Several major roads front and converge alongside the Mansfield
bus station, which in that respect has been well-sited. However, if one
is to continue along the 610, the next destination of historical note is
Mansfield Woodhouse, today often regarded as a Mansfield suburb and
the name of which prompted a group of railway employees with whom I
conversed to click their tongues and shake their heads.

Nevertheless, Woodhouse signifies 'a place in the forest where the
Royal dignitaries and wardens meet to discuss the forest laws, rights of
pannage, woodcutting and control of the deer herds and ground game'.

The Romans seem also to have lived and hunted hereabout, as was made clear by the late Major Rooke, who died in 1906. This gentleman is said to have discovered the site of a Roman villa consisting of seven rooms with newly painted walls and a mosaic pavement composed of red, yellow, white and grey tessera.

In the reign of King John a wolf hunter lived at Mansfield Woodhouse. His name was John Vivarri and he was employed under Royal Warrant to rid the surrounding countryside of wolves. One condition of Vivarri's chosen occupation was that he could not use a longbow for bringing down the wolves because he might also take aim at bigger game – the King's deer. He had to close in on his quarry and use an axe or sword.

Vivarri had with him, besides 'a band of young lads', several greyhounds and a 'strong mastiff-type hound' that could quickly despatch a wolf if the greyhounds turned it in the mastiff's direction. In due course Vivarri was succeeded by other wolf hunters. One in the reign of Henry IV carried the grand title of Sir Robert Plumpton, who persuaded Henry that Wolfhunt House needed strengthening, restructuring. Such alterations were duly made but, Henry's friend or not, Robert Plumpton had still to maintain the role of all wolf hunters which since Vivarri's day had included blowing a horn each evening 'at sunset' in a bid to keep the livestock of Mansfield Woodhouse free of the predatory wolf.

From Mansfield, the A60 continues into Warsop and flanks the west side of the colourful 'Dukeries' estates, which I intend to describe in later chapters.

CHAPTER SIX

VISITING BEAUVALE

In the school holidays of 1949 it became apparent that my father was ill and had taken to his bed; but I was not told that he was dying.

During those six weeks – when one finished school in the heat of summer and returned at the onset of autumn – as a means of easing the burden for my mother, I was taken to many places. The closest to home was a farm not more than a stride or two from the ruins of Beauvale Priory, situated in an agricultural valley between Eastwood and Hucknall. The name Beauvale denotes a 'beautiful valley', although today I have my reservations. The landscape is to some extent sweeping and pastoral but rather than describe the valley as beautiful, I would insert instead the word pleasant. It is a hard-worked valley, as is almost every tract of agricultural land, and at the time of my first visit the fields were used for grazing the sizeable and perhaps obligatory herd of dairy cattle.

I was taken to Beauvale by my aunt. Her son Derek was employed as a stockman at the farm and lived with his wife in one of the cottages adjacent to the lane that sloped from the ridge road called New Road to the farmstead below.

We alighted from a cream-and blue-liveried Midland General bus at The Horse and Groom public house and walked, according to my aunt, the two miles along New Road to the cottage. On the right was a farm tenanted by the Steeples family. My aunt was always on the lookout for a cattle dog or two, but on that first and subsequent visit we met with no such dogs. I remember, however, the grey tubular farm gate – always closed – and the cluster of harrows, hoes and tractors parked in the yard.

Unlike my aunt, I was never in a hurry when walking New Road. From between the hedgerows and while gazing out through the cottage

The frontage of The Horse and Groom in present times.

windows as the two women discussed domestic matters, I studied the distant woods, which, although I was unaware of it, rose nearly 400 feet above the mirrored surface of Moorgreen Reservoir, the Nethermere of D. H. Lawrence's novel *The White Peacock*. Had I known the reservoir was there, I would have persuaded my aunt to let me explore its sylvan banks and the neighbouring valley of woods, alongside which the wavelets lapped as the wind continually patterned the water. In retrospect, one might suggest that possibly my aunt and cousin Derek were unaware of its existence, for it was not just the expected hills but the woods that rose skyward and hid all that was beyond.

On my first visit, rain set in and I was obliged to stay indoors until after the evening meal with my cousin, my aunt and her daughter-in-law. When in the soaking dusk we left, my aunt attempting to shield us beneath an umbrella, I was aware of mud, tractor ruts and wet road surfaces. Yet still I yearned to live and work in the countryside.

On my second or third visit to Moorgreen, there was a strong sense of occasion thriving in the collective air, for the traditional Moorgreen Agricultural Show was being held midweek.

Beauvale an agricultural landscape, with the priory and farm nestled towards the right of the photograph. On the horizon, High Park Woods rise for some 400 feet above the reservoir.

The day of the show could not have dawned better. The air was fresh, the blue sky without a cloud, the sun warm, but with the noonday heat tempered by a breeze.

'Grand day isn't it?' everyone greeted, as walking or driving cars or tractors they entered the show ground.

Into the marquees and around the pens I wandered while seeing some representatives of the thirty-five types of British sheep and pigs. Aware of buntings, avoiding guy ropes and tent pegs, I wandered among the farmers and stockbreeders then took up a position by the main arena to watch the judging of the dairy cattle, bloodstock bulls and shire horses.

After the gymkhana, I was sought by my cousins Derek and Geoffrey, who after war service had also found employment at the farm, and in a battered van we drove the short distance to Beauvale. The dairy herd assembled in the yard for milking.

The scenes that followed I found fascinating, particularly since each cow walked without guidance to her stall. In those days, I recall, some cows were still being milked by hand, while others were milked by a sucking machine that extracted the milk in a method similar to a suckling

calf. On most farms the last of the milk, or 'stippings' as they were called, were taken from the cow in the old-fashioned hand-produced method. Clean milk was produced by clean cows in a byre washed down with running water. A channelled milking shed floor, my cousin Geoffrey explained, was easy to swill and also acted as a preventative measure against bovine disease and infection.

Across the yard I peered over a stable door. In a nest of hay and straw, an Ayrshire calf was curled. Instinctively associating the rattle of the bucket carried by my cousin, she rose, trotted forward, and when we entered the stable, drank from the bucket without hesitation.

Between the abbey ruins and the farmhouse, a line of geese filed by a kennel, to which was chained a cattle dog. Free-range hens explored every hummock and wallside cranny. At teatime we were ushered into the low-beamed farmhouse where there was an ample meal of fruit and vegetable salad on the table before us.

The farming family at that time bore the same surname as me, yet claimed no contacts with the city or suburbs. When, however, the farmer came in and took his place at the head of the table, I thought it uncanny that appearance-wise he so closely resembled my father. For seconds as we were introduced it seemed as if I had stepped into the future and it was my father sitting across from me. In no way did I experience discomfort. But I was pleasantly surprised.

Throughout the rest of the meal, Mr Taylor, as I was to call the farmer, and I indulged in a degree of conversation. He had been told of my interest in deer, particularly the two herds of red and fallow that roamed the parklands of Wollaton within walking distance of my home.

There were also deer in Beauvale, explained Mr Taylor; fallow deer that were regarded as nuisances because they raided the crops. Mr Taylor and his sons had permission to shoot those that habitually fed across the crop fields. Immediately I saw his point. Crops had to be protected, otherwise what was the point in going to the expense of growing them?

From then on, we may well have been father and son, the farmer and I. He insisted on driving us home and for the first time in my life I sat in the passenger seat of the car next to the driver, who insisted that I take that seat. The shorter days were coming in and it was dark by the time we reached Nuthall. Seeing the road ahead emblazoned by the glare of car headlights was a new and exciting experience for me.

Early twentieth century farm cottages on New Road.

We drove to my aunt's bungalow at Wollaton. Before leaving, Mr Taylor shook my hand and said he hoped we would meet again soon. Then after a warm drink, my uncle accompanied me along Middleton Boulevard and part of the way along Western Boulevard to my home on Chalfont Drive.

* * * *

My boyhood enthusiasm for the farm overshadowed, on those occasions, the historical connections relating to Beauvale Priory that was founded in 1343. It was tenanted by the Prior and twelve Carthusian monks. The Priory remained under Carthusian tenancy until 1538 and in that period of 200 or so years the varied work of the monks became widely known.

It was recorded that some worked at nearby Selston Colliery, while others readily accepted the role of visitor for the aged, sick and ailing people living in the surrounding countryside. During the period known as the Dissolution of the Monasteries, the priory was formally closed by the feared and much disliked Dr Legh 'on behalf of His Majesty King Henry VIII'.

Being relatively distanced from the Palace and the monarch's disagreement with the Pope, the Carthusians ignored the order of closure while at the same time refusing to accept Henry VIII in the position he desired, that of Supreme Head of the Church of England. One can imagine the prior, Robert Lawrence, entering his quarters accompanied by a former prior of Beauvale, John Houghton, who was sympathetic to his cause. It was beside the stone fireplace, which was still intact at the time of my boyhood visits, that the two men eventually arrived at the decision that they must visit Thomas Cromwell, who held the position of Lord Privy Seal. They were joined in their quest by the prior of Axeholme in Lincolnshire and set off with the intention of holding office with Thomas Cromwell, in order that they may explain their reasons for refusing to accept Henry VIII as head of the Church.

Angry and embarrassed by the priors' considered default, Thomas Cromwell instructed his guards to imprison them in the Tower of London. The three men spent six weeks in a dank cell. The fact that they had accepted imprisonment as a reason for their cause aggravated Thomas Cromwell further.

A short interview left him with little doubt that the priors were adamant and still rejected the King. He ordered them to take the Oath of Supremacy. They refused. He then arranged for them to face a jury, the charge being 'verbal treason'.

On 28 May 1535, the prisoners caused further embarrassment to the angrily pacing Thomas Cromwell, because the jury refused to condemn them. Cromwell then had each member of the jury appear before him. He threatened them with loss of status, riches and land. Such threats proved sufficient for each man to change his mind. The Priors were retried with the same jury and the verdict of 'guilty' was passed.

Before they were executed at Tyburn, the priors were severely tortured. Yet Sir Thomas More, who was at the time the disgraced Lord Chancellor, recorded that 'the three priors went as cheerfully to their deaths as bridegrooms to their marriage'.

Sir Thomas More was also executed that year, for like the three priors he too refused to accept Henry VIII as Head of the Church.

THE RED GUTTER AND BEYOND

In the 1960s, Jean's parents took us in the family Ford Poplar most fine Saturday evenings to The Bromley Arms, Fiskerton. Jean's father, who drove the car, chose a circular route, which entailed first crossing Trent Bridge then taking the A52 (now the A6110) through West Bridgford and Radcliffe-on-Trent to link up with The Fosse at the Saxondale Island. From there we continued to Newark where again we crossed the Trent, passed through Kelham, then negotiated the narrow back lanes to Rolleston and our riverside destination.

One memorably hot and overcast evening, we parked at the Paunceforte Arms, then crossed The Fosse to walk School Lane and then Church Lane in the village of East Stoke. We were, Jean's father informed us, going to look at a barely discernible tract of land, wheatfields with little more than a floodbank, but where 6,000 or so men lost their lives in a battle between the Houses of York and Lancaster; a battle staged through egoism and deception running back to the bloody and needless Wars of the Roses, which had recently finished

For those interested in visiting the site, there is a 'Battle Trail' laid out, about which the efficient staff of the Tourism Centre attached to Newark Castle will, no doubt, provide further information. Basically, the trail begins on Humber Lane, which, I learned from the above source, was an ancient drove road. The trail, after Humber Lane, provides an interesting circular walk of little more than a mile and a half. The countryside is open and agricultural. The highest tract of land is Burnham Furlong, once owned by the Earl of Lincoln.

When Stoke Wood merges into the scene, the trail strikes off to the right and here stands the 'Burrand Stone', replacing I believe a bush of

The Bromley Arms, Fiskerton.

that name, alongside which Henry VII is said to have raised his standard. The trail, I should add, is defined by way of a stony track. The 'Burrand Stone' is a plaque, informative and with the words still discernible. Over to the right, on private land, is the battlefield.

Red Gutter, a villager assured me, is today difficult to define. And she wasn't wrong. The trail continues through the Red Gutter end of Stoke Wood then swings back across the agricultural land and bypasses St Oswald's Church, where, I understand, the events of the Thirty years' War are described on wall panels in an annexe. These I have not yet seen. The villager, who thought rightly that the church would be locked which in this day and age I can well understand, told me that there was also a plaque displayed there commemorating the five villagers who were killed in the First World War and three in the Second. The trail continues by the walled estate and parklands of Stoke Hall and returns to The Fosse. If you're walking quietly, expect to see a 'covey' or two of red-legged partridges taking dust baths or filching grit from between the stones of the trail; and savour the relative silence.

But on the day of the battle, 16 June 1487, the fields here about were far from silent as 6,000 Irish rebels accompanied by 2,000 German

mercenaries, the majority of the men carrying crossbows, met the enemy a matter of yards from the banks of the Trent.

* * * *

The Earl of Lincoln, John de la Pole, and his accomplice Lord Lovell, had embarked upon a conspiracy to challenge the crown worn by Henry VII, the Earl of Richmond.

In Dublin they staged a fake coronation, crowning Lambert Simnel, an impersonator of Prince Edward whom they claimed had escaped from the Tower of London. Simnel was crowned King Edward VI. Lincoln then assembled the army, led by Martin Swartz a soldier of fortune.

After crossing the Irish Sea, Lincoln's army embarked at Furness, Lancashire. From there they marched through Yorkshire, perhaps gaining more supporters along the way, then continued south into Nottinghamshire. On 15 June they arrived at Fiskerton and crossed the Trent. The vast but only partially disciplined army camped close to the village and embankment that would from the following day be linked to the battle in which they fought.

King Henry in the meantime was leading a sizeable army north. From Nottingham, he and his men marched towards Newark. My guess is that besides scouts both armies had people, unofficial and offhanded informers, urging them in the right direction. The following morning the two outsize armies met in a conflict that lasted for almost three hours. Initially, there was much hand-to-hand or weapon-to-weapon fighting and from what we have learned from battlefield archaeology, the injuries were horrific.

The Irish were ill-equipped. Those who weren't cut down backed off, but too late. Few, if any, were given the opportunity to escape.

King Henry and his forces continued to press in the attack and drove Lincoln's army back towards the Trent. The outcome for both sides was overwhelming slaughter. King Henry is recorded as looking on speechless with shock. The estimated 6,000 men were killed or mortally wounded within the three hours of bloodshed. Local legend insists that those dead or dying on the embankment or elongated abutment, and they must fairly well have been piled and tangled there, were so badly wounded that their blood dribbled into the ditch or dyke, which from that day was given the name Red Gutter.

Such arable landscapes as this may well have been walked over by several thousand troops during the Wars of the Roses.

During the battle Lambert Simnel, the impersonator, was captured. Surprisingly he later joined King Henry's household in the role of servant boy. The Earl of Lincoln was killed, while Lord Lovel was believed to have drowned in the Trent.

The agonies of the mortally wounded came to my mind when I was standing with Jean and her parents, sipping beer while looking at the battle site from the low boundary wall of The Bromley Arms across the Trent at Fiskerton. 'An estimated 6,000.' The term in words and on paper may mean little. In terms of gaping stomach wounds, split skulls and further needless atrocities, however, the adjective 'horrific' comes to mind, especially since the majority of those not killed outright were left to die in agony in a futile bid to satisfy the egos of but two men and their simpering advisors.

* * * *

As one drives along The Fosse towards Farndon and Newark, the sweeping meanders of the Trent fringe the Stoke Hall parklands just below the stretch of river bank known to the local anglers as Gawburn Nip. On the opposite side of the river, where the river curves within a field's width of The Fosse, stands a sedgy thicket known as Gawburn Holt.

There are several bays, backwaters and peninsulars along the Trent with the name 'holt' attached. In my boyhood I learned that the word was used to describe a wooded hill, or copse. That confirmed, it was also used to describe the lair of an otter. Considering the landscape and the fact that otters once frequented many miles of the Trent, the name of Gawburn Holt in this case could refer to both.

I remember an early morning Christmas holiday when with two friends I was travelling this road. A group of feral greylag and Canada geese were grazing the fields between the river and the road. Suddenly the heavy birds all took flight for, contrary to popular belief, swans providing they are taking off into the wind and have a clear view before them can take off from land.

They were so close to the car that as the mixed group swung inland in the direction of the Grantham Canal and the Vale of Belvoir we heard the geese gabbling and glimpsed smears of mud and sand on the undersides of the swans.

In the fields on the opposite side of The Fosse here are tumuli close to Wharf Farm. The fields grazed by horses just north of the farm are laid over a Roman fort and settlement, possibly used by those who built these locals sections of The Fosse Way.

* * * *

In 1962 I spent some weeks employed as an assistant on a mobile grocery van, for at that time the village Late Shop – as we know it today – was still very much a requisite of the future.

Besides mobile grocery vans calling on a number of villages weekly as requested, mobile libraries were also part of the village social and recreational scene – more so than they are today. Throughout those weeks spent on the grocery van, I was particularly aware of how far we travelled out from the city; my wife was pregnant with our second child and, as was the case with most couples, our home was not connected by telephone.

The Monday of each week was spent loading and cleaning the fittings and fixtures of the mobile shop interior, along with stocktaking and shelf filling. The staff comprised of the van manager-driver and I.

The particular area to which I had been assigned was south of the Trent and through the villages and hamlets to the Quorn country on

The fortress-like tower of
St Mary the Virgin church,
Plumtree.

the Leicestershire border. Our first Tuesday village was Plumtree. Here
a villager who owned a splendid low-beamed cottage related how ten
or twelve years previously she and her husband had removed the old
ovens, which were used for baking bread, in order to have a heating unit
installed. Yet there were still days when the mouth-watering smells of
newly baked bread permeated throughout the downstairs rooms.

At the far end of the village we drove, just before reaching the railway
tunnel, directly up to the station house, which was complete with
vegetable garden, free-range poultry, and a cheery welcome. Both the
'railway man' and his wife, as they were known, were true country folk
who made their own wine, vinegar and much else.

From Plumtree we took the road that terminates or begins alongside
The Griffin pub and meets the A60. Here in Bunny village, the shop
manager suggested I deliver a grocery order to a blind woman who kept
geese. The door would be ajar, I was told. All I had to do was tap on it
lightly, sing out 'your groceries', and enter.

As soon as I stepped inside the yard gate, an Emden Toulouse gander and three geese came padding towards me, bills lifted as they honked and gabbled while querying my identity.

The blind woman sat to the table and in a welcoming yet slightly suspicious voice queried, 'Hello. But you're not the same man that called last week, are you?'

Surprised, I explained to the woman that I was helping out for a few weeks, then asked her softly and politely how she knew this.

'My geese told me. They use a different tone of voice when there's a stranger in the camp. Will it be you calling for the next few weeks?'

I told her that in all probability it would be, after which the woman explained that the geese would get to know me and revert to their usual low gabblings as they accompanied me to her door.

So busy were we around Ruddington, Bradmore and Keyworth in the following days, that there was little time for incident or exploration. Later on the Thursday afternoon at Stanton-on-the-Wolds, however, I called on a market gardener who was boarding (or 'walking' in hunting parlance) two foxhound puppies for the South Notts Hunt.

As I stroked, fondled and played with the hound puppies, it occurred to me that twenty years earlier I had stood about child height to their ancestors when on Boxing Day my father had taken me to the meet in Bingham Market Place.

Friday was a twelve-hour day. We were out from eight in the morning until eight in the evening. Our first calls were at RAF. Newton on The Fosse. Here we spent several hours but I was in my element because I had in the mid-1950s spent three years as a conscript in the Royal Air Force.

By the time we drove back onto The Fosse, it was opening time at The White Lodge, where we stopped for a pint each. We were the pub's only customers on those Friday mornings, but by lunchtime were usually exchanging pleasantries with ploughmen, stockmen and gamekeepers in The Martins Arms, Colston Bassett. At The White Lodge, the hunting trophy – 'the mask' of the biggest fox taken by the South Notts hounds that year – was displayed behind the bar.

Leaving Colston Bassett, we travelled a mile or two west to where we met the friendly cottagers of Owthorpe. A left turn then saw us steering back onto the A46, The Fosse, down which we journeyed until we came to the lane leading to 'The Broughtons'. The village of Upper Broughton is in Nottinghamshire, while just a bend or two in the road and a clump

of trees away, Nether Broughton snuggles into the county borderline of Leicestershire.

At a pub in one of these villages – I think it was The Golden Fleece – the landlord presented my colleague with his usual half pint of bitter (because he was behind the wheel) and me with a pint (because I wasn't). These drinks were, I was delighted to discover, 'on the house'.

Around nine in the evening I returned home with images of low-beamed pubs, cottages, foxhounds, stables and the overall hospitality of Nottinghamshire's villagers pleasantly lingering on my mind. My wife gently rubbing her child-stretched stomach, ventured, 'God! I've had an awful day,' whereupon I murmured as gently I took her into my arms and kissed her, 'I understand, but what kind of day do you think I've had?'

On the Saturday we finished at one. Consequently our day was relatively short. We spent time in the village of Kinoulton where the Duke family bred what was then considered to be a 'new' breed of dog, a Shih-Tzu or Tibetan Mountain Collie. When I was told this, the image I momentarily retained was that of a Border or 'Lassie' type collie. But, to my surprise, the breed could at first glance have been taken for a rough-coated Pekinese, so similar were the two in appearance.

From Kinoulton we drove to Hickling, where I gained my first glimpse of the bygone wharf of the Grantham Canal close to the railed roadside, known to the angling fraternity of Nottingham as Hickling Basin.

A pair of mute swans preened on the bank with eight well-grown cygnets around them. The woman who had her groceries delivered and lived two or three cottages down from the canal told me that as the reedbeds had been cut back earlier that year, the swan pair had nested on the bank. She had expected them to be disturbed by louts or foxes and was therefore pleased when they hatched off a relatively large brood.

The woman's husband was employed as stockman on a nearby farm I learned, as she poured milk from a jug into a glass then handed the glass to me 'Drink it! It's fresh from the cow today,' she hailed.

As I stood, glass in hand, at the table, the woman went to the kitchen and returned with two steaming sausage rolls on a plate 'Eat 'em! They're straight out of the oven.'

Usually I resent being spoken to in such a direct, barking manner. But on that occasion...

A WELCOME AT RUFFORD

The winter of 1963/64, so far as my explorations of Nottinghamshire were concerned, served as a turning point. But compared to the winter of 1947, we experienced little snow.

Black ice layered the fields, roads and suburban pavements for weeks. The temperatures night and day were well below freezing. Yet Nottinghamshire, while not escaping entirely, fared better than most counties.

On discussing this in recent times, it has been suggested that the proximity of several widespread power stations may to some extent shield Nottinghamshire and certain tracts of the Leicestershire border country from prolonged snowfall. The power station at Ratcliffe-on-Soar, for example, was not built until after the winter of 1963/64 but neither since that time have we experienced a winter comparable to it.

The Ratcliffe-on-Soar power station is recognised as being one of the largest and most effective in Britain. When I briefly interviewed a spokesman in 1994, he lost no time in mentioning that 20,000 tons of coal was burnt every twenty-four hours and two tons of steam per second was produced by the Babcock and Wilcox boilers. The total output supplies energy was for the four 500 MW turbine generator. Electricity, the end product, was then fed into the Trent Valley's super grid at a rating of around 400,000 volts. The spokesman agreed that it is possible the threatening snow is actually reduced into rain by the consistently rising warm air. I should, however, hasten to add that this is supposition. Nothing has been proven and may never be.

My change of direction then, my temporary exodus from the Trent Valley, had primarily to do with locating the whereabouts of

Ratcliffe-on-Soar power station as seen from the Trent Lock.

Nottinghamshire's few surviving wild red deer. As an added bonus, this search or term of research enabled me to also explore the great houses and grounds of the Nottinghamshire Dukeries and meet some of the people connected with them.

When my father died, so too did my dream of one day becoming a farmer. However, I still retained my interest in livestock, or should I say bloodstock, and spent time at the Moorgreen and Bakewell Agricultural Shows admiring the quality specimens and breeds of horses, cattle, sheep and poultry. Closer to home I also learnt from Harold Walton, the Wollaton Park deer keeper, that both red and fallow deer were bred and noted within their respective herds for carrying good or visually attractive 'heads', as the racks of antlers are known.

Shoulder, body size and weight are also included in the breeding of quality deer, a practice that both Royalty and the park owning gentry of Victorian and Edwardian times were well aware, although under normal circumstances deer cannot usually be caught, even less paraded around a show ring.

There is much sporting terminology connected with 'breeding deer for good heads' but the majority of this I will spare you, the reader, who will no doubt be thankful.

Reading beside the fireside on one particularly inclement Saturday afternoon of that exceptional winter, I learned that the Forestry Commission employed warreners to control rabbits and rangers to cull deer when appropriate. The enlightening book was entitled *Living with Deer* by Richard Prior, who has since become a world authority on roe deer.

Some months later and after a spell of research and enquiry, the East Mercia Branch of the British Deer Society was formed and the inaugural meeting held at Wollaton Park.

My association with the two herds of red and fallow deer there was know locally. Consequently, it was I who gave members from South Yorkshire, Lincolnshire, Northamptonshire and Leicestershire a tour of the parklands. There were, as expected, several prominent members from Nottinghamshire also present. The second meeting was held at Inkersall Manor on the edge of the Forestry Commission-managed Clipstone and Rufford Forest. It was at this meeting that I met two men who became true and loyal friends: the late Jim Bark, who was employed as a warrener by the Forestry Commission, and the late Eric Spafford, who lived in a lodge on the Rufford Abbey estate where he had taken on the duties of local caretaker and gardener.

Eric, who on Saturdays shopped with Margaret his wife in Mansfield, seldom visited Nottingham. He was born, the son of a miner or collier, in a cottage at Budby, which bordered the Thoresby Hall estate through which flows the River Meden.

After my first afternoon spent in the company of these two knowledgeable countrymen, Eric invited me over for Sunday tea at 'Cremorne', his Rufford home. Long before teatime, however, on that and future days, we explored by car one or other of 'the Dukeries estates', usually Clumber but occasionally Thoresby, and visited several wildlife sites, a fox earth perhaps, or a badger sett. After the meal we embarked again on a tour of Rufford's deserted ruins, outbuildings and grounds, or wandered the rides of nearby Cutts Wood or Wellow Park. Despite there being a two-hourly bus service from Ollerton, Eric always insisted on driving me home and it was not long before, at his invitation, Jean and the children were accompanying me to Rufford.

One night as we left around nine stands out in particular because for most of the way the A614 was freezing. But Eric drove, as always, carefully and skilfully, his attention never wandering.

Eric's wife Margaret was born at Rufford. She was the daughter of William Herod, who was employed full-time as Lord Savile's gamekeeper. The deer park south of Rufford Abbey and its outbuildings since the Second World War has been reverted to the agricultural land, which can be seen from the A614.

The 300-350 head of fallow deer were the black variety, said to have been introduced into this country from Norway by the hunting-conscious monarch, James I. The deer were winter fed on beet and swede grown on the Rufford estate and kept within the deer park enclosure. In my opinion, the herd was overstocked but the average buck on culling weighed nine stone and the average doe six stone. Writing in 1892, Joseph Whitaker, who resided at Rainworth Lodge, emphasised that the bucks 'are the finest both for size of body and large palmation of antler'.

From Margaret I learned that the deer park was fenced with oak or chestnut paling and heightened, to prevent the deer from leaping over, each time a buck was culled, for the buck's skull and antlers were then placed along the fence thus heightening the weak sections. Eventually the entire deer park fence was strengthened in this way. Margaret lived with her parents in a cottage close to the deer park. She played in the vegetable garden and among free-range poultry. Her father also kept one or two first-cross mongrel dogs and when various chores demanded, rode around the Rufford Park estate on a sit-up-and-beg bicycle. Margaret remembered her father coming in one October afternoon shocked, for as he wheeled his bicycle through the deer park a mature fallow buck, heightened by the activities of the autumn rutting season, had threatened him with lowered antlers and escorted him in no uncertain manner from the group of does and followers the buck was intent on herding.

When, due to the world wars, Rufford was occupied by the military, many fences were broken down. The deer escaped, but took up residence in the Clipstone and Rufford Forest on the west side of the A614. Today, with recreational assets in mind, this tract of forest has been renamed The Sherwood Pines Country Park.

* * * *

Margaret attended schools at Carburton and, I believe, Wellow which, is where she met Eric. They were often in the same classes. The schoolhouse

at the Carburton crossroads, incidentally, was once recorded as being the smallest in England.

On leaving school, Eric and Margaret began going out together, usually for walks around the villages and surrounding countryside. The village of Edwinstowe, with its legends revolving around the alleged exploits of Robin Hood, served as the main social centre for here there was at least one cinema and several Saturday night dance halls to keep young people occupied. After serving abroad during the Second World War and with many letters by then exchanged between them, Eric married Margaret at the church in Edwinstowe.

The land agent of the Rufford estate, by then owned by the Nottinghamshire County Council, provided them with a small cottage or 'bothie', which was the tied accommodation provided with Eric's newly acquired position as the Rufford estate caretaker and gardener. By the time Eric and I had met, however, the couple had moved into the more spacious and welcoming house which Lord Savile had named 'Cremorne' after the horse that had won twenty races out of twenty-six, including the 1872 Derby and 1873 Ascot Gold Cup.

Like most working-class country folk, Eric and Margaret were non-materialists. Their one luxury, as they described it, was the car, which was needed for transporting home the Saturday shopping from Mansfield.

In the beautifully laid-out garden of Cremorne on Sunday 16 June 1973, I recorded in my diary the fact that a pair of song thrushes were nesting in the clematis, three pairs of dunnocks were raising broods in the hawthorn hedges, and a robin pair had seen five fledglings eventually leave the nest built in a corner of the outhouse toilet.

As Eric and I watched the goldfish languidly sifting through the weeds of the garden pond, a dozen or so 'honeybees', as my friend described them, alighted on the lily pads and attempted to drink. Then across the lawn a pair of pied wagtails led two youngsters to the pond side stones, on which they perched, bathed and preened with Eric and I looking on.

At nine that evening the clock over Cremorne's fireplace become suffused by the sunset reflected in its face as we put our minds to the journey home. After thanking Margaret for her shared hospitality, I inched alongside Eric into the passenger seat of his comfortable Morris.

Returning to Cremorne with Jean and the children on Sunday 9 September, we enthused at 'Bill', an impressive bull of the Lincoln Red cattle strain, which grazed the paddock of Grange Farm with a cow and

a half grown calf alongside. The tea-table and window overlooked the paddock and although Eric and Margaret took 'Bill' for granted, we as a family considered it something of a novelty to be eating with a bull standing eight or so yards within sight of the house.

Eric had on that occasion a map produced by a planning officer of the Nottinghamshire County Council. The map was the first outlining and supporting proposals for reconstructing parts of the original Rufford Abbey lake for two large cracks caused, it was thought, by colliery subsidence had appeared in the lake bed several years before, and the water had gradually drained away. Moreover, the contractors were in and working with bulldozers and JCBs on the lake bed, Eric told us.

Early that evening we all accompanied Eric and Margaret to the lake and through the deserted grounds, which Jean considered impressive. We were also given a preview of the well-preserved pets' cemetery. But who, we asked, had lived at Rufford? What were its origins?

* * * *

A Roman road connecting Blyth to the village of Oxton suggests further that around AD 120 a Roman settlement was thriving around the site known today as Rufford. The name in old English or Saxon probably related to Rainworth Water, the settlement being at the 'rough ford' or crossing place, although the place name was also spelt 'Rumford' and 'Rugforde'.

The son of Suertebrand, a Saxon chieftain, was recorded as Rufford's first owner. His name was Ulf, who on these eastern fringes of the Sherwood Forest country owned twelve village-estates of which Rufford was one.

Following the Norman Conquest, William the Conqueror awarded Rufford, then recorded as Rugforde, to his nephew Gilbert de Gant as a token of William's respect for his loyalty.

In the *Domesday Book* (1086), Rufford was valued at around £3 in terms of today's money, or 60s in accordance with the Domesday accounts. Ten or so villagers lived there and were described as holding 'land for four ploughs, twenty acres and woodland and meadow pasture and one pasture one and a half leagues long and one league wide'. A league extended for almost three miles.

These villagers worked to feed, clothe and house themselves, and as a form of rent payment provided produce regularly for the household of their landlord, Gilbert de Gant.

Despite its many visitors, Rufford's interior vaults and passages still retain their monastic atmosphere.

In 1146, the Earl of Lincoln, who was the grandson of Gilbert de Gant, granted land at Rufford to the Cistercian Order. This land was given in the form of a gift – not that the Earl of Lincoln had in his youth been a kind-hearted or diplomatic man. On the contrary, during the Civil War of 1139-53 he had ransacked and burnt down Pontefract Priory. Granting land in this way, then, was surely a form of appeasement, a coming to terms with the right and wrong, for clearly the ransacking of Pontefract had played on the earl's conscience.

Thus Rufford became a 'daughter house' to the Cistercian monks from Rievaulx Abbey in North Yorkshire, although the abbey from which the Cistercians originally came was situated at Citeaux in France. There were seventeen abbots in the Rufford order. The wooden abbey and adjacent living huts were probably designed and erected by local craftsmen. As a final blessing from Pope Adrian IV, various charters awarded more

land to the abbey in 1156. Such a move meant that the early villagers of Rufford and Inkersall were given little choice but to move to the site now known as Wellow.

King John in 1208 provided the Rufford monks with a licence costing ten marks to erect a series of keepers' lodges and dykes to protect the Abbey Wood lands 'from theft'. This resulted in altercations and, the blessings of the Pope and King John or not, the villagers in protest vandalised the lodges. Many further incidents took place. That said, we must move on and leave these to be researched if necessary by the interested historian.

On mentioning research, I was delighted to discover that besides photography, gardening and botany in wild places, Eric and Margaret were piecing together what they could of Rufford's history. In these investigations they were aided by several local historians from Mansfield.

Studying sections of the abbey and derelict cornfields, as I several times had while walking with Eric in the evening's faded light, I asked if the monks themselves had built the abbey and put the stonework together. And, if so, how many generations of monks had been literally bent to the task?

Eric then explained that the planning, designing and building of the stone-built abbey seemed to have begun around 1160 and continued throughout the decade. The locally quarried red sandstone was used for the outer walls while a more textured pale, almost white, type of stone was used for parts of the interior.

The sandstone came from Mansfield and possibly the paler stone, which I later also encountered in Annesley and Mansfield Woodhouse tracts of forest. Here the paler stone was evident in the spoil heaps excavated by badgers boring out and enlarging the varied subterranean passages and tunnels to their setts. Quite a lot of the red sandstone is evident along sections of Mansfield's relatively recent Maun Trail, which runs beside the mill dam and river by which the trail is named from Field Mill to the Sheepbridge Lane slopes fringing the Bleak Hills Dam.

Eric agreed that the monks may have helped with building the Abbey but principally local craftsmen were hired, not the least of whom was Simon of Budby, which, as I mentioned earlier, is where Eric himself was born. From Ollerton came Garth to join John of Mapledeck and Robert Muskham. Nor, I suspect, did they arrive single-handed for with each of

them, no doubt, came a gang of helpers much like the builders' labourers who have existed since buildings were first erected. The vaults, cloisters and impressive arches were built alongside wooden supports, which, once the mortar had set, were carefully removed. Hewn stones were piled into strong baskets and hauled aloft by men working the handles of wooden pulleys. There were men on ladders and platforms then, just as there are on building sites today, except that the scaffoldings are now more secure and cranes and jibs have replaced the baskets and pulleys.

All Cistercian abbeys had to be built to a specific design and inspectors periodically arrived, not only to ensure that the monks worked and worshipped according to the Order, but also to check that the abbey was being built to the standard required.

* * * *

Following the Dissolution of the Monasteries, Rufford – its parklands, villages and all forms of income – were granted in 1537 to George Talbot, 4th Earl of Shrewsbury. His wealth was continued throughout the family lineage of subsequent earls but with that wealth extending noticeably when the 7th Earl, Gilbert, married the daughter of Bess of Hardwick, Mary Cavendish. At this time the Great Hall achieved its full purpose as a banqueting house, particularly on the several occasions when King James I stayed over as Gilbert's royal guest, for the two men liked nothing better than to be out hunting through the glades of the still extensive Sherwood Forest.

In 1616 Gilbert died, but his sister-in-law, to whom the estate was bequeathed, lived at the abbey until around 1625-26.

In 1626 the Rufford estate was acquired by Sir George Savile and Lady Mary his wife, who was the sister of the Earl of Shrewsbury. The journey for Rufford's new owners was not over-long for they had previously resided at the well-established family seat of Thornhill Hall situated near Huddersfield in West Yorkshire.

The Savile's family motto of 'Fear god and honour the King' was honoured to the letter by William Savile, who in July 1642 received Charles I at Rufford before the King rode to Nottingham on 22 August and appropriately raised his standard outside the castle walls.

William Savile fought the Parliamentarians at Wakefield and Leeds. He was made a Royalist commander and led an attack at Bradford. But the

Royalists were defeated. He was also to the fore and wielding the sword at Sheffield and York. A colourful and allegedly fearless figure who made his name in the first two years of the English Civil War, William died at York in 1644. He was little more than thirty-two years of age.

After the Restoration, the succeeding William Savile was given the title of Viscount Early by Charles II. He then became the Marquis of Halifax. It was he who had the old monastery pulled down and more acceptable reception rooms, galleries and a stable block added to Rufford, which by 1680 was described as 'a magnificent country house'. When in 1695 William died, he was buried 'with honours' at Westminster Abbey.

The lineage continued with changes occurring and improvements made to the country seat, including high walls, garden pavilions, a bath house and in 1729 The Broad Ride which is, I believe, the one that is still to be seen today.

The original lake was created in 1750 and the 8th Baronet had the corn mill built, all due to damming a fast-flowing stream, an outlet of the deep lake known as Rainworth Water.

By this time the Savile family owned several villages, among which were Boughton, Kirton and nearby Ollerton.

By 1784 Richard Lumley Savile carried the title of 6th Earl of Scarborough. He had the corn mill rebuilt and played host to the future George IV. In 1837 the succeeding Savile acquired the aid of Anthony Sagvile, the famed Victorian architect, who was given the task of redesigning the house.

Thus a residence comprising of over 100 rooms with twenty staircases, fourteen bathrooms, a Tudor-style entrance with porch, steps and balustrade, a south-facing bell cupola and a clock tower was built at the cost of over £13,000. Parts of this building can be seen as one strolls around the house and grounds in present times.

The Saviles, however, were well behind other country houses, whose lime avenues or formal driveways had been established for some 150 - 200 years. However, in 1841, Rufford's lime avenue was planted and the imposing West Gateway built.

On one of my visits Eric pointed out the stone gateposts and the gates ornately crafted in wrought iron along with the armorial bearings of the Lumley-Savile families. He and Margaret were particularly interested in Captain Henry Savile (1820-81), by whom Margaret's great grandfather was employed as deer keeper and paddock maintenance man.

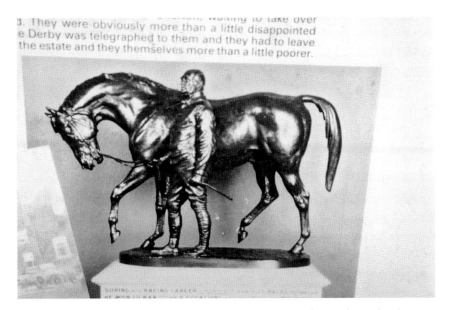

d. They were obviously more than a little disappointed
e Derby was telegraphed to them and they had to leave
the estate and they themselves more than a little poorer.

Plaque by the pets' cemetery commemorating Cremorne, the racehorse bred at Rufford which won the 1872 Derby and 1873 Ascot Gold Cup.

It was Captain Henry who bred the 'racehorse of all racehorses', as he described Cremorne, whose successes on the racing field I mentioned earlier. Cremorne, like most of the Savile racehorses, was bred and trained at Rufford. 'Captain Henry', as this eminent gentleman continued to be known locally, was succeeded by Augustus his younger brother, who by then had employed Margaret's grandfather as deer and pheasant keeper. Augustus had already acquired the reputation for being a great party-goer and socialite. He was also a good friend of the Prince of Wales, who visited Rufford and the Dukeries estates whenever chance permitted. The two men attended the local hunts and arranged shooting parties in the appropriate months. Captain Augustus probably met the Prince of Wales at Sandringham or Windsor because Captain Augustus held the official title of Master of Ceremonies to the Queen. Both men, incidentally were also seen and often photographed at the Doncaster Races.

Margaret's father knew well of the friendship between these two eminent gentlemen and when she was a small girl had pointed them out to her when holding Margaret's hand he guided her towards the lake, pets' cemetery or The Broad Rise. Margaret recalls life at Rufford as being 'a very closed in and self-supportive world'. Both her parents and

other families in residence undertook what for long was described as 'back-aching work'. Yet they were thankful because they did after all have jobs and, more importantly, somewhere to live.

'A roof over your head. Food, fuel and good health. Who could ask for more?' murmured Margaret to my son, reflectively.

Like most estates, Rufford played its part in the First World War by supplying roughly hewn coffins in readiness for the fallen.

* * * *

After Lord Savile's death in 1931, his son George Halifax Lumley Savile, because he was twelve years old, relied upon a Board of Trustees to administer the affairs and running of the Rufford estate.

If one has a meal or coffee in the Coach House Café today, it is worth remembering that the building was designed with stalls for around twenty horses in the 1830s. Attached to all stable blocks of that time were the head groom's family quarters, tack rooms, ostler's flat, and the saddlery. A blacksmith and farrier's shop was most likely situated close by.

On the interior walls one will see displayed framed photographs interpreting some aspects of Rufford's social history and elitist grandeur dating to the beginning of the twentieth century. For instance, from these photographs one is left with little doubt that a groom, Thomas Coxwell, posed alongside a Brake Carriage in 1899, and that in 1903 Lord Savile accompanied his royal guests to the Doncaster races on St Leger Day, the distinctive party travelling by coach, limousine and horse-drawn omnibus. Another quaint form of transport was the dog cart, which is also featured in some of the photographs. In 1904, by the Western Entrance on the A614, the coachman escorting Lord Savile in his carriage-and-four posed in full livery for an unrecorded photographer. Leaving Rufford in Lord Savile's Daimler, King Edward VIII also posed obligingly, as did the coachmen and mounted escort of the London Carriage outside the splendidly monumental Thoresby Hall when in 1912 His Lordship paid a visit to Earl Manver's.

Margaret had a photograph of the Grove and Rufford Hunt meeting in front of the house in 1924. The huntsmen and whipper-in were of course present, as were several lady onlookers, members perhaps of the Savile family; Margaret wasn't sure. What we mused upon were the foxhounds, several of which were looking directly at the photographer.

From the photographs taken at around this time, Eric also learned that one of his predecessors was John Doe who had been employed as head gardener.

* * * *

When the estate's running costs, finances and rising taxes signalled the end to a certain way of life, Rufford was put on the market. The entire estate covered some 18,730 acres. Sir Albert Ball, father of the local war ace pilot, purchased the house and inner grounds. The contents of the house, however, he had sold at auction. During the Second World War, Rufford was requisitioned by the War Department and the 6th Cavalry Brigade of the Leicestershire Yeomanry were stationed there. The high-ranking officers lived in certain parts of the house, whereas the non-commissioned officers and soldiers were billeted in twenty or so Nissen huts. At a later date, the 4th Battalion of the Coldstream Guards took over until 1944. But the huts were still needed and used for billeting Italian prisoners of war.

When the war ceased, the Forestry Commission used the house, stable block and billet huts as its North Nottinghamshire headquarters and administrative centre. For many the planting of commercial pine blocks was underway. These extended from Deerdale to Clipstone and the boundaries of Edwinstowe, while other blocks and plantations were established around Thieves Wood and the eastern side of Papplewick, with still more extending towards Rainworth and Blidworth. Eric worked for a few years on some of the nearby plantations. Then when he learned in 1952 that Nottinghamshire County Council had purchased Rufford he acquired the position of gardener, whereas previously he and Margaret, paying rent yet uncertain of their landlords, had lived in a 'bothie' within the abbey grounds, which Margaret had known since childhood.

The Nottingham branch of the Civil Defence used the existing billet huts for a time and its members were about the only people Eric and Margaret saw in the Rufford grounds 'from one weekend to another'. Eric's notebooks recorded some 10,000 trees being planted throughout the 130 acres of land the Nottinghamshire County Council had purchased with the house. To restore the lake and resurface the lake bed cost in the region of £55,000. All the building work and alterations were in the 1950s carried out by the Ministry of Works and it was through the

administrative side of this department Eric learned that a Government Order, as such forms of preservation were known, had been placed on those parts of the twelfth century abbey that were still standing.

* * * *

By the 1960s, Rufford Abbey became known as 'the most haunted place in Nottinghamshire', a declaration that astounded both Eric and Margaret for although they took Sandy the labrador out around the buildings and avenues last thing at night, they saw and heard nothing that could be categorised as 'the unexplained'. Bearing in mind that Margaret had, as I previously mentioned, lived at Rufford throughout her life, one would think that unusual.

'In the autumn and winter months we hear tawny owls and that is it,' confirmed Eric.

He did, however, relate the experience of someone else, a photographer who had sought the permission of the Nottinghamshire County Council to photograph the Rufford Cyrpt. The man arrived by car one morning when Eric was gardening. After introducing himself, the man unloaded his equipment and Eric helped him to the crypt and unlocked the door. Eric did not enter but returned to his garden plot. Five minutes or so later the man left the crypt and Eric experienced surprise because, being a photographer himself, he thought the man had been extraordinarily quick about his task.

Thanking Eric, the man loaded his gear into the car boot and Eric returned to the crypt and locked the door.

Almost a year to the day the photographer returned and Eric duly unlocked the crypt for him. On this occasion the man asked Eric if he would stay while he took the photographs. Eric obliged. The entire session took around three-quarters of an hour. When, with the crypt locked and Eric helping the man with his equipment the two men returned to the car, Eric asked why it hadn't taken the photographer so long on the previous visit.

The man then admitted that on the first visit no sooner had Eric left and he had placed his gear on the floor of the crypt, he received two sharp, unfriendly and therefore memorable digs in the back. Consequently, he picked up his gear and left, but chose not to mention the incident to Eric because he didn't expect Eric to believe him.

Margaret's father – or one of his workmates – occasionally saw an apparition on The Broad Ride in daylight. Several generations of Rufford's employees claimed to have seen the well-dressed, smiling young woman who was known to them all as 'Maisie'. From Margaret's description, I gathered that this young woman had a definite air of composure about her. Maisie? Perhaps there was such a person who was known throughout the Rufford fraternity and who after her death they continued to have occasionally seen in apparition form, walking The Broad Ride.

'My dad used to say that Maisie had really classical features. She was a crinoline lady. He used to come in and say that either he or one of the estate workmen had "seen Maisie today",' but no one was afraid. 'She was so lovely they were "quite intrigued",' Margaret recalled, while Eric, pursuing like myself several diverse interests, kept an open mind. He seldom speculated on whether or not the Abbey and its grounds were haunted because, alleged sightings or not, the house he shared with Margaret retained that atmosphere of peace and individuality that so many of us seek yet never find, and the name Rufford to them both meant home.

TIME SPENT AT CLUMBER

The best-travelled and therefore best-known section of the A614 extends from the Leapole Roundabout to the formal gates of the Aspley Head entrance to Clumber Park.

When I began travelling to Rufford by bus I memorised certain road signs and landscapes, while realising that apart and on either side were the villages of Blidworth and Farnsfield, Rainworth and Bilsthorpe.

The Limes Café, its forecourt tightly packed with lorries, reminded me of the pleasant manor house at nearby Inkersall, and at Ollerton I glimpsed colliers or miners going to or from their shift, for in the times of which I am writing, Ollerton was very much a colliery village.

At the Ollerton-Edwinstowe crossroads I once asked the AA patrolman if he occasionally glimpsed deer feeding along the grass verges thereabouts. Obviously surprised by the question, he gave me a polite, but negative answer. Fifty yards from his patrol box, however, where a sandstone track intersects a tract of silver birch and bracken at Bilhaugh, I came across the tracks or 'slots' of two fallow does.

If, in the 1970s, someone had told me that a decade later I, too, would be driving a Land Rover along the A614, I would not have believed them. Usually I was towing a trailer stacked and tied down with lengths of post and rail fencing which were used for defining the boundaries of the country park at which I was employed. The fencing, I should add, was loaded from the timber yard on the Welbeck estate.

On one occasion I called to settle a car park query with the desk sergeant at the Sherwood Lodge Police Headquarters. From him I learned that the A614 played host to one serious accident each week and had been doing since the mid-1970s. One accident black spot occurs

where the A6007 to or from Epperstone and Lowdham merges with the A614. Here the duty sergeant explained that while both outlooks are relatively clear, it is misjudging the speed of the oncoming vehicle that causes the pile-up. Nottinghamsire 'SPEED KILLS' signs flank the boundary roadsides in present times but were not around in the 1970s and 1980s.

Throughout the winter months, black ice proves another hazard if the gritting lorry fails to make it to this certain stretch, a hazard intensified by the refusal of the average driver to recognise the danger, maintaining that he or she was driving over several miles of what they considered to be 'just water on the road'.

Those Sunday afternoons when I travelled on the Worksop bus to meet Eric and later Margaret at Rufford, the route deviated from the A614 in case passengers were waiting at Eakring or Farnsfield.

Either side were arable and dairy farms. Then into sight as we linked up with other villages came Hexgreave Wood, its stands of mature timber protected by private parkland and a wood for long nurturing fringe coverts and earths best known to the earth stoppers and hunts' people of the Grove and Rufford.

Across these narrow, Sunday-deserted lanes, flew, in the winter months, flock of finches and in particular the conspicuous bramblings searching for food along the hedgerows, around the shippons and potato clamps. After its detour, the Worksop bus returned to the A614, where I met Eric across from the formal entrance gates of Rufford Abbey.

Quite often we drove by the row of cottages at Budby which in one, as I mentioned, Eric was born. To achieve this we diverted slightly north-west of the A614. This was a wooded and agricultural roadside. From here we journeyed the B6005 and passed through Carburton where at the crossroads Eric turned right and about half a mile on we entered the grounds of the National Trust owned Clumber Park.

* * * *

I first visited Clumber by Skills coach with my friend Chris Collins in the summer of 1954. The trip revolved around a 'tour of Nottinghamshire Dukeries' for country seats and great houses, as a means of income, were opening their gates to the public eight or nine years after the Second World War.

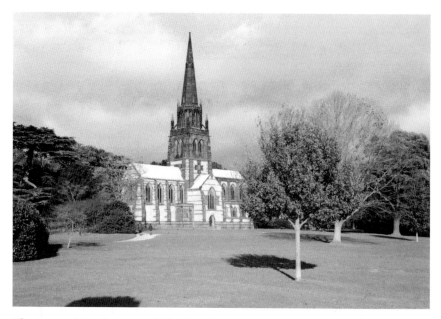

The eye-catching frontage of Clumber Chapel.

We had a coffee at the cafe, a look at the then 'new' family parties of Canada geese, and were given a guided tour of the Gothic-style St Mary's Chapel. The highlight for me occurred when, having left the grounds of the Carburton entrance, the coach driver took us along a 'B' road to the Welbeck Abbey villages of Norton and Cuckney. To my delight, I discovered that there is a chain of lakes on the right-hand side of the road. Called locally 'The Carburton Dams', these impressive sheets of water form the great lake system that flows from Welbeck Park. Moreover, on that particular afternoon, we not only saw herons preening in the roadside fields but also saw one such bird sprinting like an ostrich towards the waterside. The dams provide the water source for the River Poulter which feeds the dammed lake in Clumber Park.

When one enters or leaves the Carburton entrance of Clumber Park, one becomes aware of the oaks, beeches, limes and thickets of rhododendrons. In most of the plantations close by there are some quite splendid stands of larch. This is known as The Dukes Drive. The intersecting drives, today well-signposted, guide the visitor to the car park, chapel and adjacent buildings. Around the outbuilding propagation garden avenues there are varied trees including types of

pine or evergreen that I have never, without recognition book in hand, attempted to identify.

Winter birdwatchers look for the spectacular hawfinches here. My only sighting was of a hawfinch perched high on the pinnacle of a towering pine but in silhouette. Beside the lake, however, and within five strides of the car park, one Monday morning I stood looking at several ruddy ducks merging with the hand-fed coots, feral mallards and tufted ducks, while aware at the same time of a flock of house sparrows perched in the hawthorns, waiting for people to throw bread. Suddenly, as one body, they arose, and a sideways-darting bird with larger wings appeared among them. A female sparrowhawk! With all the sparrows gone, her prey missed, she clung momentarily to the hawthorns sideways on, giving me a glimpse of her malevolent glare before returning to the branch of the oak from which she had swept, intent on a killing.

* * * *

The Clumber estate boundaries extend to almost eleven miles. The entire estate covers some 4,000 acres. It would seem that the original owners were intent on having built a grand house and the Chapel of St Mary within the woods.

In 1707 the necessary royal consent, administered in the form of a licence, gave the Cavendish Hurley family permission to enclose the park and hunt deer and other game there. The park boundaries would have been pole fenced. Because they were granted a substantial tract of Sherwood Forest, the early Cavendish Hurleys were probably encouraged to make more of the acreage. Clumber House was built seventy years after the enclosure was granted, but by the Duke of Newcastle, as further legacies changed ownership. Built of local stone, the house was not outstanding in design but was described as being 'ornate yet very comfortable inside'.

The Newcastles were great patrons of the arts, although many of the most valuable paintings were destroyed on 26 March 1879 when a fire swept through twenty rooms of the house. Mr Charles Parry, an eminent architect, designed and organised the buildings of the 'new house' wings, which the family requested 'should be more palatial than the many rooms that have been destroyed'.

The grand staircase was engraved from marble. The grand drawing room was, many guests decided, the finest of 'the mansion's many

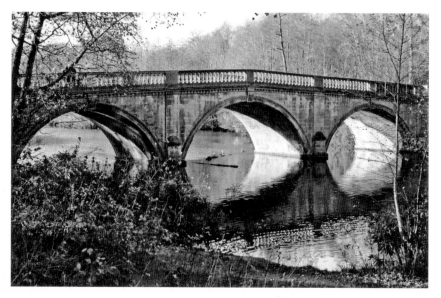

The Classical Bridge spanning the River Poulter in Clumber Park.

interesting departments'. The Grand Hall was eighty feet in length and forty-five feet wide.

The lake was achieved by damming the River Poulter and it took fifteen years to construct. It covers some eighty-seven acres. Several acres of landscaped gardens spanned the short distance between the water's edge and the French windows of Clumber House. The lakeside path walk extends for four and a half miles.

Eric and I chose to walk in the clockwise direction and parked in an official National Trust car park after entering by the Drayton Gate on the A614. Bird tables and feeders were positioned about the branches of the nearby trees and motorists enjoyed their lunch and birdwatching at the same time. All the expected garden and woodland small birds were to be seen, including the woodpeckers and treecreepers. A pair of jays were and are always the highlight.

We crossed the Classical Bridge then took the woodland path clockwise, while exploring the oaks and pines of the lakeside.

The islands at this end were still densely planted with rhododendron, thus providing roost and covert for the wildfowl.

Goosander and merganser can be seen here with much else in the winter months. Across from the Hardwick Corner, the silver birch

woodlands merging with tall rhododendrons pleasantly overshadow a barely definable path. After rain it is, of course, swampy in parts but Sandy the Labrador picked out most of the paths for us, but why have every path definable?

Across the main expanse of Clumber Lake stands Hardwick village and the nearby Grange Farm. This is a really attractive place; compact, pretty, and bearing of course the ancestral name of Bess of Hardwick. Always eager to complete a circuit of the lake so that I can move on to another lovely spot, this Hardwick is, I think, a hamlet. But I cannot say for certain, because the truth is I have never explored it, if indeed one is allowed to explore.

Some years following my first visit with Eric, I arrived with a group on a crisp January morning of blue sky and landscape-whitened hoar frost. As we rounded the Hardwick outbuildings, I recognised the corpse of a cock blackbird slewed slightly to one side in a tree branch, yet with its toes still clasped tightly to its last roosting branch. Obviously the blackbird had frozen to death, but why it had chosen to roost in the open when roosting habitats of all the thrush family in winter induces them to seek box and yew hedgerows, or the inner soft types of ornamental conifer, I have no idea. Perhaps it was a sick or ailing bird.

The River Poulter leaves Clumber here at Hardwick, and it was as we crossed by the white rails that I first saw in the newspaper a photograph depicting a last meet of otter hounds in Nottinghamshire. The descending stretch of river is a true wildfowl haven. It can be seen from the A614 and crossed by entering Clumber at Normanton Gate and following the lane right to Hardwick Grange, with a car park near the village hall.

I was walking over the bridge at sunset one April evening when a cob swan took off towards me and dispersed the reed-side reflections into a suddenly tilting mirror of pink. Local bird groups now come at sunrise and sunset, the intention of most members being to add a hobby falcon to their individual list.

This little falcon is a summer visitor to the heath lands and plantations of Britain. It resembles a small kestrel but has long, narrow wings. The hobby soars and glides, yet has a moth-like direct flight. It feeds on moths and insects but mainly small birds, particularly swallows and house martins to which it attaches especially on the migrating flights to and from these shores, so that in fact the hobby is never really wanting for prey.

At dusk the hobby roosts in a nearby tree while the swallows and house martins roost in a flock and prefer the warmer reed beds.

When there is a good stand of these at Hardwick, the birdwatchers with 'scopes' and binoculars look for one or more hobby falcons rising with the swallows and house martins against the red glare of the sun, then hope that the rest of their day will be as interesting.

Moving down from Hardwick and still following the bank of the River Poulter, Eric and I passed fields and wooded tracts, then the temple grottoes containing several Grecian statues. We continued then to the locally famous Classical Bridge. This was designed and erected by Steven Wright in 1770. It is a bridge of the Palladian style with three distinctive arches.

<p style="text-align:center">* * * *</p>

The stretch of the River Poulter extending from the Classical Bridge to the Carburton entrance was a wildlife habitat in every sense of the word. Willows, alders, reeds and phragmites surrounded small, hidden islets. Woods encircled the waterside.

Fortunately, and I suspect because there is not a definable path, few people ventured alongside this splendid backwater where in past decades at least one pair of otters were a foregone conclusion and water rails bred just as they do today.

In the 1970s the mute swan pair holding that territory hatched off each year at least two 'Polish' or white phased cygnets. Instead of a buffish-grey down covering, these cygnets, when they pip the eggshell, are white and have pinkish or pale grey feet. The first Polish cygnets were recorded in a brood hatched on the River Trent at Rugely, Staffordshire, in 1286.

The name 'Polish swan' was given to this strain by the poulterers of London, who imported the birds from the Baltic States. Polish swans are less frequently seen in Britain than Europe. I was therefore surprised to see two in a brood of four feeding on The Wilderness stretch of the Poulter when one afternoon I approached The Classic Bridge from the long wooded avenue known as Fanny's Grove.

The only 'Polish' cygnet previously recorded by the Trent Valley birdwatchers was hatched in the Netherfield lagoons in 1953. This particular cygnet survived, unlike the two at Clumber, which each summer were, I suspect, drowned by their parents because the white

plumage phase was to them a territorial threat denoting a rival swan. The occasional drowning of a 'Polish' cygnet has in recent years been recorded by wildfowl researchers in other parts of the country and to test how a territorial pair of mute swans react to the colour white, one need only throw bread or grain to a group of brown or white ducks when a swan pair is near. The swans, regarding the ducks as parasitic irritants, will surge in but the white ducks will be selected for chasing and territorial chastisement before the brown ducks.

* * * *

It was along a certain reeded stretch of the River Poulter that I achieved my boyhood ambition in establishing the whereabouts of the few remaining wild red deer of this, the Sherwood Forest country. Their whereabouts were, of course, known to the officers of the Forestry Commission, who had plantations to maintain. Therefore the numbers of these deer had to be kept to a manageable ratio, although it was estimated that there were no more than eighteen in the area. The Dukeries' gamekeepers also passed on information about the deer, as undoubtedly did the local poachers. Nevertheless, this strain of totally wild red deer has retained an ecological niche within the Dukeries estates and it would not be unreasonable to suggest that they could well be descended from 'the ancient forest strain' known perhaps by the builders of Rufford Abbey, Clumber House and several other notable residences throughout the region.

In the Poulter reed beds I came upon the autumn wallows of one or more stags. Autumn is the rutting or mating season of the red deer and besides stirring up these wallows with its forehooves and rolling to cover its body with mud, the stag urinates and sheds semen into the wallow. These combined scents the hinds find attractive. The stag will also use his antlers to excavate an autumn wallow, thus the marshy ground is often scored both by the stag's antlers and its cloven hoofprints or 'slots'.

Tracks weave down to these wallows; deer paths or 'foils' to use a medieval term, and I consequently traced them to the main source, a great tangle of rhododendron thickets, which I had no intention of penetrating. However, as I walked, I heard movement. Here and there an animal rising. I measured the sound, the almost inaudible brushing

of leaves, which reached a height of around four and a half feet. This is the height, at the shoulder, of the average red deer stag. Satisfied, I left the area but on that first or second occasion met a tweed-jacketed and cloth-capped countryman out walking his labrador. We conversed and eventually I asked if on his daily walks through Clumber Park he had seen the red deer.

The man had, but only on one occasion. As he bypassed a certain well-thicketed area, a stag suddenly leapt from its covert and crossed his path.

'Bigger than a donkey. Magnificent animal. About fourteen points on its antlers, I should think.'

Disturbed deer always turn to look back, thus the man gained a second sighting of 'his' stag before it merged silently into the understorey.

My first and only sighting of a Dukeries' stag occurred the following autumn. My wife, children, Margaret and Eric returned to the chapel car park in the chilled dusk, knowing that the wardens were ready to lock the park gates.

Suddenly a resonant roar carried across the Poulter. On the open stretch of land opposite stood a stag, head uplifted, antlers in line with its body as it continued roaring. The autumn stag displays with two types of roar. One is used to call in the hinds, informing them of his whereabouts. The second is used as a warning to rival stags. This is more often heard, and regulars in deer parks, where artificial conditions have been created and there is a preponderance of stags. In a wild state, deer are usually more widespread. I concluded that evening then that the stag within my sights was calling in hinds, although the hind territories were mainly on the neighbouring estate.

This awareness of the separate territories served in my favour the following April. I had driven to Clumber with a friend and his wife one weekend morning, the friend's purpose being to tape record the varied duration and drumming of the two types of 'pied' woodpeckers. I was there to assist him with the recording equipment. His wife, in the meantime, walked their two Norwich terriers through a long tract of woodland, which for the sake of wildlife recordings my friend and I intended to explore later. However, when she rejoined us, my friend's wife told us she had seen a red deer hind.

But I knew the woodland tract as stag territory. Hinds also move around in family groups rather than singly. As I have said, the month

was April, which is the time when most mature red deer stags shed their antlers. With these facts in mind, I decided to play a hunch. I asked my friend's wife if she would retrace her walk with me accompanying her. And so we set off. About 500 yards through the plantations we reached a rabbit protection boundary fence of low wire. Pointing ahead, my friend's wife explained that it was here she had seen the hind.

The droppings or 'fewmets' nearby were those of a stag. Then alongside the fence I saw and swooped upon a freshly cast antler carrying seven points or tines. Several feet away beneath a magnificent yew tree I picked up the second antler. My hunch had paid off – not financially, but spiritually.

What my friend's wife had seen on that first walk was a stag, which minutes before her arrival with the terriers had shed its antlers.

Although to the untrained eye the antlers of one red deer stag look much the same as another, antlers vary slightly in shape and formation according to genetics and herd variations as well as the terrain or type of country from which each animal originates. I was not surprised therefore when on Exmoor the following autumn I took one of the antlers from the car boot to show the harbourer of the Devon and Somerset Stag Hounds, who retorted, while studying its shape and size, 'That's not the antler of an Exmoor stag!'

* * * *

Before leaving Clumber Park I should mention its locally famous lime avenue, which extends an estimated four miles, and along which the dukes of Newcastle were regularly driven in a coach-and-four.

Oak is the predominant tree throughout the Sherwood Forest country but Clumber also hosts the Spanish chestnut and various commercially grown pines. The limes were not incidental to the natural plot. Imported from the Netherlands, they were considered the best tree species suited to blend with the parklands adjacent to a country seat. Being members of the tea bush family, they are also relatively fast-growing trees, although the midsummer foliage becomes consistently sticky due to intervention by aphids.

John Evelyn, who published his book *Sylva* in 1664, praised the lime trees to such an extent that the landowners acquired lime specifically for the purpose of producing a 'leafy bower or arbour' aspect for

Ornamental walk beside the Poulter at Clumber.

those travelling the avenues to the great house, either as a layman tied by occupation to the estate or a visiting peer glimpsing green vistas through the windows of a horse-drawn coach or chauffeur-driven Rolls Royce to enjoy. Nor was the word 'avenue', relating to the French verb 'avenir', used in an idle sense. Its English interpretation denotes arrival or approach and again in his *Sylva,* Evelyn gave an explanatory list of words that he considered unfamiliar to the average reader yet applicable to the test. An avenue he described as 'the principal walk to the front of the house or seat'.

By the time the lime avenues on most estates displayed summer foliage, groves of horse chestnut trees were fashionable, particularly in the 1750s, and the vogue for different tree species seemed to change every fifty or seventy-five years.

The limes along Clumber's main avenue may have been planted around the 1820s at the request of the 4th Duke of Newcastle. There are, a warden told me, 1,296 trees planted throughout those double rows.

When its parklands were matured, the average country house boasted of having something like 135 species planted, and by the early 1920s the average formal garden contained stands of maple, acacia, holme

or evergreen oak, monkey puzzle trees and Cedars of Lebanon, all of which competed with the water gardens and thickets of bamboo and rhododendrons catch the season-conscious eye.

New aspects to the country house scene occurred when in the 1960s visitors' cars filed along the avenues, sometimes bonnet to bumper, as the visiting families sought or were directed to a car park.

* * * *

The estates of the Nottinghamshire Dukeries are equally as interesting during times of prolonged snowfall. Most of the roads and country estate drives are made accessible due to regular visits from the gritting lorries. Although these estates do not have hills, families journey out with the sledge fastened to the roof rack and snowball 'fights' staged in the car park are a foregone conclusion.

One bleak Sunday afternoon, as with my wife and youngest son I drove from Barnaby Moor near Retford, south along A614, the road ahead became screened by a blizzard.

With windscreen wipers thrashing, I slowed and saw in the Clumber woodlands bordering the roadside two varieties of fallow deer, the black and the white feeding intently on beechmast in the leaf litter, scraping the snow aside with their forehooves. But had the motorist in front, or the one behind, noticed them I wondered?

THORESBY AND WELBECK

Travelling west along the A616 from Ollerton, I noticed a bulky structure on a mound surrounded by trees. Eric explained that this was a local folly known as Budby Castle. In bygone times it may have been used as a hunting tower, where the ladies gathered to watch the colourful proceedings relating to the horse, hounds and deer. The River Medan flanks the roadside for a surprising distance, then flows beneath the A616 into a delightfully reeded backwater separating the road from the widening and impressive stretch of the lake in Thoresby Park.

A right turn took Eric and I through the Thoresby estate to the A614 just below the main entrances of Clumber Park. However, in recent years Thoresby Park and its outbuildings have been opened to admit the public and I can vouch for the fact that the hall, now a Warner Hotel, looks as splendid close-up as it did, screening or overlooking sections of the lake back in the 1970s and 1980s, when motorists were usually allowed access along the estate road only.

Thoresby Park is over twelve miles in circumference with its north-easterly tracts covered by heather, gorse and beech forest. The eastern slopes are crowned by pine woods, while to the south and south-east the foliage line changes in shape, for this side of the parklands were planted with oak, sweet chestnut and lime that have long matured to provide both an excellent habitat for wildlife and the atmosphere of seclusion desired by the planners of bygone times.

The lake, created by the inflow of the River Medan, enhances a long pastoral valley and is surely the finest stretch of water in Nottinghamshire. Close to Thoresby Hall, gardens and terraces were laid out, at the rear of which stood the estate workshops where the craftsmen were to be found.

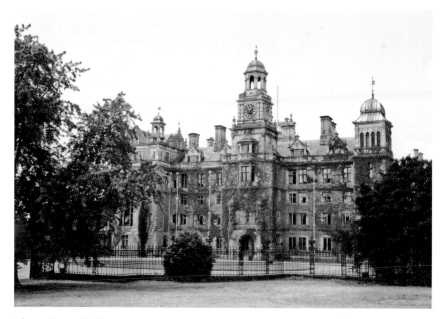

Thorseby Hall, the second mansion on the site, was built from Steetly stone. The architect was Mr A. Salvin.

The original Thoresby Hall was built of brick for the Earl of Kingston. The mansion on the site today, however, is built from Steetly stone and the building operations were carried out by a highly recommended firm based in London. The architect was Mr A. Salvin.

Both King George V and the Prince of Wales visited Thoresby with surprising regularity and once, between the massive entrance gates, His Royal Highness may have remarked upon the encaustic tiles that had been transported from Germany.

Weapons of war, sporting guns and the mounted heads of stag, fox and otter adorned the walls of the entrance hall. Two flights of steps, fitted tightly with red carpet, took the royal visitors to the Grand Hall with its floor of Sherwood Forest oak skilfully laid into an appropriate pattern with a parquetry border. A Steetly stone chimney supported by columns of granite was probably the most interesting feature of the hall because it was surrounded by a colossal representation of the host's entire family carved in stone. Two fine busts of the Ducs De Ciogmy, ancestors of the Dowager Countess Manvers, with many other family portraits adorned the Grand Hall.

In Salvin's time it was fashionable for architects to include towers in their country house designs. From these the ladies and household family members took their ease or watched deer hunts taking place across the parklands.

The Grand Staircase, with its steep stone steps hewn from Roche Abbey, led to a handsome gallery from which the upper apartments of the house extended.

The dining room was forty feet long, twenty-six feet wide and twenty feet high. The ceiling was decorated with geometric figures, the walls panelled with walnut. Family portraits were displayed alongside paintings by Creswick, Andsel, Vicat Cole and Melbey. The small drawing room, with its deep red satin damask hangings, contained portraits of the Earl and Countess Manvers, who were Thoresby's owners in the 1920s.

The library, panelled with forest oak, boasted another magnificent chimney piece with an elaborately carved Sherwood Forest scene said to have been taken from the Birklands. The scene depicts a cluster of Sherwood oaks and a herd of deer exquisitely carved by a Mr Robinson

106

of Newark. Statues of Robin Hood and Little John provided side supports to the piece, which was nearly fifteen feet high and ten feet wide.

Of all the state apartments, the grand drawing room was perhaps the most elaborate, with solid fittings consisting of maple, walnut and oak. The marble pieces were fashioned from blocks of snow-white marble bearing ornamental designs that represented the four seasons of the year. Extending some fifty-three feet in length and twenty-five feet in width, the walls were covered in damasks of blue satin.

Pink, blue and gold were blended into the ceiling decorations while the rich upholstery of the carved and gilded furniture finalised the effects of other luxuries just as the owners and designers intended. The most prized possession in the room was a handsome vase mounted on a pedestal 'by the Empress Eugene to the Countess Manvers in 1854'.

The house also included a fine billiard room and no less than sixty bedrooms, most of which had dressing rooms attached.

* * * *

Eager to explore Thoresby's lakeside, I telephoned the estate office seeking permission. It was arranged that I meet Monty Carter, the head gamekeeper, on the track by Budby Castle the following Sunday morning. Monty was a Scotsman, immaculate in countryman's tweeds, and with a trilby sporting the traditional jay's feather cockade.

He took me around the estate in a Land Rover equipped with close-circuit radio, for at that time he and his staff of keepers were experiencing trouble with poaching gangs that the police said came from Ollerton and Worksop. I was surprised to see, as we neared the lakeside, the mute swans sailing away rather than towards us, their wings arched defensively, not expecting bread to be thrown. It was then I realised that these were truly wild mute swans who did not depend on humans for handouts. They were not town or suburban birds, but those which kept their distance and which in later years I encountered on the gravel extraction lakes of Misterton, Lound and Ranskill in the tidal sections of the Trent Valley.

Like all countrymen, Monty worshipped working dogs and labradors in particular. He explained that so far as poaching gangs were concerned, it was better to have several black labradors alongside. This was because people feared black dogs as opposed to, say, golden coated or paler-coated

dogs. The colour black instils an inherent fear in most people, myself included. As the legendary hounds like Sir Arthur Conan Doyle's *Hound of the Baskervilles* and the ghost dog of folklore that is said to roam the coastal marshes of Suffolk and Norfolk, *Black Shuck*, they too were black. Therefore, for a gamekeeper to appear at the end of a ride with two or three black labradors at his heel is more psychologically effective than if he had golden labradors or retrievers.

The bounty sought by the poaching gangs was mainly pheasant. Monty had reared them by the hundreds each year throughout most of his life. But like most gamekeepers, Monty was also an experienced naturalist, an observer of the changing world around him and a conservationist in the broadest sense of the word.

The shooting man relies on the gamekeeper to provide the seasonal sport. If there was a wet season when newly hatched pheasant and partridge poults, the size of bumble bees, succumbed in their dozens to the cold, the shooting men tended to grumble about the 'lack of sport' and blamed the situation on the gamekeeper. If, however, the summer was dry and the pheasant poults proved prolific, the autumn shooters said it was due to 'the good season', the gamekeeper seldom being praised or mentioned. Pheasant rearing is about hen coops and wire netting enclosures, but more so in the old days, perhaps, than in present times.

Broody hens were frequently used to rear and foster pheasant chicks. Occasionally pheasants were allowed to sit and incubate wild, the gamekeeper marking the resting place with a stick or notch so that he hadn't to spend long searching for and relocating the nest. But more often the clutches of pheasant eggs were removed and placed beneath a broody hen, which reared the chicks from within a coop.

While exploring Thoresby in the estate Land Rover, I listened as Monty explained the finer points of shoot management: rearing pheasant and partridge poults by the 'electric hen' method; turning or liberating pheasants into the covert; trying to prevent the season's crop of birds from straying over the shoot boundary; wintering partridges, both the red legged and common; the hatching of eggs in incubators. The subject matter was tremendous and for those truly dedicated to countryside management only.

I next met Monty on a pre-arranged visit to the Thoresby estate village of Perlethorpe, just off the A614, some years later. Perlethorpe is best

described as the Thoresby working estate village. There is a strong and welcoming atmosphere of seclusion here with heavily foliaged trees and tucked away cottages. While he was working on the hall, the architect Anthony Salvin also designed the church, which was built in 1876, and he was subsequently the overseer. Like many of her kind at the beginning of the twentieth century, Lady Manvers expected the estate staff to attend the Sunday services, and visited the children who failed to attend Sunday school. She gently told off those who did not have a reasonable excuse but ensured that a midday saucepan of hot soup was delivered daily if the child was considered genuinely unwell.

From Monty I learned that the estate staff, aided by officers of the Forestry Commission, had decided to enclose where possible the fallow deer that were roaming throughout the area, particularly since quite a number were habitually crossing the main roads to what were obviously much favoured feeding grounds. But with traffic – fast traffic – very much on the increase throughout the region, the deer, to some extent and despite the DEER CROSSING signs, which ranged through the coverts of Bilhaugh and Thoresby could, it was pointed out, become a liability. Until the Second World War, the Lord Manvers' estate had maintained a herd of

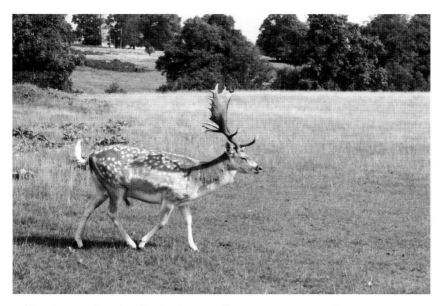

Fallow deer, such as this fine buck, are still maintained on the Thoresby and Welbeck estates.

seventy fallow deer in a 600-acre enclosure. As far as a grazing programme was concerned, these were very favourable conditions. Thus fewer red deer escaped from the enclosure around 1910 and it is possible that these were descendants of the 'old Sherwood Forest' strain that I surely encountered both at Clumber and Thoresby in relatively recent years.

However, due to military occupation, as was the situation elsewhere, the fences were removed or broken down and the deer extended their territories throughout the Forestry Commission plantations while others journeyed in from the nearby estates of Rufford and Welbeck.

Gradually, by putting out winter feed of beet and potatoes, the Thoresby estate management group kept the deer to one specific area and over a matter of months fenced it off. Thus a new deer enclosure was formed.

On the morning of my visit and with Monty Carter's guidance, I saw two splendid fallow bucks, a black and a meril, which mounted a rise and faced our direction while accepting us at forty feet. In the background, exploring their new surroundings, were several does and fawns.

The deer enclosure was situated less than three miles from the AA patrol box at the Bilhaugh-Ollerton crossroads. Therefore, it was probably just the one patrolman with whom I had spoken who had not glimpsed the free-ranging deer, while his colleagues probably had not bothered to mention it.

* * * *

Whenever chance permits, I visit a country show such as the Chatsworth Game and Country Fair or country weekend events at Thrumpton Hall. In July 1980 the biggest countryside event staged in this country, The Game Fair, organised and maintained by the County Landowners' Association, was staged at Welbeck in Nottinghamshire.

As well as volunteering to help out on the British Deer Society stand, I saw this as an opportunity to see something of the Welbeck estate, which was normally and understandably closed to the public.

I had to travel out by bus and alighted at the by then familiar Carburton crossroads. Flanked to my left by a continual and slow moving procession of cars, I walked the road bordering the Carburton Dams and watched disturbed herons flying slowly and conspicuously towards the quieter reaches of the River Poulter in the Clumber backwaters.

The Welbeck estate is owned by the Duke and Duchess of Portland and covers some 1,640 acres. It is around ten and a half miles in circumference. The trees are mostly oak. Over each side of the entrance gates shields carved into the stonework bear the arms of Welbeck's owners, the Cavendish and Bentinck families, respectively. Once inside those gates, the passengers in a bygone coach-and-four had another three miles to travel along the formal tree-lined avenues before they reached the locally famous Welbeck Abbey.

Among the trees a coach-driven visitor may have glimpsed the red-bricked buildings of St Cuthbert's or Welbeck College. Built in the domestic style of Queen Anne, the college contained a chapel founded by Lord Mountgarret, 'a most generous friend to the school', and an assembly that was130 feet long and sixty-two feet high.

It was long rumoured that a member of the Cavendish-Bentinck family had spent two or three million on the installation of interlinking underground departments constructed beneath the abbey. Brick tunnels, the local folk insisted, ran in every direction beneath the estate and some fifty lodge houses, used by their employees, were similarly constructed to give the occupants extra space.

An anonymous visitor once wrote:

> The magnificent suite of rooms below Welbeck Abbey are lit by bull's-eye lamps from the roof above. Of these, the picture gallery is of the most startling dimensions and calculated to awaken the greatest interest. The walls of the corridor by which it is approached are decorated with works of art and would constitute a more ordinary collection. Mahogany fittings, tapestry hangings, portraits and decorations go to adorn the palace which geniuses have spent themselves in embellishing.

The picture gallery was illuminated by 1,100 burners and originally intended as a ballroom. By the kindness of the duke and duchess, it was on occasion thrown open for dances in aid of various charities.

The paintings of the great masters adorned the walls: Sir Joshua Reynolds,Tintoretti, Bassano, De Vass Greffier, Van Dyke, Holbein and Dale, to name but a few. The Welbeck estate has long catered admirably for its employees through the management of a social club that originally boasted a library, billiard room and refreshment lounge. Games of golf,

cricket, bowls and football were encouraged by the duke, who was an enthusiastic motorist. Attached to the outbuildings, pineapples, tomatoes and strawberries were grown in a hothouse alongside plums, nectarines, peaches and muscatels.

The royal visitors to Welbeck occasionally walked or rode out to the locally famous Greendale Oak. In 1724 an aperture was cut through the hole of the tree and sufficiently enlarged so that a carriage and four could be driven through. Naturally, this had a disastrous effect on the tree's matured constitution and by the early 1920s it supported but one bough of green foliage.

The Greendale Oak was not on my mind when, pass in hand, I arrived at the Game Fair where before finding the British Deer Society stand I had a look around.

There was every kind of country stall available: paintings and prints, taxidermy displays, outdoor wear and leisure clothing. There were trade stands and gun dog displays, clay pigeon shooting, pluck a pigeon competitions, ferret society shows, and fly casting. I particularly enjoyed exploring the stands along Gunmakers' Row.

The British Deer Society stand was administered by the Hon. Major X. Between us the staff answered questions and sold items to the public.

Around midday the editor of the society's quarterly magazine *Deer* arrived. Peter Carne had driven with his wife and family up from Southampton that very morning. I was grateful to Peter Carne, for he had published several of my articles in the various editions of the magazine, but nevertheless I chose that day not to make myself known to him.

In the late afternoon heat, three keepers arrived. Cheerful and tanned red by the wind crossing the grouse moors of North Yorkshire where they were employed, they introduced themselves as moorland keepers and rightfully so.

A little earlier they had glanced through the game books of the Welbeck estate and come across a term relating to deer that they did not understand. The word or term was 'havier'. Peter Carne, who would no doubt have answered that question, had left on the long journey south before the ensnaring traffic put further hours on to his journey. I knew the answer but left it to the Hon. Major X to explain. He was, after all, as earlier he had made clear, 'in charge' and the senior member of the group.

That endorsed, I left it to the Hon. Major X to honour the question with an answer. I waited. He shuffled around uncomfortably, and

found items on the display stand that he decided wanted straightening. Senior member or not, I eventually ignored the Hon. Major X, who was obviously evading the question, and explained to the moorland keepers that the term 'havier' was used to describe a castrated stag.

Years before, Welbeck and other estates had castrated certain stags in their herd when they were young, so that their antlers ceased to grow. Instead, all the mineral intake and weight went directly to the stag's body; i.e. its meat, the venison. These haviers were kept in paddocks extending to little more than two or three acres. That way stags maintained their weight in readiness for the table.

Shaking my hand, the moorland keepers left while saying that if ever I found myself walking the grouse butt moors above Rosedale in Yorkshire to seek them out. Tracts of these moors I have since wandered. I have seen both grouse butts and red grouse, but never the wind-keened keepers, much though I would have liked.

Fortunately, a Deer Society colleague had promised me a lift home that day and he was as good as his word. As at sunset we drove from the Welbeck show ground, I became aware yet again of how the once-quiet lanes of the Nottinghamshire Dukeries were becoming gradually ensnared with traffic. There was no room for overtaking because the lanes were narrow, designed to hold the gig, horse and cart, or at best the carriage-and-four.

If the countryside needs to cope with the endless procession of cars, then the drivers of those cars would in turn need to cope with the countryside. The two factions would need to form an alliance.

DISCOVERING
D. H. LAWRENCE

Born on 11 September 1885, David Herbert Lawrence, the fourth child and third son of schoolteacher Lydia Beardsall and coal miner Arthur Lawrence, eventually left the pram and toddled around his first home in Victoria Street, Eastwood.

Due to his recurring bronchitis and several related illness that were regarded as 'dangerous' in those times, Mrs Lawrence prepared herself for the possibility of losing David Herbert at a relatively early age. But although recognised as a 'sickly child', David Herbert won the love of every member of his family, his doting mother in particular. He was also a born scholar and gained a rare but significant county scholarship, which took him a few miles south of Eastwood to the Nottingham High School.

Here he spent three years then served as a general clerk at Haywood's Surgical Goods Factory, situated in Castle Gate, Nottingham.

He then became a pupil teacher employed at schools in Ilkeston and Eastwood. Nevertheless, ambition still beckoned and aided by his mother he provided the entrance fee and aptitude which directed him on to a teacher course based at the Nottingham University College. Here Lawrence studied and in 1908 qualified fully as a teacher.

Formal training and instruction, however, cruelly interrupted Lawrence's artistic inspirations. But he found himself one of a group of omnivorous readers who were both students and teachers. This group became selective in that they gave themselves the name of 'the Pagans.'

One of the highlights of this group occurred most Sunday evenings, when they assembled at the home of Eastwood politician, William Hopkin. Here they indulged in political and social arguments. The

minister of the Congregational Chapel, the Revd Robert Reid, also played a prominent role in the Lawrence family life.

Lawrence's mother was friendly with Mrs Chambers, who lived at Haggs Farm, Greasley. The two women had been neighbours many years before the Chambers family moved to Haggs Farm. But moving house did nothing to deter this friendship and when David's mother regularly visited the farm she took David and other members of the family with her.

The countryside around Greasley, Moorgreen and Beauvale had a profound effect upon David Herbert Lawrence, and particularly upon his future novels and short stories. He became, like most north-west Nottinghamshire folk, aware that two communities – mining and farming – admirably co-existed within a variation of landscapes. Lawrence encouraged May Chambers, the eldest daughter of Haggs Farm, to progress doggedly with her school work and with her younger sister Jessie he formed a bond that lasted for many years.

It was she who encouraged him to write, she who persuaded Lawrence to send his first short story, *The Prelude,* to the Nottingham Guardian Christmas competition. *The Prelude* won first prize.

Meanwhile, Lawrence collected scenes of the winter cottage, the midsummer harvest, life in a country house, Nottinghamshire farmsteads, miners' houses and Eastwood's street market, all of which served as foreground and background materials for the novels and stories that were gnawing away inside him.

At Haggs Farm, the youngest son David also welcomed Lawrence. In later life this brother of Jessie became known as Professor J. D. Chambers.

Eventually Lawrence acquired a teaching position in Croydon, Surrey. He kept in touch with the ever-encouraging Jessie Chambers and continued to work on his first novel, *The White Peacock.*

He was by all accounts frequently homesick as he moved within the educational and literary set. He also met another teacher, Helen Corke, who gave him enough material to form the basis of his second novel, *The Trespasser.*

Lawrence's mother died in 1910. He returned to Nottinghamshire and the following year, due to physical illness and exhaustion, his doctor advised him to give up teaching and live, if he could, by the income from his writings.

Louise Burrows lived in this cottage near Cossall Church. It is known as Church Cottage, but in Lawrence's novel *The Rainbow* he called it 'Yew Cottage'.

These years were the worst of his relatively young life. His mother's illness and subsequent death worried and depressed him. He also lost the supporting friendship of Jessie Chambers when he became involved with and eventually engaged to Louise Burrows, a member of 'the Pagans'.

Louise Burrows lived in a delightful cottage near Cossall Church.

Not surprisingly, the name of the cottage was Church Cottage but in *The Rainbow* Lawrence called it 'Yew Cottage', as he called Cossall, 'the village of Cossethay'. Nor will the modern day reader of Lawrence be surprised by the vivid descriptions of the cottage, interior and exterior, the view of the church from the windows and much else. In most of the Lawrence biographies is a photograph of the striking-looking Louise Burrows extended 'By courtesy of Professor J. T. Boulton'. Many scholars of Lawrence's work believe it was she who provided the character of Ursula Brangwen in *The Rainbow*. The reredos in Cossal Church was carved by her father Alfred Burrows, who Lawrence portrayed in the same novel as William Brangwen.

The Rainbow and *Women in Love* are very much novels rooted in Nottinghamshire, as are the controversial *Lady Chatterley's Lover* and *The White Peacock*. His novel *Sons and Lovers* also belongs in

the same category. Many of Lawrence's short stories were also based in Nottinghamshire, some touching upon the theological, farming and mining themes.

The surrounding countryside also featured in Lawrence's poetry which he began writing when he was twenty, but the mining colliery themes are never far away as is evident in his poem *The Collier's Wife*.

Five of the eight plays written by Lawrence are also influenced by his dual awareness Nottinghamshire background.

Returning to a brief biographical account of Lawrence, he met and found himself attracted to Frieda Weekly (née von Richtofen). Her family were German aristocrats and she was married to a professor teaching at University College, Nottingham. Despite these attachments, Lawrence eloped with Frieda in 1912, the year that his third novel *Sons and Lovers* was published.

During this period his first collection of poems, a book of short stories, *The Prussian Officer* and Lawrence's first and memorable play *The Widowing of Mrs Holroyd* were also published.

Lawrence and Frieda married in Europe and returned to England at the onset of the First World War. Because he was married to a German woman, Lawrence suspected that their marriage was under constant surveillance. He was considered for a period of conscription, but failed his medical on the grounds of ill health.

He was then faced with literary persecution when his novel *The Rainbow* was confiscated, banned and declared obscene. It was probably this incident and the resulting publicity that turned certain members of the Eastwood community against Lawrence.

After the war he and Frieda wandered parts of the world. As husband and wife, they were not always compatible. Lawrence was said to be searching for peace as the couple wandered through Italy, Ceylon, France, Germany, Australia and New Mexico.

By this time, and despite his restlessness and the tuberculosis to which he eventually succumbed, Lawrence continued writing travel books, plays, critical essays, short stories, poems and novels. His output, in my opinion, was tremendous for the forty-four years in which he lived. But it was in Vence, France, and not his native Eastwood, that on 2 March 1930 David Herbert Lawrence died.

* * * *

28 Garden Road, the house in The Breach and the second Eastwood house of the Lawrence family. This dwelling and its immediate surroundings were described in *Sons and Lovers*.

In the early 1970s, I returned to Eastwood with a friend and member of the Nottingham Writers' Club who now lives in Ireland.

Using as our guide a copy of the book *The County of My Heart* by Bridget Pugh, we embarked upon a Saturday morning exploration of the Eastwood known to D. H. Lawrence. It was here that he learnt about the almost corrupt levels in social status, although Eastwood was not unique. These inequalities were to be found everywhere. Each generation has become aware of them, my own included. They were to be seen in Eastwood on the morning of our visit. But we were there to look at the homes in which Lawrence had lived and the streets in which he had walked. In the house where he was born, Victoria Street, there was a plaque over the door, and deservedly so. Neither Lawrence or his mother particularly liked the house. More spacious and to their liking was their second home, a house in The Breach and now re-addressed for modern times as 28 Garden Road.

Lawrence described this house adequately in *Sons and Lovers*. Although still very much part of the mining community, it was more spacious than the Lawrence family's previous home. Yet, for some reason, Arthur and Lydia Lawrence moved again with their family to a house in Walker Street.

According to Jessie Chambers, this was referred to as 'Bleak House' by Lawrence because it faced the variable winds. From the upper windows and the houses beyond Lawrence watched the cloud shadows crossing the fields towards Beauvale and the edges of High Park Woods.

This, incidentally, was a terraced house and Lawrence's parents, still wanting to improve themselves socially, moved yet again in 1902. They moved to the house addressed today as 97 Lynn Croft Road.

To the Lawrence family this was an improvement because the house was semi-detached. All four homes made an impression on Lawrence and were used in his novels and short stories.

That Saturday morning visit was my second to Lynn Croft Road, although I had no intention of knocking on the door of the house to which I had previously been invited and reintroducing myself. The road was deserted. In fact, we had not seen a soul while strolling down the three previously mentioned streets. The impression we gained was that of exploring a vast outdoor mining community museum and being its only visitors.

On Mansfield Road we saw the Wesleyan Chapel which in describing Connie's drive *(Lady Chatterley's Lover)* Lawrence twice used the word 'blackened' in one sentence, no doubt to gain a fleeting yet overall picture for the reader.

For the Congregational Chapel on the corner of Albert Street and Nottingham Road, Lawrence again neatly used one sentence to inform the reader of the materials from which it was built while in the same sentence describing the steeple.

On the corner of Nottingham Road and King Street we passed the Empire Picture House, although I cannot recall whether it had retained the name when we looked at the street corner building that day. On the opposite corner stood the Wellington Inn, then farther along Nottingham Road and closer to Lynn Croft Road we reached the Three Tuns Inn. Retracing our steps along the length of Nottingham Road we passed The Lord Nelson and Eastwood post office before we arrived at The Sun Inn on the corner of Mansfield Road and Church Street. Had Lawrence not mentioned these places in *Lady Chatterley's Lover*, I doubt that we

Splendid inn sign on the site of The Three Tuns.

or anyone would have given them a second glance on that overcast day spent among Eastwood's obviously thriving shopping community.

In a greasy plate café, over equally fitting mugs of tea, we were told of the plans to create a D. H. Lawrence Literary Walk, or several walks, around Eastwood. Such attractions would deservedly see David Herbert Lawrence, his work, home and bygone landscapes commemorated in not just a colloquial but national tradition.

* * * *

From the writings of both Lawrence and Jessie Chambers, my Writers' Club companion and I learned much about Lawrence country: Hucknall Torkard and Long Lane, Watnall Park, Greasley, High Park Woods, Felley Mill, Annesley. We traced routes and footpaths on the map. It was not entirely flat countryside. There were views from ridges here, just the same as there were at Strelley. The woods, throughout all the four seasons, were sequestered and inviting. Despite the Fordson tractor having long replaced the plough teams of the past, gulls still followed the deep, loamy furrows, rising and dipping with the contours of land.

The countryside was, however, not exactly as Lawrence had seen it, particularly around Annesley because since his time, the Forestry Commission had planted several widespread plantations throughout the area. Nevertheless, the places that he had known and so vividly described were still intact, and still creating an atmosphere, give or take a millpond or two.

Had Lawrence been born in another part of Nottinghamshire, I feel that his descriptions would have been equally as vivid. The countryside around Eastwood, however, if properly explored, leaves one with the impression that it was meant to be described – meant to be used – not merely for dual purposes of agriculture and mining, but to provide the seasonal and colloquial authenticity that continues to link the past with the present.

<center>* * * *</center>

After my first visit to Lynn Croft Road, my link with D. H. Lawrence was forged further in 1960 when the obscenity laws were challenged in respect of *Lady Chatterley's Lover* which in 1932 was published in this country but only as an expurgated version.

In New York the Postmaster General imposed a ban on the original version in 1958/59. On 25 March a Circuit Court of Appeals in New York overturned the ban by declaring that the novel was not obscene.

Fortunately, it was pointed out that it was hardly fair that a novel by an English Writer could be read without changes or reservations in the United States of America and not in England. As a result of this a court was set up in this country. It was described by the media as 'The Lady Chatterley Trial'. On 2 November 1960, the British court sided with the United States: *Lady Chatterley's Lover* was not obscene. Consequently, it was destined to become a bestseller.

I bought my copy one overcast November afternoon at the Nottingham Midland Station bookstall, the frontage of which was almost hidden by display copies of Lawrence's novel. People were going to buy it! I joined the queue while knowing that when I had read it the novel would find its way out of the house, as my Errol Flynn and a Marilyn Monroe biography had already. But if I wanted to keep the copy, which was after all mine and bought with my money, I would buy a second just to prove a point. And that eventually I did.

Because of her busy working life, I doubted that my mother had heard of D. H. Lawrence before the Lady Chatterley Trial. Nevertheless, she read the daily news with regularity and would have familiarised herself with the then recent notoriety of the novel. It was not obscene. But in my mother's eyes it was suspect. There was no argument. The novel, after I had read it, was never seen again. The third copy I purchased lasted a few years longer because I was by this time married and under a lesser degree of censorship.

* * * *

Ten or so years after the publication of *Lady Chatterley's Lover* literary critics, biographers and journalists wrote sympathetically of Lawrence's beliefs in sexual impulse as a creative driving force, and of his passion for detail. They were at last understood. He was, many explained, breaking new ground with a structured novel. He sought honesty, forthrightness, competing in some cases with human emotions. He was attempting to create his world as authentic, with a storyline that was frequently autobiographical, because he was intent on preserving a world that he knew would eventually become overtaken by technology.

* * * *

In 1974 a group of Eastwood enthusiasts launched the D. H. Lawrence Society. The meetings held monthly in Eastwood Library attracted a membership that was eventually extended throughout the world.

The posthumous Lawrence gained many literary admirers and his international reputation overshadowed by far the attitudes of the relatively scant few people who several decades before had chosen to berate him.

The D. H. Lawrence Society's meetings varied from readings of Lawrence's work to historical and topographical connections interpreted through visits and outings. Discussions and readings have played a great part in the society's success.

The society apart, Lawrence still has his critics. People were and are offended by his views on racism and fascism. Bertrand Russell more or less regarded him as a Nazi sympathiser, so far as I can make out. And Lawrence is not popular with feminists. How the young readers regard

him today, I have little idea. Those few I have spoken with describe his work as 'old-fashioned' which, to a youngster, it could well be. I gently argue that for an author attempting to describe his world before he died in 1930, how could it be any other way? Yet in literary value, he is still highly rated, and there are many who hold David Herbert Lawrence on the same level as James Joyce. Both share the same artistic and literary rostrum.

The present-day visitor to Eastwood could spend some interesting hours discovering the world of D. H. Lawrence. There is a 'Blue Line Trail' connecting his house and the places he knew as a youth. There is also the Birthplace Museum at 8a Victoria Street. It was here that Lawrence spent the first two years of his life. Like all houses of its time, the house has seen many changes but in recent years has reverted to the Victorian times in a bid to catch something of life and the atmosphere as the Lawrence family had known it.

Schooldays, life with The Pagans, and the working day of a miner or collier are displayed and interpreted at the Durban House Heritage Centre, a spacious Victorian building from which the young Lawrence collected his father's wage packet.

All the interpretative work and ideas are jointly managed by the Eastwood Phoenix Partnership Project and the Broxtowe Borough Council. There is, I emphasise, an admission charge required for both centres. Leaflets are also available at nearby Eastwood Library and most tourist information centres throughout the East Midlands.

In recent years, one D. H. Lawrence enthusiast pointed out to me the pit headstocks at Brinsley Colliery. This is the colliery where Lawrence's father was employed. The headstocks I had never been aware of, unlike the local residents, many of whom objected to the idea of them being moved to the mining museum at Lound Hall, which was, I believe, managed by British Coal. But objections or not, the headstocks were removed. When in comparatively recent times the museum closed, negotiations were soon underway for the headstocks to be returned to their rightful place at Brinsley. To the delight of many local people, this request was met.

Brinsley Colliery has also closed, but the reclaimed land around the headstocks is a recreational area and picnic site with the headstocks serving as a centrepiece, much photographed and monumental against the changing formations of cloud.

As part of the Nottingham University Golden Jubilee Campaign 1997-2002, the D. H. Lawrence Pavilion was opened at the head of the lake in University Park. On my first visit I viewed the original drafts of Lawrence's novels, his notebooks and other materials. I know nothing about graphology, but was nevertheless impressed by the neatness of those first and second drafts. There were insertions and deletions, as one would expect, but there was also an inner striving to be neat and orderly.

Back in my early 1950s schooldays, our geography teacher Mr Barks visited, with hands clasped behind his back, each desk in turn and for seconds studied our style and manner of handwriting. If one of us happened on average to be writing five or six words to the line, he would softly reproach him by saying, 'Eight or nine words to the line, lad. Eight or nine words to the line,' then move to the next desk for a further scrutiny and comment, as he thought necessary.

I believe Lawrence was similarly schooled to write in this manner, because his handwriting, although masculine, was relatively small and those pages on view at the exhibition were neatly set out. Yet, at the same time, he described adequately a person, place or patch of colour.

I gained the impression that he wrote as an artist, like a painter creating images for a canvas. Words were to Lawrence the images, however large or small in proportion to the work, that he endeavoured to portray and in balanced form onto or into the canvas. Each sentence was the equivalent of a brush stroke, representing background, substance and colour. As I moved from one exhibition case to another, I realised also that I was looking at the very drafts, manuscripts and notebooks that a small group of Eastwood residents thirty or forty years ago allegedly intended to burn publicly, had these residents gained access to Lawrence's vast accumulation of work.

Lawrence's girlfriend, Jessie Chambers, probably read and checked over those manuscripts, as perhaps in later years Louise Burrows and Frieda Weekly did. The manuscripts were, and are, as much a part of Eastwood's heritage as the headstocks at Brinsley. As I have stated previously, had Lawrence not lived in Nottinghamshire he would still have adapted his landscape and characters according to their backgrounds. But Nottinghamshire is where Lawrence was born and the landscape that to which he was literary endowed.

It is and seems always to have been a landscape of contrasts, all of which needed to be favourably balanced if a Lawrence was to succeed.

The farming was as important as the coal mining. The squire, backed by his country house grandeur, was in the humanitarian sense equalled with the gypsy and the villager, who having fallen upon hard times had been admitted to the workhouse. Lawrence considered all aspects, all situations, and used the contrasting backgrounds as few had done before him.

Lawrence the storyteller, portraitist, human historian and philosopher was apparent on almost every page of *Lady Chatterley's Lover,* and in the novels and short stories I have read since. But what about Lawrence the naturalist and countryman? He too was apparent.

'D. H. Lawrence must have written down every single thing he saw and experienced!' exclaimed a friend with whom I was enjoying a pint one recent eventing.

Lawrence, in *Lady Chatterley's Lover,* expressed his acute awareness of the seasons, and the woodland seasons in particular. Each time Connie met Mellors, the carpets of flowers, catkin thickets and daffodils around the cottage are described economically, yet give the reader an awareness that the changes had occurred, imperceptibly, in the past few days or within a week. I am not well enough informed to know whether or not Lawrence kept a day diary. But his meticulous noting of the woods and all that took place within them leaves me with the impression that he did.

Jessie Chambers probably helped him identify some of the plant and flower species, at least she if not other members of the Pagans. As a whole, the group were too young to be described as seasoned botanists. Keen amateurs would perhaps be a more fitting description. Or perhaps there was just one keen amateur among them? Whichever the situation, Lawrence had fitted everything into or onto his floral canvas admirably and were it not for my recent reading of *Lady Chatterley's Lover,* the fact that in his time the burdock was locally known as 'Robin Hood's rhubarb' would have escaped my notice completely. He was also aware that the oaks came into foliage around the same time that the glades are enhanced by bluebells.

Celandines, forget-me-nots, columbines, hyacinths, primroses, dandelions: Lawrence saw and listed, whether on paper or psychologically, and he used them all. He was particularly drawn to the hazel thickets. Fresh green foliage, the springtime flowers and the hatching of the pheasant chicks, appropriately coincided with the fusing together of two human bodies. *The White Peacock* is equally illuminating.

BECKONING ANNESLEY

So vivid were the descriptions of Annesley Church in Lawrence's first novel *The White Peacock* that I took a bus out to The Badger Box pub one afternoon and facing oncoming traffic walked a section of the A608 to the church and the west entrance of Annesley Hall. Lawrence described the church in its ruinous state and on the afternoon of my visit a notice emphasised the fact that the church was still in this state. Annesley Hall, so far as I was aware, had been vacated by its owner, the now late Major Robert Patricius Musters, who with his wife had moved to Felley Priory. In the meantime, negotiations were underway with the Football Association, who had stated their interest in using the hall and its formal gardens as a training centre.

I had stowed my surviving copy of *The White Peacock* into the rucksack with a map and binoculars, the latter items being needed to hopefully locate the pair of barn owls I imagined roosting in the ruined church. That is until I saw the buildings of Home Farm situated on the corner of the A611 and the A608 and decided that barn owls, if they were still in the area, would more likely be roosting and breeding there.

Eventually, I came to the formal gateway, and heeding the safety notice, sat on a grass bank and read the description of the church, as seen by Lawrence. His prose was such that I could almost *see* him exploring the ruins while I looked on.

Because my friends Eric and Margaret Spafford were caretakers at Rufford, it occurred to me that Annesley Hall might also have a caretaker. If so, then I would seek his or her permission to have a look around the grounds. My request, if not granted, could only be met with a refusal, at which I would leave, as prompted. When *The White Peacock* extract

finished, I wandered around to the terrace and lawns. I met as expected a man hoeing the borders. Beside him was a motorised garden tractor and trailer.

He was surprised to see a loner strolling towards him and introduced himself as Des the caretaker-custodian. Des didn't mind if for twenty or so minutes I wandered around but he was concerned about how 'Major Bob', as Major Chaworth Musters was affectionately known, would view the situation if he showed up. I told Des not to worry about the Major. I would take the rap – the full responsibility – if he arrived, which I thought unlikely.

Several years after, and due to a project on ground game, I was invited to the home of Major Chaworth Musters of Felley Priory and found him a most charming and amiable host.

His grandfather, and I believe his father 'the Colonel', had met D. H. Lawrence. One described him as looking 'like a red bearded prophet, more or less'. The other thought him 'a strange sort of fellow', but that term must have been used to describe just about every wandering or investigative person on this earth, myself included, over the years.

Promising Des that I wouldn't take too long, I left to explore the paths, bypassing shrubberies and noting several fine beech trees, a broad lawn once used for tennis, and a small pond in the ornamental grounds that were pleasant but not extensive. In a pathside shrubbery I came across the stone marked:

Grave of Donald, a shooting Pony
Aged more than 30 Years
Died of Annesley 1863
The property of the late John Musters, Esquire

It was the wish of John Musters that 'Little Donald', as he called the pony, grazed the park and paddocks until the end of his days and similarly that 'Old Gypsy', the retriever bitch, would have 'two pennyworth of bread and milk every day of her life'.

Donald was obviously used for bringing shot game in from the parklands, particularly deer.

In the Scottish Highlands a pony used for the same purpose was called a 'garron'. The shot stag was transported back to the game larder strapped to the pony's back and led by a stalker or his 'ghillie'.

Nearby were the moss-bordered gravestones of two foxhounds, one being Tarquin, the other Tinker, and possibly if one had the opportunity to study the hound stud book, father and son.

Obviously they were favourite hounds bred by the enthusiastic fox hunter John Chaworth Musters, who was master of the South Notts Hunt and rode occasionally with the Belvoir and Grove and Rufford hounds in the early and mid-eighteenth century.

John's father had also been a keen hunting man and gave his son twenty-five couple or brace of hounds with which to establish his own pack.

Both Tarquin and Tinker were honoured, not only with a headstone each but an inscription:

Tinker
Born 1860. Died 1868.
The best of dogs and truest friend.
Like all things else must have an end.

Tarquin
A Foxhound
Bred by J. Chaworth-Musters
Born 1868. Died 1877.
But the pick of that pack
So fleet is Tarquin
With tongue so true.

In many hound packs, the litter bear the same name of the first letter as their parents, which is why I think Tinker – 'T' – who died in 1868 may well have sired Tarquin – 'T' again – who was born in that year.

There was once, I later learned, a splendid painting of Jack Musters, his hounds, and his hunt servants displayed in the dining room of Annesley Hall.

'Nimrod', the nom-de-plume of a leading field sportswriter of those times, described in flowing prose John Chaworth-Musters as a first rate 'British horseman' and a man who could handle a pack of foxhounds like no other.

John's fame as horseman, master of foxhounds, athlete, ballroom dancer and pugilist reached the ears of a local chimney sweep who was

The Annesley Hall stable block from inside the grounds. The kennels were situated by the main entrance, which is surmounted by a cupola and weathervane.

also a pugilist. To provoke John Musters, the chimney sweep purposely fished in one of the estate's eight ponds and refused to leave when ordered to do so by a gamekeeper.

Eventually, and as the chimney sweep had hoped, John Chaworth-Musters rode over and told him that if he did not leave he would personally give him 'a good hiding'.

To John's surprise, the chimney sweep accepted the challenge.

The two are said to have boxed and wrestled for two hours, a no doubt exaggerated account. But what became apparent was the fact that both men were equally matched. Moreover, at least one source insists, the chimney sweep beat John Musters. The bout ended when John, perhaps not totally beaten but impressed, invited the chimney sweep up to Annesley Hall, where food and wine were laid on for both men. When the chimney sweep left, it was with the assurance that he could fish in the Annesley estate pond whenever he wished, though whether John Musters gave him verbal or written permission remains unrecorded.

Before leaving, I strolled over to Des and thanked him for allowing me to look around. He had been employed by the late Colonel John Musters

Esq. as a gardener since before the war and recalled the mornings when his employee, who regularly served as a J.P., used to walk the paths of the ornamental gardens with his bloodhound, several labradors, a Scottish terrier and a terrier that belonged to the housekeeper, Mrs Fisher.

It was then I saw the kennels attached to the stable block entrance and gatehouse. The stable block was surmounted by a golden cupola, a weather vane, and a splendid clock, which had been built into the gables. These, Des told me, came from the Chaworth family home at Colwick, but exactly when he could not say.

It was to this corner of the Hall's formal grounds that the host, guests, keepers and beaters of the many estate shooting parties that took place assembled before going their separate ways, the keepers to kennel the labradors and retrievers before hanging 300 – 400 brace of pheasant, partridge, woodcock and hare in the game room while the guests made ready for dinner.

The guest list usually included the Duke of Portland, Lord and Lady Middleton of Wollaton, Colonel Clifton, Drury Lowe of Locko Park, Sir Edward le Marchant of Colston Bassett and Major Hardy, a family friend. The local newspaper magnate, T. Bailey Forman, was considered the best shot.

Quite a proportion of the shot game was sold to Burtons the Poulters, or Fish and Poultry Merchants as they were also known, who for many years ran a city centre business from the South Parade precinct alongside the Nottingham City Council offices. Outbuildings containing fuel stores and an early form of central heating unit were situated near the courtyards.

Leaving Annesley by the churchside entrance, I returned some weeks later. This second exploration of the Annesley Hall grounds was less direct and almost eventful. I was again accompanied by my friend from the Nottingham Writers' Club, with whom I had explored something of D. H. Lawrence's Eastwood.

He had one Saturday dined with myself, my wife and family, then he and I drove out for another look at Eastwood before viewing Annesley Hall in its bygone setting: across the parklands and backed by woods, from a formal avenue diverting slightly north-west off the A611 and known, I had previously learned, as Dog and Bear Lane. My late friend Bernard Harling once told me that the trees, laurel and evergreen bushes bordering this lane were at one time trimmed into the shapes of these animals, which is why the lane was so named.

After viewing Annesley Hall from this lane, my Writers' Club friend suggested we had a pint further along the road at The Badger Box.

Once inside the pub, the attractive and friendly barmaid recognised me as a stranger and as we conversed upon both my interest in the Lawrence country and Annesley Hall, she asked if I wanted to look around the Hall that afternoon. Was that possible? Gesturing towards two retired miners, she told me that if we bought each of these men a pint she was sure they would be only too pleased to show us around. They were, after all, weekend caretakers. Within minutes the deal was made and half an hour later keys were turned in the locks of the ornamental gates, and the formal entrance to Annesley Hall.

One of the miners wandered with my friend through the grounds while the second accompanied me around the hall. We were indeed treading ancient boards, exploring a place of long and varied tenancy.

* * * *

There was at that time a series of booklets in circulation entitled *Hills of Annesley*, after the poem by Lord Byron. These were being written and, I think, published by Canon Lyons.

Bernard Harling learned through local records research and the booklets that the name Annesley had been spelt six or seven different ways at various times. He suggested, as possibly have other amateur historians, that Ana or Anna was a man of the eleventh or twelfth century who owned a 'lea', or clearing in the forest.

Moreover, through further research, Bernard discovered that the Anseleis, as in the *Domesday Book* they were named, were of Norman-Breton descent, but their status at that time was not fully recorded. Immediately after the Norman Conquest, however, the land was awarded to Ralph Fitzhubert whose lineage was succeeded by generations of the Annesley family.

Robert Fitzhubert fought on the side of King Stephen and in 1154 was taken prisoner at Devizes Castle which was besieged. He was considered a man capable of inflicting extreme cruelties on his enemies. Thus he was hanged from the castle battlements.

The Annesleys, I understood, lived first in a castle, then a vaulted house, and the succession continued until 1442 when Alice, the last in the family line to carry the name, married while considerably young, George

The crest of the Chatsworth-Musters family prominently displayed inside the ruins.

Chaworth. He was the third son of Sir Thomas Chaworth, Knight of Wiverton, and due to this marriage the Annesley estate was merged with that Sir Thomas owned at Wiverton. The Chaworth history dates from the eleventh century and originates east of Le Mans in France.

After the Annesley castle, a house with aisled halls was built ,or perhaps derived from the early castle foundations. Historians describe a dwelling with aisled halls extending from ground level to roof. The fireplaces were the open hearth type, situated in the centre of the main hall. The rising smoke was drawn through louvres positioned on a ridge in the roof.

Around 1610, during the reign of James I, sections of the present day Annesley Hall were planned and built at the request of George, the 1st Viscount Chaworth. It was a house of late Elizabethan style, designed

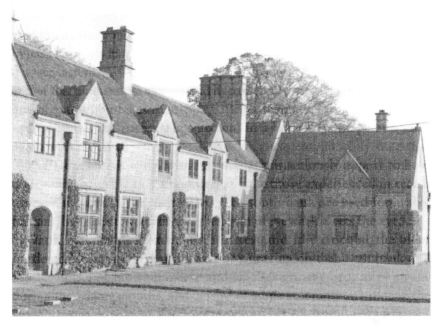

Parts of Annesley Hall were rebuilt in 1835.

with cross wings and a great hall and chamber that were standing on the day of my visit, although architects refer to the overall building as being mainly constructed in the seventeenth century.

In 1617 the garden terrace, still imposing despite its walls of red brick, was built. Thus the gentry had a terrace and balustrade on which to confer, criticise, boast or flirt. In later years, because it was said he frequently attempted to intercept Mary Chaworth here, this became known as Byron's Terrace.

It was not until comparatively recent times that, Canon Lyon's booklets aside, the history of Annesley was researched but fortunately a comprehensive history does now exist. Entitled *Annesley through the Ages* and researched, written and, I believe, published by Denis R. Pearson, this splendid and much-needed volume has, since I began this chapter, just been brought to my notice.

Fortunately Mr Pearson secured prints of the Hall's exterior and interior, thus we learn that when parts of the Hall were rebuilt in 1835 twin gables were added at the same time as a wing containing the library and dining room were added at the request and cost of Jack Musters.

The great hall I also learned, but on my visit had not noted, was one storey high. It had a flat ceiling and the beams were widely spaced.

There is in Mr Pearson's work an account of the morning room, which contained antique sofas, upholstered and scarlet-cushioned. Shield-mounted stag and fallow buck heads, along with framed portraits and hunting prints adorn the walls of this and most of the rooms used by members of the family.

A photograph depicts the mounted heads of two fallow bucks, obviously bred in the paddocks of Annesley Park, positioned beautifully so as to catch the eye.

Des, the caretaker, mentioned on another visit how animal heads and cases of stuffed birds were the first things that met the eye when a visitor was shown into the formal entrance. A great snake – a boa constrictor, perhaps, was wound around a marble support. Gibbs of Ollerton was, I believe, the taxidermist who set up the specimens for what became known as 'The Annesley Park Collection' and was rated among the Chaworth-Musters' family peers and friends as being 'one of the finest in Britain'.

* * * *

On the Saturday afternoon I was shown around Annesley Hall by the miner, I was aware of space and light. But, of course, the place was empty. There was no furniture – Victorian-Edwardian one would expect – or carpets, chandeliers, curtains or drapes. Most of the possessions had been sold off in an auction that took place shortly before Major Robert and the Right Honourable Lady Chaworth-Musters moved to Felley Priory.

But as well as the ornate staircases, I was also aware of the black and white floor, which the miner told me was inlaid marble.

Both Des and the two miners had known the long-term housekeeper, Mrs Fisher, who from Mr Pearson's book and *Kelly's Directory* of 1922 I learned was a member of a family of cowmen, stockmen and butchers. The Fishers had lived at Sherwood Farm, Annesley Woodhouse, which has since been demolished.

And Jack Musters? Who but a keen historian like Mr Pearson would have put his finger on the fact that this nationally famous huntsman had his hound kennels built close to Annesley Hall soon after he married

Mary Chaworth? It was from his work that I surmised that if D. H. Lawrence met up with an Annesley gamekeeper, it would have been William Pettitt, or one of his sons. The Pettitts came from Norfolk in the early twentieth century, or rather moved here, the senior Pettitt in the role of the estate joiner as the tide and terms of employment demanded.

Stepping out of this historic fuddle and turning my attention on the caretaker I became, at the same time as he, alerted by loud voices. From a window we saw on the gravel path below my Writers' Club friend and the second retired miner, glaring at each other and almost coming to blows.

The argument was over an oar. It had at some time, and for some purpose, been carried from the lake at the Wighay end of Dog and Bear Lane up to the ornamental gardens. Glancing at each other, the retired miner and I left the window, hurried over the landing, descended the ornate staircase, and crossed the glaring floor of black and white marble to intercept the argument.

For seconds I envisaged the chimney sweep and John Muster's situation recommencing – round two. And again, strangely enough, the provocative subject had indirectly to do with water.

On joining the two would-be yet improbable pugilists, we learned that the retired miner intended to take the oar home as a keepsake (or sell it!), while my friend objected and said – rightly – that it was not his to take anywhere. Within a couple of sentences the second miner and I had put the matter to rights, although I cannot recall exactly how we achieved this. Nevertheless, the four of us walked away leaving the oar bereft of its lake and rowing boat, and positioned in the centre of the lawn, hopefully for Des to pick up on Monday.

The hall was then locked, the formal gates also. We then gave the two miners a lift back to The Badger Box. As we thanked them, I sat quietly stunned while thinking how an inoffensive object like an oar had provoked two grown men into an argument. Who knows what may happen tomorrow?

'THE WHITE PEACOCK' COUNTRY

Annesley Hall I decided to include in the route for a guided walk of the Lawrence country, although I intended that the participants and I should be viewing it from Dog and Bear Lane initially.

Before embarking on the actual guided walk, I explored the circular route and footpaths one morning with my friends Bernard and Joan Harling, who lived at Teversal. We set off from the lay-by in front of Greasley Church, noting as we did the splendid beeches with sprawling roots close to the churchyard gate.

The footpath had, I believe, just become an official walk opened up and planned by the footpath officers of the Nottinghamshire County Council and local landowners. There were footpath signs and, where appropriate, stiles fixed into the stock-proofed hedgerows. Crossing the road, we walked the hedgeside path gradually climbing uphill while to our right in the fields just south of Greasley Church Lawrence, in writing *Love Among the Haystacks,* chose to describe his days spent haymaking there with the Chambers family of Haggs Farm.

In the adjacent fields, Bernard pointed out traces of the medieval ridge and furrow system where, long before Lawrence, families grew crops in rotational strip lynchets. This open-field system probably originated in Saxon times, when three or so ploughfields were allocated to a settlement or village. One field was designated for the hay crop. Another was left fallow or to rest until the following year.

What Bernard's eye and the combination of morning shadows and available light revealed that day were the long scars that had once served as furrow created by oxen pulled ploughs.

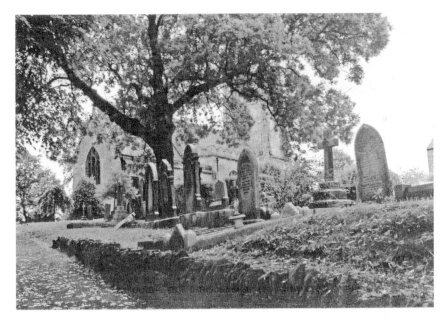

Greasley church, the main entrance.

At the end of each furrow the oxen were guided round as the ploughman prepared to plough another 'strip' or furrow. The shapes we saw clearly, patterned on the sloping turf less than a quarter of a mile away; the shapes, at the end of each furrow, of an elongated letter S, of that there was no doubt.

The clods of earth were thrown to the left as the ploughshares sliced into the ground and after an hour or so a distinctive 'ridge and furrow' pattern opened up. The width of these ridges and furrows hereabout extended to about 4 yards, Bernard explained, and between two and five furrows were recognised as a strip – or furlong.

The peasants who worked these strips shared the poor and better soils. Crops were exchanged as one family worked to help another. The lord of the manor also required shares of the varied and hard-worked harvest, as no doubt did the dignitaries of the local church.

All forms of manure – animal, household and rotting vegetation – were used for the production of crops in this way.

Mention of ploughshares and oxen brought about a discussion, as Bernard, Joan and I wended our way up to the ridged lane by Brookbreasting Farm, on how the word 'acre' originated.

The land and estates in the *Domesday Book* (1086) referred to land assessments as 'hides'. These were recognised as an area in which an ox team could adequately and annually plough. But, due to the strength of the oxen, changes in the soils and the location of the village, these varied across the country. The thinking changed when it was again assessed that a square with furlong sides, if fixed at 220 yards, contained an area of around ten acres. Originally the word 'acre' had been used to describe whichever area of land a yoke of oxen had ploughed in a day. The land measurement term of 'linke' also originated at around this time, due obviously to Domesday-recording necessity. A chain was, Bernard emphasised, also a stretch of land which was 22 yards along. The measurement was convenient for the purpose of multiplication when it came to dividing a land mass into acres.

Returning to the open field system within sight of Greasley Church, such traceries, however faintly they appear, exist throughout most agricultural counties. Those at Greasley then are not unique to Nottinghamshire, but at Laxton north of the county this practice is unique because the open-strip farming system, which I have recently visited, is not only worked on allocated tracts of land but also within the administrative format of a manor court, which, in the absence of the lord of a manor, appoints a foreman and jurors to allocate the strips to be worked across Laxton's three extensive open fields.

When Bernard, Joan and I topped the stile with Brookbreasting Farm away to our right, I little realised the Beauvale of my boyhood was within walking distance and to the north-west.

Eventually, we followed the footpath sign that directed us towards the M1. As one travels the motorway today, between junctions 26 and 27, one has only to see the varied fields, tracts of deciduous woodland merging with the Forestry Commission plantations, stands of silver birch and bracken to realise that this is truly wildlife habitat.

Fallow deer can be glimpsed crossing the fields, or from the motorway as a Raleigh progress chaser made clear one October dusk when from the passenger seat of a homeward-bound car he saw 'a magnificent fallow buck' couched in a field. But all the expected British mammals, except of course wildcat, pine marten, otter and roe deer, thrive hereabout, and the woods are rich in game birds, particularly woodcock.

Bernard and I could have shortened the walk by remaining west of the motorway and progressing, as I have in recent times, alongside High

The north-west end of Dog
and Bear Lane.

Park Wood to Moorgreen Reservoir, which, as I mentioned earlier, served
as the 'Nethermere' in the novels of D. H. Lawrence. I was, however,
thinking in terms of 'a day out' and wanted to include an exploration of
the lanes and tracks around Annesley Hall. And so using the flyover, we
crossed the motorway and followed the path across the Misk Hills, then
descended by the Monument Plantation opposite Whyburn House and
proceeded by Wighay Wood to the A611.

Each time that I walked by Wighay Wood, whether alone or in
company, I was approached by Joe Archer, who lived with a surfeit of
dogs and cats in a cabin just offset from the path and on the edge of the
wood.

According to Joe, he was, as the practical joker of a large Edwardian
working-class family, literally thrown out of his Hucknall home by his
enraged father at the age of nine and told never to return. Nor did he. Joe
lived off the land and was helped by gypsies, poachers and gamekeepers
alike, all from whom he learned the skills of outdoor living. He slept in

barns, caravans and haystacks before enlisting as an army unit batman in the Second World War. A full account of Joe's life I have included in an earlier book, *Old Nottinghamshire Remembered*.

Bernard insisted on the morning of our walk that I be photographed with Joe but unfortunately I was never given a print and Bernard, like Joe, has since passed on.

Turning north we walked the A611, then strolled Dog and Bear Lane, before passing the formal entrance to Annesley Hall then rounding onto the A608 by the ruined church. Here I spent some minutes with my copy of *The White Peacock*, discussing with Bernard and Joan the church ruins as they were on the day of our visit and in Lawrence's time.

From there we turned left by the estate farm, its yards crammed with Friesian cattle, and proceeded downslope and with the landscape falling away on either side. Audrey Wood was to our right before we re-crossed the M1. Had this been named after a bygone member of the Chaworth-Musters family, we wondered? Once across the motorway we saw to our right William Wood, where the fallow deer gather, and the fields known collectively as Cockshutts.

After Newhouse Farm and with Pamela's Larches to our right, we continued into the wooded and pastoral valley and saw the weed-choked millpond by Felley Mill Farm. We were back in the country of *The White Peacock* and possibly on the path long wandered and well remembered by D. H. Lawrence.

Off to the right in the fields stood Haggs Farm, but Felley Mill had been demolished, along with the farm buildings that stood beside the ford. The surrounding land tracts, I should add, are strictly private unless way marked.

We saw around the millpond the masses of nettles, indicators of previous human and animal habitation, brambles, and the muddy 'foils' made by fallow deer crossing from the fields to the woodlands flanking Moorgreen Reservoir.

In the first chapter of *The People of Nethermere*, Lawrence described three stretches of water but sadly, although a thread trickled through the ancient naturally gorged watercourse, both millponds were choked with willows and nettles about which in a further chapter, *The Education of George*, were evident in his time but choking the stockyard of a farm. Fortunately, there are several references to these millponds in Lawrence's first novel and to Bernard and I they represented harshly the changes that

Winter light on Moorgreen
Reservoir, the 'Nethermere' in
Lawrence's novels.

had occurred, not only in *The White Peacock* country but throughout
the length and breadth of Great Britain over the past sixty or seventy
years. But Lawrence, at least, had left a local record. In his novel we
perceive the millponds and their surface patterns, which form according
to the direction of the wind, time of day and the formations of cloud.

The mill, barely recognisable, Lawrence called 'Strelley Mill'. We saw
remnants of stonework but little in the way of foundations due to the
encroaching vegetation. Yet in words at least the mill and its ponds have
been preserved.

Eventually, the path dipped through the woods but with the still
– impressive sheet of water – Moorgreen Reservoir – highlighting the
oaks, maples and pines to our right, and creating photogenic silhouettes.
This, as every reader of Lawrence must know, is 'the Nethermere' of *The
White Peacock*. Some literary scholars also insist that Lawrence used
it to describe 'Willey Water', but Lawrence described Willey Water as
'narrow' and Moorgreen Reservoir is hardly that.

NEWSTEAD AND ANNESLEY REVELATIONS

William, the 5th Lord Byron of Newstead, born in 1722, earned by the time he was a young adult the title of 'The Wicked Lord'. He was, in family lineage, uncle to the poet George Gordon Byron. Immediately he succeeded to the Lord Byron title, William satisfied a childhood whim by having two forts erected alongside the lake. From these forts, while aided by servant Joe Murray, he sailed miniature ships and using a small cannon staged naval battle engagements. He also had built in the woods a small castle and hosted some memorable parties there. Not all of the parties were held at Newstead for a group of Nottinghamshire landowners, the Byrons and their cousins the Chaworths among them, journeyed to The Star and Garter Tavern in London's Pall Mall, where they dined to the extent of the party becoming a well-known dining club.

On 26 January 1765, 'The Wicked Lord' quarrelled there with his cousin William Chaworth, the subject being no more explorative than the best way to hang game for the larder. There is, however, another version in which Byron is said to have boasted that he preserved more hares to the acre on the Newstead estate than Chaworth, who pointed out that Mr Charles Sedley, the owner of estates at Hucknall and Nuthall, also nurtured a reputation for preserving hares.

How the differences could be put right, apart from having beaters go through the game thickets while the two men looked on, I have no idea. But, and foolishly to my mind, Byron wagered £100 that his estate was the richer for hares and Chaworth accepted the wager.

One may ask: was there more to the altercation than that? Did some deep-rooted distrust or hatred manifest during this seemingly petty

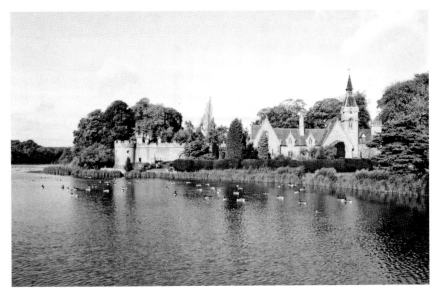

Byron's Fort with residential quarters later added by Colonel Wildeman.

argument? I explore that possibility because the two men, not wanting to argue in front of the eight other dining club members, asked for a room in which they could continue in private.

A servant accompanied them to a landing room and left a single candle burning on the table. Byron is recorded as having entered the room first and Chaworth, intent as his rival on gaining privacy, closed the door.

One can again imagine the argument or quirk of family hatred fuelled by whisky or claret, or both.

Byron is said to have turned while drawing his sword and commanded 'Draw!', which to his surprise Chaworth did, and quickly. Moreover, Chaworth lunged forward, but his sword thrust was thwarted by Byron's waistcoat, whereupon Byron retaliated and plunged his sword into Chaworth's belly. The wound was deep and a surgeon was called. The surgeon, after examination, gave a true verdict: it was a fatal wound.

In the little time he had left, bitterly regretting the argument and his foolishness at being drawn into it, Chaworth made a Will. In it he made provision for a lady friend, for whom he cared deeply, and it was to her house in Berkeley Row, London that he was taken and where he died.

Chaworth's body was taken to Annesley. Here he was buried on 5 February 1765.

Meanwhile in London, where Byron was held in the Tower, a coroner's jury convicted him of wilful murder and ordered that he stood trial before his peers in the House of Lords. At this trial 119 peers voted him as 'not guilty of murder but guilty of manslaughter'. There was, however, no prison sentence to endure. Instead Byron paid a fee drawn up and approved by King Edward VI, which guaranteed his discharge.

He then returned to Newstead. Here in his bedroom he hung the sword with which he had mortally wounded William Chaworth. But among his peers Byron was no longer popular and presumably the Star and Garter dinner parties ceased after the duel. On the few occasions that he returned to London he used the name of Waters.

For reasons best known to the couple, Byron's wife left him. He became reclusive. A servant known as 'Mrs Hardstaff', however, sympathised with him and under the Byron-invented title of 'Lady Betty', she bore him an illegitimate son.

The Wicked Lord then found himself in debt and decided that the best way this situation could be resolved was to have his son William marry an heiress.

Young William, having met his intended, had other ideas and on the eve of the wedding eloped with his first cousin. She was the daughter of Admiral John Byron (1723-86) who was also known as 'Foul Weather Jack'.

On learning of the elopement, the Wicked Lord was furious and his creditors later proved adamant. Thus followed what might best be termed the spoliation of the Newstead Abbey estate. He ordered that stands of timber be felled and sold, then had 2,007 deer killed over a period of time and the venison sold at Mansfield market. For a sum of money, less than the true valuation, he also leased, illegally, a group of Rochdale coal mines.

Age increased his eccentricity but the Wicked Lord outlived his son William, who died in 1776, and a grandson of the same name who in 1794 was killed while fighting in the Battle of Calvi.

On 19 May 1798, William the 5th and 'Wicked' Lord Byron died.

The next notable Byron to reside on the family's Nottingham estate at Newstead was George Gordon, 6th Lord Byron (1788-1824).

After moving with his mother from place to place, the new Lord Byron at ten years old travelled in August 1798 with his mother and nanny to the ancestral estate.

Byron, like myself and most small boy visitors I shouldn't wonder, was much taken by the lake and the way in which the sandy formal driveway eased it into view. This he described in Canto XIII of *Don Juan* which he wrote in 1823.

He had already heard of the ghostly monks and friars who were said to haunt the abbey. And he knew well of the duel in which his uncle had mortally wounded their estate neighbour, William Chaworth.

Awaiting Byron, his mother and his nanny at Newstead was Joe Murray, factotum to the Wicked Lord. Byron soon chose a first floor bedroom which looked out onto the lake. Then the family lawyer, Mr John Hanson, arrived from London.

The Newstead property, extending to 3,200 acres included sixteen farms. In total these were calculated to bring in annually a revenue of between £1,200 – £1,500. Instead this income was used to pay off the Wicked Lord's debts. There was only, Mrs Byron discovered, £150 from which she would need for herself, son George Gordon and nanny, the greater portion. In other words, there was no further income to administer the running of the estate.

While John Hanson was discussing this and the legal documents, he and Mrs Byron decided to make her son a Ward of Chancery. That way he would, as a minor, receive a state income. Hanson also hired as the Abbey steward one Owen Mealey. He wrote from London to advise Mrs Byron that it would be near impossible to live at Newstead in the coming winter of 1798/99.

On taking his advice, Mrs Byron moved to Nottingham with her son and nanny and stayed with the late Lord Byron's relatives in Griddlesmith Gate, which has since been renamed Pelham Street. From there the trio moved across what is today the Old Market Square to lodgings at 76 St James's Street.

While in Nottingham, Mrs Byron sought medical advice with regard to her son's club foot and the thin leg that was so obviously part of the deformity.

Between the Byron's arrival at Newstead and their winter spent lodging in Nottingham, Gordon George, accompanied by his mother and their lawyer John Hanson, visited the Chaworths of Annesley. While George Gordon Byron was again reminded of the duel that had taken place, he was also aware, though at first in a detached manner, of how pretty was his distant cousin Mary Chaworth. She was two years older

than Byron, exceedingly attractive and, according to some biographers, became in the sense of young, passion Byron's first love.

In the summer of 1803 Byron appeared to become more infatuated with Mary, whose mother, Mrs Clarke, invited him over to Annesley. Mary's mother had been widowed but remarried Mr Clarke, the rector of Gonalston.

Despite being only sixteen, Mary was being courted by John (or Jack) Musters of Colwick. She had already inherited the Chaworth estates when George Chaworth of Annesley died in 1791.

Jack Musters, huntsman, ballroom dancer and son of the lord of the manor in every sense of the word, was born on 29 June 1777. A master of the Pytchley and other hunts, he was described by hunting journalists as 'King of the Gentleman Hunters'. Mary's mother, Mrs Clarke, was aware of the attraction between Mary and Jack and after applying to Lord Eldon, serving then as Lord Chancellor, Mary was made a Ward of Court. This meant, of course, that Jack Musters was forbidden to contact Mary in any way. But neither he nor Mary were thwarted. Resolutely they rode each day, Jack from Colwick and Mary from Annesley, to the hill within sight of Annesley Hall and which Byron later called 'The Diadem'. Here the young couple left, in a secret place, letters to each other but how this arrangement first came about both Jack and Mary have taken to the grave.

On her daily rides Mary was always accompanied by her cousin, Ann Radford.

Constantly aware of what was taking place around him, Byron learned of these romantic connections as possibly did various trusted members of the two households. Byron wrote in 1816 *The Dream – Occasional Pieces* which was basically about Mary and Jack's affair by letter or otherwise on Diadem Hill.

Byron, whom the Clarkes always welcomed to Annesley, was allowed to occasionally stay over especially after he had used as a ruse the story that while riding back to Newstead one deep winter dusk his horse had baulked and almost thrown him when they encountered a 'bogie', or ghost, on a woodland ride. I doubt that the Clarkes seriously believed this any more than I do myself, but Byron was awarded quarters and allegedly found Mary flirtatious.

During these stays at Annesley, Byron is recorded to have fired his pistol at the door of a vaulted room, which was built into the hall garden

terrace. When on the afternoon my writers' club friend and I were shown around the grounds, we passed the door and had pointed out to us a series of bullet holes that one of the miners insisted resulted from Byron firing at the door. When a few years later I mentioned this to the late Major Robert Musters, who had spent a career in the British Army as a Coldstream Guard, he shook his head while saying that the holes were probably the result of him using the door for the same purpose as Byron – target practice – but in the Major's case he had fired an air gun then explored the possibility of the original door, or the door used by Byron, having been replaced and left the matter at that.

In Byron's time it was not unknown for lovers to exchange locks of their hair, but when Byron suggested this to Mary she refused and Byron sulked.

His disappointment was short-lived because when the Clarke family planned a trip out to Matlock and the adjacent Derbyshire caverns, Byron was invited to join them. He was fifteen years old and elated.

Years later he recalled the highlights of that trip, describing Mary Chaworth by initials while writing the essay *Detached Thoughts*.

The Clarke family, with Byron, then spent an evening at a high society ball staged at Malvern in Worcestershire. Unable to dance because of his club foot, Byron stood angrily beside the wall while Mary was partnered by several admirers. To some extent the Clarkes appear to have looked upon Byron more favourably than they had Jack Musters, if indeed they were thinking in terms of a husband for Mary.

On returning to Annesley, Mary, as all Byron's countless admirers are aware, once exclaimed to the maid who was teasing her about Byron's attraction, 'Do you think I should care anything for that lame boy?' When eventually Byron was told of this, possibly by the same maid, he was so hurt that despite the late hour and the possibility of a 'bogie' along the route, he had his horse saddled and he returned to Newstead.

The Clarkes on learning of Byron's sudden departure were as equally upset. It was, however, Mary's stepfather Mr Clarke, and an unapologetic Mary accompanied by Ann Radford, who rode to Newstead and persuaded Byron to return.

For a reason that has escaped my notice, if ever it was given, Lord Eldon in August 1803 decided to reassess the situation between the Chaworth and Musters families. Having read of Jack's strength of character, it was probably he or his father who had approached the Lord

Burgage Manor, Southwell, the home of Lord Byron's mother in the early eighteenth century.

Chancellor. The Chaworths' way of saying that they were not prepared to take 'No' for an answer. Whichever, Lord Eldon with the two families before him decreed that he saw no reason why the young couple should not continue seeing each other.

On learning of this, Byron was stunned. His mother was, of course, fully supportive, as was their lawyer and friend, John Hanson. Byron eventually rode from Annesley for the last time. He returned to Newstead. Mrs Byron was by this time living twelve miles from the ancestral home, at the delightful Burgage Manor, situated in a leafy and quiet part of Southwell. The house overlooked the green, around all of which the atmosphere is one of relative tranquillity to this day. Despite this atmosphere, which few can ignore, Byron did not join his mother there. He remained at Newstead and played host to Lord Grey, a friend of his school days. Lord Grey was twenty-three, a bachelor and allegedly attractive. The two men annoyed the estate steward Mealey because day after day Mealey observed them wandering along the lakesides and through the estate coverts shooting game. Mealey, writing complaints to John Hanson about this, described it as 'a waste'.

Mrs Byron in the meantime was arranging for her son to return to his education at Harrow. She was able to extend or postpone this and to Byron's surprise, she began frequently visiting Newstead. She was by all accounts flattered by Grey's attention. They flirted and became infatuated with one another, often and obviously in Byron's presence.

Infuriated, Byron told her that she was intruding in what he regarded as a special friendship. Then he cooled towards Lord Grey, who was surprised when Byron went to live at his mother's home in Southwell. Nevertheless, I gained the impression from a member of the Lord Byron Society that Grey and Mrs Byron continued their flirtation, or fling, whenever it was possible.

* * * *

In Southwell Byron befriended John Pigot when he was home from studying medicine and the two swam occasionally in the nearby River Greet.

When one day his mother told Byron that Mary Chaworth had married Jack Musters, he appeared to take the matter lightly. But of course he felt to some extent deflated, humiliated. Yet it was not a form of humiliation that prevented him from writing the lovely poem *Hills of Annesley* some weeks, perhaps some months, after hearing and bearing the news 'Mary Anne Chaworth of Annesley married John Musters of Colwick by special licence at Colwick on August 17 1805'. John (or Jack) then assumed the name of Chaworth by Royal Licence.

Soon after the couple returned to Annesley, Jack had a set of foxhound kennels built close to the hall and resumed his interest in hunting, breeding bloodstock horses and hounds.

Byron saw Mary at Annesley some three years after she and Jack Musters were married. Unbeknown to him, apparently the couple by then had been experiencing difficulties and experienced more. But along with a friend, Byron was invited one evening to dinner.

Mary and Jack and by this time a daughter to whom, perhaps after seeing her and his beloved together, Byron wrote the stanzas of *Well! Thou Art Happy* in which he admits surely that he wished the little girl was his and further that he was still in love with Mary.

* * * *

Before moving on from Newstead, I recall the 1960s visits with my wife and children. We were always accompanied alongside the garden lakeside path or across the lawns by a string of Anglo-Chinese geese. These were, I suspect, surplus goslings brought from the pairs breeding in Arnot Hill Park. In recent times Geese are still present, but they are of the Toulouse-Emden or mixed strains, due to the Anglo-Chinese retinue having succumbed to age, fox and possibly human predation.

Geese are apparently kept at Newstead because George Gordon Byron, along with much else, was fond of them. I am reminded then of the menagerie he installed but which, due to the poet's wanderings, was probably maintained by the faithful Joe Murray whose portrait is displayed in the abbey, as well it should be.

Two of the menagerie inmates were, I think, a bear and wolf dog. Joe was obviously a many coated man!

Byron's favourite dog Boatswain, a Newfoundland, died in his arms of rabies. I find it interesting that in the Byron vault in Hucknall Church there is a floor plaque bearing the words 'Byron Born January 22nd 1788, Died April 19th 1824', whereas for the poet's dog, which is buried close to Newstead Abbey, Byron had a monumental tomb with a ten line epitaph erected.

* * * *

When visiting Annesley Hall, I was told that Byron's ghost was said to haunt the terrace where he had often lingered during his term of infatuation with Mary Chaworth.

But why Byron's ghost, I asked? Why not the ghost of an old footman, steward or a member of the Chaworth-Musters family? Because the terrace was, after all, not unique to Byron.

My wife and I, each time we moved house, experienced some form of phenomena and whereas as youngsters we had boasted of being sceptics, by the time we had a young family around us we were believers – almost unwilling practitioners – to the forms of phenomena that were forced upon us.

I did not, therefore, scoff at the prospect of the terrace being haunted, but simply asked, 'Why Byron?'

There followed a pre-arranged morning with Des, in which I took my schoolboy son Stuart to Annesley. Hardly had we alighted from a

The rose garden where
the author experienced
an 'aggressive presence'.

double-decker bus on the A611 than a woodcock startled us by rising on
whirring wings from the roadside bracken. Both Stuart and I marvelled
at the speed with which the bird flew to the deep plantations.

From Annesley's formal entrance I took Stuart across to Des, then
showed him the foxhound and shooting pony graves in the ornamental
gardens. We then strolled over to a hand-gate leading into a small rose
garden situated below the terrace and bordered on two sides by the
corner periphery walls of the hall.

Beyond the hand-gate a gravel path led directly to a wooden bower, a
shelter overhung by roses, within which was placed a garden seat. The
instant I put my hand to the latch of the hand-gate, I was arrested by
an unseen, yet incredible force – an aggressive presence – which left the
bower and came directly down the path.

I have never known to this day if Stuart was aware of it but the presence was surely that of someone, a man I surmised, protecting his privacy.

I saw and heard nothing. Yet before us stood the overpowering force to which, uncharacteristically, I gave way. Suddenly I was making excuses to Stuart as to why we shouldn't waste time looking around the rose gardens. I suggested we walk up to the terrace, the lawns and Des the caretaker. As we turned by a shrubbery of golden yews, I heard several deep crashing sounds like someone walking, but put them down to the intervention of rabbits or grey squirrels.

While conversing with Des, I chose not to relate this experience but asked him casually if he had experienced anything strange taking place in and around the gardens. Des didn't answer immediately. Then pointing to a section of the lawn border, which was opposite and almost in line with the rose gardens, he told me that occasionally when he was hoeing or pruning down there, he felt a presence beside him. This presence he described as that of standing over and supervising him. Some old head gardener of bygone times perhaps?

Ten years later a photographer friend, John Jackson, hailed me from across a Nottingham street. Seconds later we were talking on the same pavement. He had, a month earlier, been to Annesley Hall. John then described in detail his tour of the ornamental gardens. I then realised that he was verbally approaching the rose gardens.

'I saw the roses and went towards this hand-gate...'

I held my hand up. 'Don't tell me any more, John. I will tell you what happened,' I interrupted. I then related the experience I had when I visited with Stuart.

John was astounded. 'But how do you know that I met up with this invisible force?' 'How one earth do you know that?' he half whispered in surprise.

'Because exactly the same thing happened to my son and I ten years ago,' I told him.

Since reading Denis Pearson's previously mentioned work, I have concluded that the presence may in fact be protecting the roses rather than his own privacy, because there is one mention that I can find appertaining to the roses and the request of the late colonel, or his late son Major Robert, that the roses should not be cut. I find this and the rose garden 'presence' interesting, to say the least, but will leave the matter there.

ACROSS COUNTRY – HUCKNALL TO CALVERTON

South of Annesley along the A611, and today connected by junctions 26 and 27 of the M1, stands the historic but relatively plain town of Hucknall. It has been described respectively as a market, a colliery and an industrial town, and in many ways it resembles Eastwood.

In all honesty, I cannot imagine its visitors being persuaded to stay for any noticeable length of time. The majority of these visitors make directly for the imposing St Mary Magdalene Church, which is surely Hucknall's centrepiece.

The church has twenty-seven stained glass windows, a fourteenth century font, and the previously mentioned memorial slab in marble, which bears the Byron inscription. I have heard of people hiring a car and driving from the East Midlands Airport purposely to see and photograph this inscribed marble slab.

As a reminder, the slab bears the words:

BYRON
BORN JANUARY 22ND 1788. DIED APRIL 19TH 1824.

The inscription is highlighted by a laurel wreath. Presented to the church in 1881 by the King of Hellene, the memorial reminds one that Greece is where Byron died while enlisting his support for the people of that country, who revolted against the imperialist regime administered by the Turks.

Once or twice in the 1980s I perused, by contrast, the Thursday night 'flea market' dominated at that time by the aromas of vinegar, chips, pie and mushy peas. Like all markets, Hucknall's flea market permeates

Hucknall's centrepiece attracts visitors to the Byron vaults.

an atmosphere of its own. It is admittedly not Greenwich, but nor is it Camden Town. It is, as any market trader will explain, quite simply Hucknall. To some extent, the atmosphere on those evenings was that which one experiences today at a car boot sale. Stalls piled with car spares, batteries in particular; extended play and long-playing records, pile after pile; and second-hand books, which were the reason for my visits.

I didn't really know which book I wanted until I saw it, although at the back of my mind lingered the novels, often relatively plotless, of John Braine, a Hammond Innes adventure or two and the edition of John Fowles' *The Ebony Tower* which featured Toyah Wilcox on the cover.

Perhaps overshadowed somewhat by the monumental Byrons, the inner core of Hucknall can rightly claim and celebrate the birth of Eric Coates, the late and famous composer of light music. Born in the town on 26 August 1886, at the age of six he persuaded his father, a

The striking beauty of the church entrance.

local doctor, to buy him a violin. This acquisition proved to have been more beneficial to Eric and his future than the average childhood whim, because eventually he was recognised as the most accomplished of all the nationally known viola players. By 1933 Eric Coates was rightly termed 'an English composer', having applied his musical talents with such arrangements as *London* produced that year. This included the *Knightsbridge Suite* and the much-requested *Covent Garden; The Sleepy Lagoon*, which was selected as the signature tune for the long-running BBC programme *Desert Island Discs* introduced by Roy Plomley. By 1942, and historically appropriate, Eric completed his stirring *The Dam Busters March* along with two songs, *The Green Hills of Somerset* and *Bird Songs at Eventide*. He died in 1957.

* * * *

155

Leaving Hucknall by the A611, a cross-country journey to Southwell would be incomplete if after turning right the visitor failed to spend a little time exploring the village of Linby.

Like many coal measure communities, Linby has in the past been described as a colliery village. But bygone slag tips or not, the village has retained its character and was described by Pevsner as, 'One of the prettiest villages on the north side of Nottingham.'

The main street is a delight, particularly in the daffodil season, for the flowers enhance the already eye-catching broad grass verges bordered by the silver winking stream.

In the background stand the cottages built of local stone, their gardens colourful with the occasional white painted cartwheel or wheelbarrow crammed with flowers. I cannot imagine anyone wanting to take leave of the Linby main street cottages.

As always I am aware of water and its sources. Therefore, if I met a visitor wanting to learn more, I would suggest we stroll to the bridge over the River Leen, usually faster flowing here and dividing narrowly the marshy woodlands which provide habitat for moorhens, mallard teal, woodcock, all the expected woodland bird species and the sparrowhawk which regards them as prey.

The heights as such are a few miles to the north where in the grounds of Newstead Abbey the Wicked Lord Byron had the river dammed to provide an 'oceanic' playground for his model battleships. Beyond Newstead to the north and west, the land rises again to the source of the Leen at Kirkby-in-Ashfield. But in this damp lowland valley, the watercourse that we see today was, in the late eighteenth century, recognised as being commercially appropriate by mill owner George Robinson, who had an enterprising six or eight mills built. The best known of these is Castle Mill which Robinson likened to Byron's fort at Newstead by having battlements and various ornate designs added.

To work these mills, and probably having acquired them through several agencies, Robinson is said to have used children from all over the country, and in particular from London orphanages. According to several bygone local historians, they lived in squalid lodges attached to the mills and worked under the guise of 'young apprentices'. But they were no more than slaves and were apparently treated as such. The clothing provided was minimal, the food likewise. Not a few were cruelly assigned to the cotton and weaving machines by the time they were ten years old.

I am reminded of these times and conditions whenever I watch the Lionel Bart production of *Oliver*. Many of these children died as a result of measles and cholera. In Linby churchyard there are the graves of forty-two child apprentices, all victims of a callous businessman.

From an appropriate viewpoint, although by no means on high ground, I would point south towards Bestwood village and explain to my visitor that a farmer ploughing his land sometime around 1980-81 unearthed six or seven child skeletons. Assuming that they had been the victims of a mass murderer, he phoned the police. A pathologist, however, established the fact that the remains were those of mill children who had not even been allowed the dignity of a churchyard grave.

George Robinson was not totally without his problems, particularly when he realised that the water supply – 'the wheel-driving current' of the River Leen – while still flowing had receded considerably in velocity. The problem was not related to low rainfall. It was, however, related to the 5th Lord Byron of Newstead Abbey, who needed to pursue his whim and therefore had the River Leen widely dammed from Newstead to Linby. Consequently, the Robinson Mills suffered in production until 1786. It was then that Robinson's sons installed a Boulton and Watt engine to one of the mills and thereby experienced the ease and related continuity of steam power. One would assume that at around this time the days of child slavery at the mill drew to a close. 'And not before time,' the visitor might add.

* * * *

When given directions on how to reach a bus stop in Hucknall from a newly built house close to the previous site of the Linby colliery, I reached the bus stop opposite the inaptly named Byron cinema without faltering. Yet when a police constable patrolling on a bicycle gave me directions to Linby Quarry, where he watched a pair of barn owls quartering at twilight, I turned obviously in every direction but the right one. These directions were given to me twenty years ago, and the truth is I still haven't found Linby Quarry.

* * * *

Almost adjacent to Linby and separated by fields, spinneys, cottages and a house or two, the village of Papplewick is one of those many through

which motorists drive but seldom explore. Papplewick is worth an hour or two of anyone's time, which should include a meal at The Griffin's Head. Local historians insist that the village name is derived from Anglo Saxon times, and a settlement administered by a chieftain known as Pappa. Recently, however, I discovered the name in *The Penguin Dictionary of British Place Names* by Adrian Room.

The word 'wic' apparently denotes a special place, which in this instance could be a dairy farm. The 'papple' or 'papol' signifies a pebbly place. Dairy farm at the pebbly place? Feasible, although pebbles are by no means noticeable in present times. That said, I would not argue with a dedicated expert like Adrian Room, nor a local historian prepared to buy me a pint while extending my thanks to the author and publisher of this, the ultimate book of place names and a book that should be stowed into the rucksack of all wandering folk of Britain, be they amateurs or professionals.

The Griffin's Head stands at the corner of the busy village crossroads, a division between Forest Lane and Linby Lane.

The inn, central to the village, is believed to be around 400 years old (a coaching inn, no doubt) and an inn like many through which generations of forgotten – indeed unrecorded – landlords, barstaff, maids, valets, servants and probably ostlers have passed. There may well have been stables and tack rooms attached in the days of the coach-and-four, and ante-rooms or bothies for grooms and ostlers. What has been uncovered, in fairly recent times and due to refurbishment, is a well, sinking for some six feet, perhaps deeper. Today this feature of the restaurant floor is covered but can be seen and suggests, to me at least, that the restaurant is an interior extension and the well was originally positioned outside the premises. But the truth is, no one can say for certain, and understandably. Across from *The Griffin's Head,* with its extended car park, low beams and genial welcome, a notice informed a friend and I that Papplewick was

(2003) WINNER OF THE COUNCIL FOR THE PROTECTION OF RURAL ENGLAND ANNUAL TROPHY FOR THE BEST KEPT VILLAGE IN NOTTINGHAMSHIRE.

The notice further informed us that Papplewick's population numbered then 300 – 700 people.

A well-known bend fronted by bygone cottages at Papplewick.

French marigolds, lobelias and petunias were displayed in a garden plot close to the notice situated on the corner of Moor Road. These we enthused upon briefly on the July morning of our visit, then crossed the roads to walk Main Street, which a notice further informed us becomes the long hill and ridge road known as Blidworth Waye and joins eventually with the busy A60.

Choosing the left-hand side pavement, we enthused at the cottages, windows and small fronts bedecked with garden flowers, the informative '*c.* 1800' was inscribed above one. There are also some splendid houses and conversions, like The Oaks and West View Court, the aptly named West View Farm and the Wheelwright's Cottage.

To the right, private houses face the road, the majority rail- or wall-fronted. There is also a farm, with a barn or outbuilding roof that would interest, I feel, the late keen-eyed photographer Faye Godwin. Another interesting cottage or homestead exterior is that of Post House Cottage, and splendid too are the purple-flowering vines and creepers almost hiding the interesting brickwork of Morton's Farm.

Near the corner, which swings sharply right then abruptly left into the shaded beginnings of Blidworth Waye, are the buildings in which surely once lived the head stewards and the land agent who administered the affairs of the Papplewick estate.

Discreetly I noted the colourful gardens, the sundial and the thickness of the yew tree's bole, all of which add an atmosphere of village corner seclusion to this walled and splendid property. Following the pavement around the corner and up onto Blidworth Waye, one becomes immediately aware of trees: the 'tunnel effect' on the road itself, and the magnificence of the firs and pines towering close to the road but rooted within the grounds of Papplewick Hall.

If the feeling that something is missing persists, that 'something' could be the church. So far as the village is concerned, the steep but short ascent onto Blidworth Waye is where the village ends. Being aware of this, my friend and I retraced our steps to the Main street corner on our July morning exploration, then strolled the lane-cum-footpath on the right to a set of railed gates.

The path continues as over to the right the churchyard surrounds, with the expected yew trees and gravestones become apparent, although this northern section of the churchyard is regarded as private property. I like the way in which St James' Church was built well back off the road. There are lush, cattle grazed fields either side and beyond the church gates an aisle of trees – sycamore mostly, some chestnut, a low walled spinney of yews, and to the right, closer to the mossy church wall, fewer beech.

The church was built in the twelfth century, rebuilt in 1795, and then restored in 1940. The rebuilding was largely financed by the Honourable Frederick Montague, who employed as architects the Adams brothers. His initials are carved above the porch. Montague lived at nearby Papplewick Hall and is buried, obviously in the churchyard. His tomb is a curious feature: prominent, surrounded by ugly railings, and resembling an ornate six-legged table.

To the left as one approaches the church, a footpath leads off alongside the hedge and across the field. Here a seat has been thoughtfully placed, probably by the local parish council. The field's descened imperceptibly to the line of vegetation – alder, bramble, and willows mostly – which traces the course of the River Leen. The land then rises, but again not steeply, as the footpath takes the walker across the fields to Linby.

The steepness, the abutment, rises in the background: the hills of Annesley about which Byron wrote but which are today swathed with Forestry Commission plantations. These forested slopes also extend down into Annesley Woodhouse.

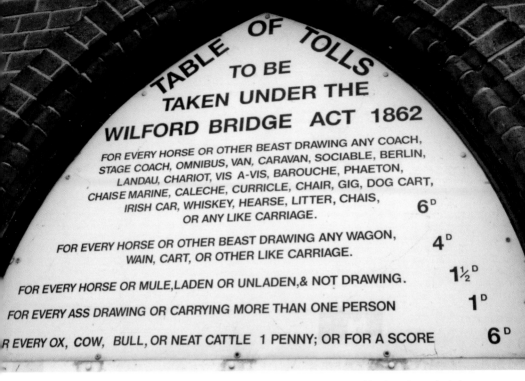

TABLE OF TOLLS
TO BE
TAKEN UNDER THE
WILFORD BRIDGE ACT 1862

FOR EVERY HORSE OR OTHER BEAST DRAWING ANY COACH, STAGE COACH, OMNIBUS, VAN, CARAVAN, SOCIABLE, BERLIN, LANDAU, CHARIOT, VIS A-VIS, BAROUCHE, PHAETON, CHAISE MARINE, CALECHE, CURRICLE, CHAIR, GIG, DOG CART, IRISH CAR, WHISKEY, HEARSE, LITTER, CHAIS, OR ANY LIKE CARRIAGE.	6D
FOR EVERY HORSE OR OTHER BEAST DRAWING ANY WAGON, WAIN, CART, OR OTHER LIKE CARRIAGE.	4D
FOR EVERY HORSE OR MULE, LADEN OR UNLADEN, & NOT DRAWING.	1½D
FOR EVERY ASS DRAWING OR CARRYING MORE THAN ONE PERSON	1D
R EVERY OX, COW, BULL, OR NEAT CATTLE 1 PENNY; OR FOR A SCORE	6D

Above: 1. Tolls in accordance with the 'Table of Tolls Act' on Wilford Bridge, which has spanned the Trent since 1860.

Below: 2. Summer daybreak over the Trent at Wilford.

3. The drinking fountain by the schoolhouse in Strelley village.

4. Pantiled roofed cottages in Strelley village.

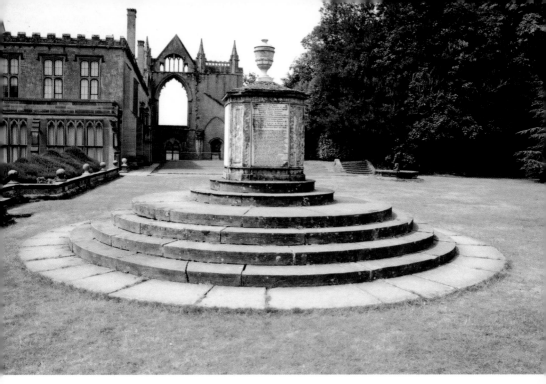

5. Monument to Byron's dog at Newstead Abbey.

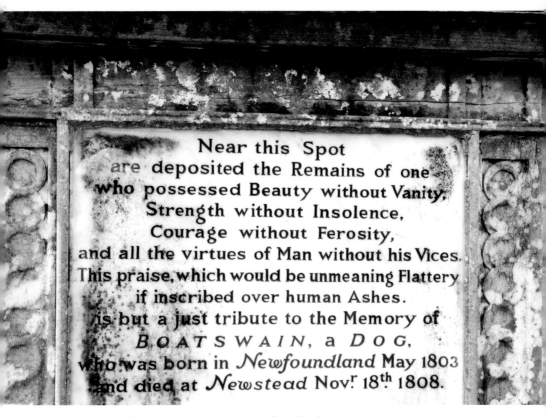

Near this Spot
are deposited the Remains of one
who possessed Beauty without Vanity,
Strength without Insolence,
Courage without Ferosity,
and all the virtues of Man without his Vices.
This praise, which would be unmeaning Flattery
if inscribed over human Ashes,
is but a just tribute to the Memory of
BOATSWAIN, a DOG,
who was born in *Newfoundland* May 1803
and died at *Newstead* Nov.r 18th 1808.

6. Byron's wording commemorating his Newfoundland.

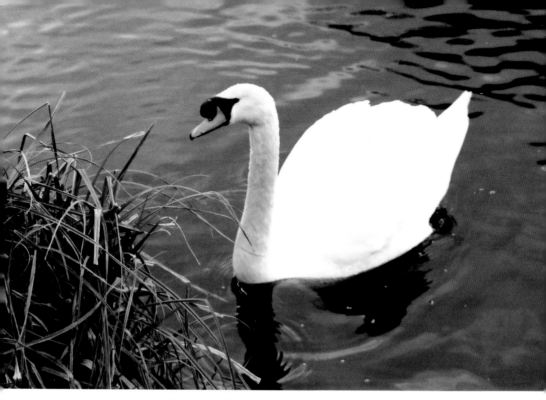

7. Mute swans tenant the Newstead lakes.

8. From inside the Waterfall Cave at Newstead

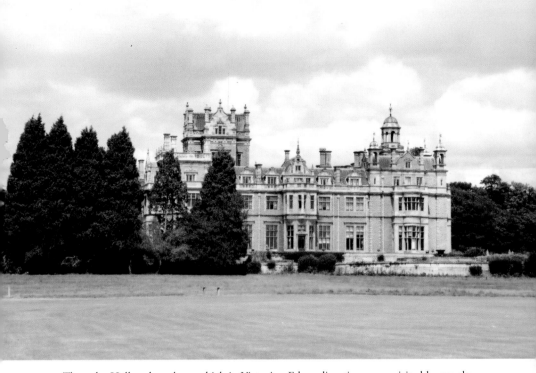

9. Thoresby Hall and gardens, which in Victorian-Edwardian times was visited by royalty with surprising regularity.

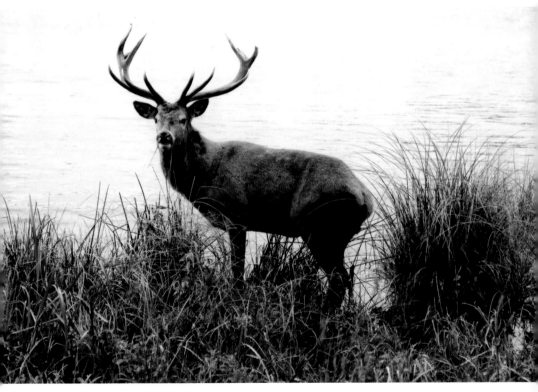

10. A mature red stag. Small herds of red and fallow deer are currently maintained in a parkland enclosure at Thoresby.

11. The locally famed Brinsley Headstocks on the site of the colliery.

12. Durban House, which was originally used as office premises for the Eastwood mine owners.

13. Sequestered Epperstone village main road.

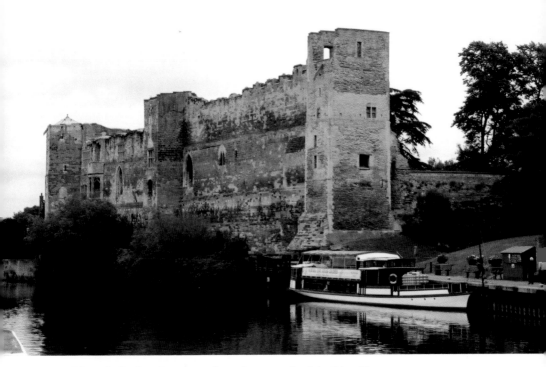

14. Newark Castle ruins as seen from the towpath of the River Trent.

15. Close-up of the ornate Market Cross in Bingham market place.

16. Cattle summer on the village green at Car Colston.

17. The Peacock Inn, Redmile, a popular hostelry out towards the Vale of Belvoir.

18. New and old brickwork used in the rebuilding of the Grantham Canal bridge at Stathern.

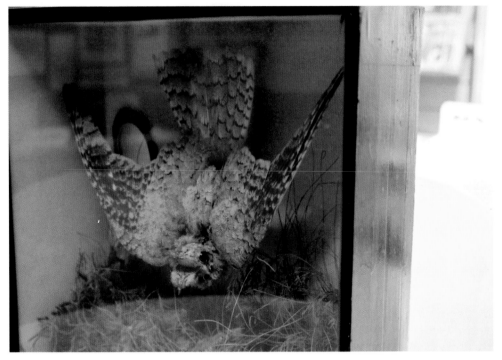

19. The Egyptian Nightjar shot in Thieves Wood, now on display at Mansfield Museum.

20. Used now for recreational purposes, these Forestry Commission plantations are believed to have been planted on the original site of Haywood Oaks.

21. Oaks flank the roadside along the aptly named Haywood Oaks Lane. There is also much self-regenerated silver birch thereabout.

22. The bygone stabling attached to The Saville Arms at Eakring.

23. Green countryscape around the lane winding down to Eakring.

24. June morning beside one of the lakes in spacious Daneshill Country Park.

25. A historic site endorsed by the remains of King John's Hunting Palace.

26. Much local labour was used to build these quarters for King John.

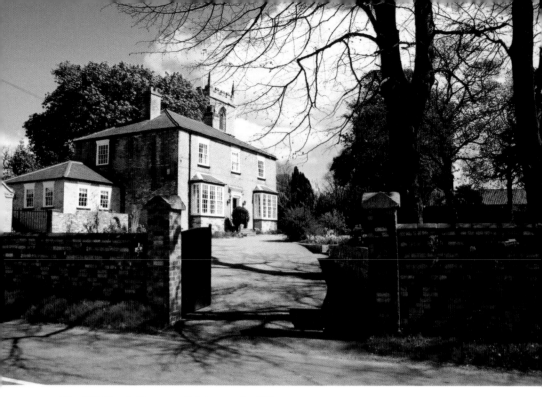

27. The Old Coach House at Grinley-on-the-Hill.

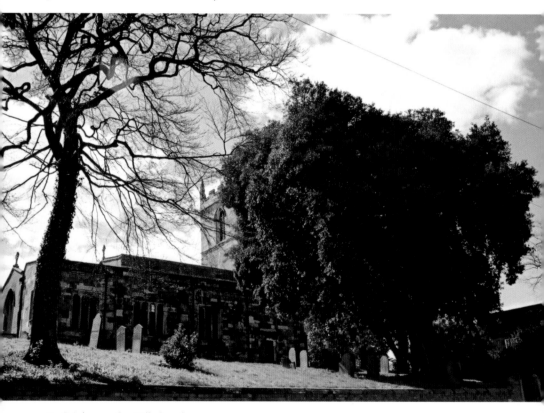

28. Grinley-on-the-Hill church.

29. Ploughing matches are still part of the Nottinghamshire scene.

30. Treescape in Sherwood Forest.

Above: 31. Leaving the lock for the tidal Trent at West Stockwith.

Below: 32. The Medan Millpond at Pleasley Vale.

The River Leen passes along the bottom of the footpath fields. It has been dammed here to form a lake for a local angling club. The waterside hedgerows and vegetation is tightly and securely fenced. From the bridge by the footpath hand-gate we glimpsed between the foliage masses, beds of white water lilies and willows.

Grey wagtail, snipe and woodcock frequent the river's edge and these kind of leafy channels are much sought after by teal, a small species of dabbling duck that I have watched on the Leen's lower reaches near Mill Lake, Bestwood.

From the bridge we retraced our steps back to the church and village, while remarking on the swallows and house martins hawking low over the pasture and cottage roofs. Papplewick, we decided, is a village needing further exploration appertaining to all four seasons of the year.

* * * *

The B683 dividing Papplewick village, cuts into the elongated hill known as Blidworth Waye. For the passenger travelling by bus this is a most attractive road.

Ranks of ornamental pine fail to hide Papplewick Hall, fawn stoned within its paddocks and parklands, while to the right wide agricultural acres of land used mainly for arable farming extend beyond the roadside tree belt and left the contours well clear of the Leen Valley while promising further footing.

The steep ascent resembles in places an Exmoor or Dorset lane, lifting and winding as if to meet the clouds, and to the left stands of mixed pine, silver birch and rhododendron thickets fronted by green mossed walls remind one of the Derbyshire hill country.

These tracts of woodland shade or shelter fine detached houses, in most cases approached by a gravel drive, a few with the postbox positioned in or near the gatepost. Sequestered, and therefore exclusive because of it, these properties back onto and hide from view Newstead Abbey's private grounds.

Along this road the motorist may be forgiven for thinking there is not a worthwhile viewpoint or stretch of water to be seen for miles around.

For me, however, as a passenger on the upper deck of a bus travelling this route to Mansfield one autumn afternoon in the mid-1970s, the land opened up suddenly and unexpectedly. Consequently, I glimpsed on

that crystalline day the wide, low landscape of the Leen Valley – green, extensive, pebble-dashed with farmsteads and holdings, and emblazoned by the chain of blue sky-reflected lakes and dams that form an aquatic staircase through and below the Newstead parklands, to the village of Papplewick and beyond.

If I was commissioned to produce a book on the East Midlands as seen from the cockpit of an aircraft, this is one of the landscapes I would need to include in order to gain an aspect of Nottinghamshire's true perspective.

Eventually, the climb levels on to a long, wide agricultural plain. To the right, Gibbetdale Wood pleasantly blocks the lower skyline. The great tract of land rises and lowers as one travels east across the county with the Leen Valley deep down in the north-west and the Trent Valley east, still to be reached and skirting the borders of Lincolnshire. Yet still along this roadside, the oak, pine and silver birch woodlands and spinneys persist and I delight in the mossy walls continuing to front the more exclusive properties, while noticing as I travel how tiny but unmistakable fronds of bracken have somehow become rooted between the stonework and change colour according to the season as if endorsing the fact of their existence, despite the seams of cement holding the stone walls together.

On one of those afternoons when I travelled a double-decker, I glimpsed a grey squirrel, one of the disturbing many, feeding on the broadly inlaid top of a roadside wall. All around the rodent, acorn husks and beech mast cases were scattered. Clearly, the wall also served as the rodent's feeding table in the way that gale felled trees and stumps are used by squirrels for the same purpose in woodland. Fifty or sixty years ago it would have been a red squirrel feeding there, I reflected.

This long climbing road eventually links with the busy A60 Nottingham-Mansfield Road. To the left, on the opposite side, stands the hostelry long known as 'The Hutt'.

The site dates back to medieval times, when a dwelling or meeting place was established during the reign of King John. The men associated with 'The Hutt' of those times were keepers of the forest, appointed by Royal Warrant. In around 1400, a more established building was erected. This is thought to have been a chapter house used by the monks of Newstead Abbey.

* * * *

To leave the Leen Valley one needs, after exploring Papplewick, to drive east with the arable fields of Papplewick Moor and Stanker Hill Farm to the right.

A footpath crosses Papplewick Moor which I have walked on one occasion only. Alongside the farm an old mineral railway line levels and a bridge takes the walker over to Seven Mile Wood.

If one is exploring by car, then at the T junction by this bridge and Seven Mile House one needs to turn right and then some yards along, left.

The B6386 and another signposted right turn should indicate the proximity of Calverton. Yet again for the motorist the countryside is pleasantly rolling with wooded hills, spinneys and the agricultural 'feel' that one experiences when travelling over the Leicestershire Wolds. It is, as a motorist friend put it, pleasantly scenic rather than wholeheartedly photogenic countryside.

If, however, one chooses to divert and turn left at the village of Oxton on the A6097, then if the arable crops of midsummer allow, a gentle yet photogenic staircase of hills rise, these being the Windmill, Robin Hood and Loath Hill respectively.

These are best seen in the autumn and winter, mostly darkened by the plough, but again to which I would hasten if I had to accompany such landscape photographers as Fay Godwin, Charlie Waite or the incomparable Joe Cornish on a tour of Nottinghamshire. In many ways the hills I admit are dwarfed by the hills of most other counties, but would stand out in a photograph if certain weather effects, and particularly a streak or patch or two of cloud shadow, were used. As for my celebrity photographers, I would have to explain that apart from glimpses of Newark, weather permitting, from a high field path near Southwell, the previously mentioned diorama of the Leen Valley directly below Newstead and a choice of viewpoints in this direction from the comparative ridges of Kirkby-in-Ashfield and Nuneaton, we have very little to work on.

Dorket Head might solve the problem if a selective viewpoint could be found. This steady climb rises just a mile or two to the south but offers viewpoints of a countryside much changed since Alan and I climbed it on bicycles in the 1950s.

The road winds through wooded hills and escarpments for a short but scenic way and is pleasant at all times of the year, except in freezing

fog. Stories of the supernatural occur hereabout but on my summer evening visits to Calverton in the 1970s I was busy, as a part-time tutor for the Workers Education Association, working out the direction of my evening course while looking forward to meeting the students. Wide leafy roads guide the motorist into Calverton's small centralised precinct, which houses the library where my courses were held. The suburbs are leafy and surprisingly widespread. The housing estates are spacious. The colliery estate was built in 1937. Thus the atmosphere at the time of my visits was that of farming and colliery communities working together. The colliery and its houses were designed by G. A. Jellico.

The inner core of this much-extended village is the covered shopping centre and precinct to which most of Calverton's estimated 7,000 residents go at some time during each working week.

An occasional shop, the post office or lone kerbside equestrian remind one that Calverton in appearance was once a village in much the same way as other villages: it is linked with a man who was neither poet, mill owner or cavalier.

His name was William Lee, the curate, who in 1589 invented the stocking knitting frame. The cumbersome machine was considered complicated by many, but could produce work ten to fifteen times faster than the most adept knitters. Lee approached Elizabeth I with a view to obtaining a patent, but she refused him on the grounds that his invention would put people, 'many people', out of work.

Disappointed, Lee travelled to France, although he was by no means a wealthy man, receiving less than £20 at each of the churches he served and the majority numbering less than 150 villagers.

The stocking frame machine, made from wood, was transported to Rouen and the French king at least took an interest but was then assassinated. The Reverend William Lee, as he was by then known, died in 1610 and was buried in France.

His brother James eventually travelled to France and returned to London with the stocking frame. It was London and not pioneering Calverton that experienced the growth of the hosiery industry.

The stocking workers in Calverton were desperate for work and a decent living. Many experienced poverty throughout their lives. But by 1815 throughout England some 27,000 stocking frames were in operation while the overall world count came to 42,000. Robert Harrison was an apprenticed stockinger at the age of thirteen. A Kirklington lad,

he is said to have still been working a stocking machine seventy-six years later. In his early life he moved from Kirklington to Calverton, perhaps having married a woman from the parish.

The cottage, which became the Harrisons' home, was tenanted by the family for 100 years. The Harrisons' sons became renowned cricketers, one of whom played for Nottinghamshire in 1901 when the county team lost to Yorkshire while needing thirteen runs. By the beginning of the twentieth century, Calverton nurtured nine cricketers, all of whom turned professional.

One of the class members, who told me of the Harrisons, recalled his father saying that some members of the family and other stocking frameworkers also made cricket bats at Calverton.

Calverton's 'show cottages', as one might think of them, were once lived in by the framework knitters of the early nineteenth century. The cottages were shaped originally in the manner of a triangle. The wide windows were designed specifically to provide light relating to the rooms of the ground floor, whereas the 'knitting factories', as they were known in the cities, had windows positioned along the length of each building's upper storey.

The cottages that we see today have been admirably restored by the Nottinghamshire Building Preservation Trust.

What I enjoyed about the two courses I held in Calverton were obviously the outdoor explorations and also the evening's end when we all adjourned to a local pub. Here, in good company, I quietly revelled in the atmosphere created by low beams tempered with the aromatic tangs of pipe tobacco, the low exchanges of genial conversation and the awareness of the sun burning golden on the westering horizon.

OXTON AND GONALSTON

Just north of Calverton nestles the leafy village of Oxton. The early settlement was obviously linked to the fast flowing Dover Beck. There is the ring of the Norse man here, because 'beck' is the Norwegian name for stream as 'boce' is the Danish for brook. The term 'Dover' is not unique to this attractive mill stream, although it is the only watercourse carrying the name in Nottinghamshire, whereas throughout England no fewer than forty-four streams are named Dover or Dur.

The original site of Oxton is thought to have been at Oldox Camp, one of the best-preserved Iron Age forts in Nottinghamshire. This lies north of the present village. The fort, extending to three or so acres, is surrounded by a bank and ditch, the only exception being the entrance, where the defences are doubled.

It is thought that the fort originated due to the fears of Roman invasion, although the Romans did not occupy Nottinghamshire so much as pass through it while laying the Fosse Way. Nevertheless, some ancient Britons obviously regarded themselves as exposed to invasion which is how these earthworks probably came about. Other examples are tumuli on private land at Grange Farm, Oxton, and also Coombs Farm, Farnsfield. Local historian Major Rooke is also said to have excavated relics at nearby Oxton Warren.

A Domesday scribe listed Oxton as 'Aston'. In 1086 Oxton, according to this scribe, was overlooked by a lord and worked by free sokemen, villein sokemen and the cottagers. A sokeman owned land and related deeds but was answerable to the lord of the realm. The free sokeman was the equivalent of an English yeoman.

The Dover Beck 'Watersplash'
at Oxton.

In the days of Henry VIII sheep farming was profitable within Oxton but by the end of the eighteenth century poverty was such that Henry Lowe, formerly of Bingham, instigated the workhouse where people with no work earned their keep by undertaking a variety of tasks, not all of them pleasant.

It was apparently not uncommon in those times for people to walk from such villages as Lowdham, Epperstone, Gunthorpe and Oxton to Southwell, Newark and Mansfield in their search for work. Some died during the bleak winters in the spinneys and hedge bottoms of hunger, exhaustion and hypothermia.

Sick clubs were formed in the surrounding villages and at The Green Dragon, Oxton, the 'Female Society' was instituted in 1818. The society welcomed all traders and strict rules were enforced by a mistress and two stewardesses. The intention of the society was to help the poor and all money collected was kept under lock and key in a strong box, the amounts paid out recorded in an account book. This society saw to it that all doctors' bills for the poor were paid and funerals likewise.

A white-haired and retired miner with whom I once enjoyed a pint in The Green Dragon repeated his grandfather's recollections of Oxton's 'Plough Monday' celebrations.

The boys who were taking part met regularly for rehearsals at the blacksmith's shoeing shed. One was elected as Tom Fool and once the day was on hand, these mummers, clowns and general paraders, including the Farmer's Man, the Recruiting Sergeant, Dame Jane, Beelzebub the Devil, and Eezie Squeezum brandishing a frying pan and besom, called at the home of every villager.

Eventually they collected enough sweets, homemade pork pies, cakes and mince pies, along with cash in a box. Portions of such booty were again handed out to the poor.

By 1885, the Oxton Church of England Temperance Society was well-established and 800 or so people attended a fête and gala held in the Pleasure Grounds.

Tea was provided on trestle tables placed together within a covered shed. Not surprisingly, one of the most popular meals on such occasions was bread and cheese sandwiches with pickled onions.

There was a brass band in attendance, among whose members were euphonium players Richard Foulds and John Allwood and drummer Henry Clay.

The rail protected grave of Quaker Robert Sherbrook, who died in 1710.

The landlord of The Green Dragon was John Hopkin. It was he, his wife, and his brother James who cooked the dinners for the Oxton Whitsuntide Feasts. At the age of ninety-five, a year before he died, John saw Nottinghamshire and possibly the surrounding counties from the seat of an aircraft.

When one summer evening in the 1970s I sat over drinks with my wife and children outside The Green Dragon, I was aware of Oxton's seventeenth- and eighteenth-century cottages but failed to see the tombstone in the works yard opposite.

Years later I discovered that the tombstone was that of Robert Sherbrooke, who died in 1710. Being a Quaker, he was buried at what was in his time the meeting house but is now a works yard. The Sherbrookes have lived in Oxton for some 450 years. The early families were related to the Lowes by marriage.

In 1803 Lieutenant-Colonel Sherbrooke raised within the Oxton parish a volunteer force to thwart the threat of an invasion by Napoleon's army. For such an action he was rewarded with a bust positioned prominently in the Shire Hall, Nottingham.

In 1816 Sir John Coape Sherbrooke became Governor General of Canada. In 1868 another distinguished member of the family was made Chancellor of the Exchequer and in 1880 awarded the title of Viscount Sherbrooke.

In the First World War, Captain Henry Sherbrooke DSO, commanding HMS *Tarantula,* flew the white ensign then had it displayed in Oxton's parish church.

In the Second World War another ensign was flown on the HMS *Onslow* by Captain Sherbrooke, who due to his outstanding services while with a convoy bound for Russia, was awarded the Victoria Cross and Distinguished Service Order, which in turn gained him the title of Rear-Admiral R. St V. Sherbrooke.

With just a slight change to the surname, the Sherbrookes originally came from Shirebrook in Derbyshire, but for reasons probably no longer on record settled, during the reign of Elizabeth I, in Oxton.

* * * *

The part of Oxton best known to me is a string of small wide lakes, called today 'Oxton Bogs', that in the eighteenth century probably maintained a duck decoy and its attendant decoy man, and with several of the lakes

dried up, these sheltered habitats still attract wild mallard, teal, tufted duck and pochard.

According to the map, there is a footpath extending through the Sherbrooke parklands to the water's edge. From Oxton village, Peter Dawson and I walked a muddied hedgeside path one December Monday, then at the pine plantation swung left and followed the Land Rover tyre tracks down the pine-wooded hill to the lakes.

Everywhere was saturated; the track was a muddy morass. The lake water mud-coloured. Flocks of titmice, chaffinches and goldcrest explored the tree belts.

This is excellent woodcock country: Cockshutts. Along the blind bank of the nearest lake about a hundred wild mallard were gathered. Wild mallard – not the ubiquitous feral mallard that feed from the fingers in town and suburban parks. They were ready to rise, but we continued walking and that way the mallard retained their confidence and sorted through the floating leaves for drowned or torpid insect life.

Sheep fed on the root crops; the fields were secured with electric fencing.

Two gamekeepers eased by in a Land Rover, waved, then ten minutes later put up their thumbs as they inspected a stand of game crop, planted no doubt by members of a shooting syndicate.

My favourite account attached to these lakes was related to me by a gamekeeper who has since passed on. It was decided, I think in the early 1980s, to try trout breeding and angling on one of the lakes, but a swan pair hatched a brood of cygnets there. When the autumn came, the swans, as expected, flew with their grown cygnets, but returned each day within twenty or thirty minutes. By the end of the winter the cygnets were as large as their parents, which would eventually drive them off as the breeding season came around.

The anglers, however, so I am told, were anxious to get their project underway, and so the day came when keepers caught the swan pair and their nine cygnets, put them in a van and drove four miles to the River Trent at Gunthorpe. Here the keepers released the swan family and drove back to Oxton. As they trundled in the Land Rover down to the lakeside, a skein of swans flew in: two adults and nine cygnets of the previous summer. The family had returned.

* * * *

To take a slight detour on the route to Southwell, I have occasionally journeyed a short distance down the A6097 to the village of Woodborough, which is just south-west of Calverton and Epperstone to the east.

During the war, when restrictions permitted, the South Notts Hunt met many times at Woodborough. This I learned when, as a boy still attending infants school, I browsed the weekly hunting fixtures published in the *Nottinghamshire Guardian Journal.*

Woodborough was once a village providing employment for the stocking knitters. The Church of St Swithin, noted for its ornate east window, was financed by de Strelley in the fourteenth century. The village originally provided homes for at least 100 people, one of whom was the generous Elizabeth Bainbridge, until her death in 1798.

One incident that I have found worth recording occurred in 1817 and was related in a local autobiography, *The Story of the Years,* by the Revd John A. Leafe. That year a Staffordshire potter, William Clowes, visited Woodborough. He was founder of the Primitive Methodist Church and looking to convert the villagers hereabout. But the Woodborough folk would have none of it. Rather than accept this visiting preacher, they not only pelted him with eggs but had the ringing team go up to the church tower and ring the bells in a successful bid to send the interloper on his way.

During those wartime 'mystery trips' with my parents, I learned that my father's favourite pub was The Cross Keys in Epperstone as I mentioned earlier.

According to the Rates and Taxes Bill in the reign of Edward III, one Johanne de Eperston, the settlement's founder, was deemed eligible for payment under the Wapontake of Thurgarton Assessment List. Roman coins have been excavated in Epperstone, suggesting that some casual bypassing trade may have taken place there. The sale of domestic animals, clothes, or tools perhaps? The Normans placed a value of £7 on the village. The tile-roofed church was built in the fourteenth century. The relatively few present-day village visitors tend to photograph its steeple, which like most rises well above the tree line.

William Robinson, a Methodist, was born in Woodborough but moved to Epperstone in 1900 at the age of thirty-one. Employed as a framework knitter he embarked upon a six-month American tour, his purpose being to introduce the knitting machine industry to the Americans.

171

On returning, William Robinson continued to play in the local cricket team and was in his spare time a cricket coach. He married a woman who, not so unusual for those days, was one of ten children. The family cottage was situated close to the Methodist Chapel. The Robinsons eventually turned to the grocery business, which, I believe, Mrs Robinson successfully ran herself.

William Robinson died in 1919 but although my father would have only been around twenty at the time, I wonder now if he knew of him and his reputation as a cricketer, for one had only to mention Epperstone and my father would smile reflectively, although The Cross Keys may also have crossed his mind.

* * * *

A turn left if one leaves the A6097 brings one to Gonalston, a village now on the A612. This is good badger country, a village backed by hills. It is here that the Dover Beck, having in the past powered twelve mills, cuts through the fields and enters the Trent. Most local folk know of Gonalston's old water mill, which I have heard mentioned in Lambley, Wollaton, Nuthall and a Nottingham coffee bar. Moreover, an old countryman once told me the story of Robert Blincoe, who at seven years old was sent in 1799 from the St Pancras London warehouse to work at Gonalston Mill. Robert was not alone; there were several other 'young apprentices' with him. But unlike many, he lived long enough to tell his story.

The roast beef dinners were for the mill owners only. The young workers – young slaves – were fed on the equivalent of the leftovers while working a fourteen hour day. Robert Blincoe survived long enough to become a winder, but one who because of his obvious lack of height failed to reach his work. The overlooker lost his patience with Robert and thrashed him several times, as probably he did others. Once when he discovered an escape route, Robert used it in a bid for freedom resulting in him being caught and thrashed again.

Not infrequently children lost their finger joints in the machines. Such was his fate that Robert had his left forefinger crushed. After it was attended to by a surgeon, Robert Blincoe was transferred to Sutton Mill near Tideswell in Derbyshire. When he was a young man he drove a carrier cart and became what was known as a 'journeyman'. He

The beautifully restored Gonalston Mill on the Dover Beck.

had survived an ordeal extending some fourteen or so years. He later acquired a small grocery business and in doing so made people aware and wrote of what had been expected of anyone unfortunate enough to be orphaned or cast from a family as 'unwanted' in those times.

My Gonalston contact had read a book on Oxton and the surrounding parishes by local author Tom Shipside. The trouble was that he could not remember the title. As if to compensate, my friend related from it the whereabouts of village's pinfolds, water mills and the isolated windmill. Tom Shipside had included the story of my friend, first heard from his mother who was born in Farnsfield which is situated about four miles from Southwell.

200 – 150 years ago, the prominent residents of Farnsfield persecuted the Quakers and imposed upon them fines for loss of goods, particularly hay, and forfeits of livestock, for seemingly no reason other than that the Quakers preferred to assemble in a meeting house and could not be persuaded to change their way of life.

Tom Shipside wrote of George Yates, who lived in Farnsfield. Although he was blind, George was the village postman. Moreover, he carried the letters and parcels daily from Southwell post office, and in learning of this

one should be thinking of the weather. As he neared the village, George blew a few blasts on the horn he carried with him and the cottagers went to their front gates and each sorted their mail out from the rest. This task George continued with every day but Sunday until the day he died. He is buried, I am assured with a fitting epitaph, in Farnsfield churchyard.

But for my conversation with this Gonalston resident, I would have known nothing of these aspects of Farnsfield's social history.

There is much church shadow writing in Tom Shipside's book apparently. Feasts and religious occasions are mentioned, plus an appendix of ministers who served in the Mansfield and Southwell districts throughout the nineteenth century, and perhaps before. There are also by contrast interesting accounts relating to each village and also a few of Tom Shipside's observations, not the least of which was one endorsing the fact that in bygone times a man could be fined 5s for molesting his wife, whereas if a man was caught with a freshly killed rabbit dangling from his fingers he could expect to pay £1 or serve a short-term of imprisonment.

Gonalston Mill was used as an animal feed production unit in the late 1930s and until the outbreak of the Second World War. During that war, the building was used by the Lowdham and District air raid wardens. Consequently, fire-fighting practice took place there and other units trained accordingly. By the 1970s, the mill with its rusted water wheel was in a ruinous state. The culverts and sluices were covered with weed. A sycamore was rooted to an interior floor and was growing. Thus the mill remained, until it was seen and its potential as a residential property explored by a local developer. He is obviously a man of extraordinary insight and lives today in a securely converted property which is a Grade II-listed building.

Plans are currently under consideration to have both the mill race and once important wheel restored. The Nottinghamshire Industrial Archaeology Society are also keenly interested in the mill and its acre of adjacent ground. The entire atmosphere of the place has turned full circle since the days of child labour experienced by many unfortunate young people of two and a half centuries ago, one of whom was Robert Blincoe.

IN AND AROUND SOUTHWELL

From Gonalston the A612 winds between the fields and farmsteads bypassing the villages of Thurgarton and Halloughton before continuing through the minster town of Southwell to join the A617 near Newark. If there was not a minster at Southwell, many people would still consider it a town worth visiting. Nor does one need to attend an autumn ploughing match to see that the soil hereabout is red, as are the soils that can be seen throughout most parts of Devon. The roads leading into the centre of Southwell from whichever direction one happens to be travelling are narrow and flanked by cosy-looking cottages, the majority with a front door that opens directly onto the pavement.

There are tight corners, slimline bends and in present times occasional traffic problems, but Southwell like every county town in Great Britain was not developed with the car culture of the twenty-first century in mind.

The tourists make directly for the minster opposite, which is a car park for local shoppers and visitors alike. A Saxon church was first built on the site. Its chief benefactor around the year 1050 saw fit to furnish this church with bells.

The minster as we see it today was built between the twelfth and fourteenth centuries. Many of its patrons, and indeed its hard-worked builders, never saw the completion or even a section completed. What immediately meets the eye when one looks over this magnificent Norman building are the twin towers that face west and are featured on the cover of just about every other book on Nottinghamshire. They are 150 feet high.

There are guides and pamphlets relating to the minster that cover everything from its towers to its foundations. But for me the columns

Southwell Minster, built on the site of a Saxon church between the twelfth and fourteenth centuries.

of the Chapter House serve well enough to interpret the splendour of the entire building. Known as 'the Leaves of Southwell', these include various vines, maple, oak and hawthorn leaves, among which can also be seen flowers that most people identify as buttercups. For how long a medieval sculptor worked on the carvings, I don't think anyone has the slightest idea. There may be accounts and stories, but how authentic are they? And the irony is that the sculptor remained unnamed and therefore unknown. But at least he left something behind that remains unique in that 'the Leaves of Southwell' are estimated to be the earliest form of sculptured décor to be found throughout the length and breadth of England.

With leaves, trees and greenery in mind, I usually make my way along the paths in the Minster grounds and around the paddocks and sports field fences of the minster School to a reedy pond, where I probably spend as much time watching the behaviour patterns of the feral mallard or the moorhen pair seeking food among the reeds and feeding various

individuals of their large brood as the average visitor spends in the aisles of the minster.

On leaving the pond I continue along the drive, bypassing the Bishop's Manor, then rejoin the twenty-first century on Bishop's Drive which leads onto West Gate and the old market place at the top of Church Street.

It is here, or across the road at The Saracen's Head to be exact, that the English Civil War reconnects with the historical scene, although the County of Nottinghamshire was seldom free of its life-taking intervention throughout the nine-year conflict between the Royalists and Parliamentarians.

* * * *

All around Southwell the houses of the gentry were garrisoned for what was described as 'the royal cause', which meant of course the King. At nearby Thurgarton where the Cooper family had made living quarters within the priory, the outbuildings, stables and church were similarly garrisoned.

Sir Roger Cooper drilled a force of forty men. But two years passed before they saw action by way of an ambush that was laid for a troop of Roundhead infantrymen marching from Mansfield to Newark. Described as 'musketeers', the Thurgarton defensive group fired on the Roundheads and killed the captain. Any celebrations that followed were short-lived, due to the Cooper defensive group having brought attention upon themselves, for Colonel Thornhagh rode in with a full Parliamentarian force, ransacked the garrison, forced the men to surrender, then marched them to Nottingham as prisoners.

There was a bigger affray at Shelford Manor, which was offset from the village by about a mile. The manor was built on the site of a twelfth-century priory occupied by the Augustinians. It was home to the Stanhope family, who eventually became the earls of Chesterfield. The house had a moat, drawbridge, palisades and ramparts added as defensives. It was therefore considered a fitting garrison for the King.

In the autumn of 1605, the Parliamentarians, intent on storming the Royalist defences of Newark, decided to lay siege upon the surrounding garrisons, which included Shelford Manor. On Saturday 1 November, Colonel Hutchinson arrived in Shelford. He had with him Colonel

Rossiter and General Poyntz, plus battalions of horse soldiers and infantrymen.

A group of local men took a small cannon up to the Shelford Church bell tower. They also carried up the ladders and knotted the bell ropes high as they climbed. This was no idle threat, for the tower defensive company fired the canon at the Parliamentarians. In retaliation, Colonel Hutchinson had straw piled at the foot of the tower. He then had it set alight and in no time the group surrendered and were again taken prisoner.

The fact that Shelford Manor was holding a defensive force of 200 Cavaliers under the leadership of Colonel Stanhope did nothing to deter General Poyntz who planned Stanhope's surrender for the following Monday.

At four that Monday afternoon, Stanhope had not surrendered. General Poyntz was there for a purpose, as were his men, and he made that purpose known. Moreover, a regiment of Roundhead Dragoons arrived from London. They were led by Colonel Webb. The Dragoons joined in the hand-to-hand fighting, while from the ramparts and windows of the manor, Royalist musketeers fired upon them.

Eventually, the manor house was stormed. The fighting was brutal, frenetic. Man seemed to be fighting man regardless of his side or cause. Forty odd men are said to have been killed on the staircase. Eventually, General Poyntz ordered the soldiers to cease fighting. There was an estimated 160 Royalists killed and at least forty were taken prisoner.

The number of 'sixteen Roundheads only killed' was never believed. As for Colonel Philip Stanhope, he was shot in the battle and considered therefore to be badly wounded. But according to Lucy Hutchinson in her *Memoirs of the Life of Colonel Hutchinson*, he suffered the indignities of being stripped naked and 'flung upon a dung hill'.

A surgeon was called to attend to Colonel Stanhope, but the wounds were fatal and he died the following day. Shelford Manor was then set on fire. Meanwhile, King Charles, at that time only a matter of miles away at Newark, left for Oxford.

* * * *

Facing the end of Church Street, The Saracen's Head, white-fronted and low-beamed, twice hosted Charles I. During his reign it was fittingly

The Saracen's Head, Southwell. During the reign of Charles I it was fittingly called the King's Arms Inn.

called The King's Arms Inn. It was here in 1642 that the King and his entourage stayed before riding on to Nottingham Castle, where he raised his Standard, thus signifying that the Royalists were at war with the Parliamentarians.

He returned at 7.00 a.m. on 5 May 1646, for having learnt that Montrose was defeated in Scotland and Prince Rupert had surrendered at Bristol the previous September, the King after much trepidation decided to surrender to the Scots who were relentlessly laying siege to Newark Castle and town. The King made this decision in Oxford from where he left for Stamford, a clean-shaven man, his hair trimmed, and describing his occupation as that of clergyman. On arriving at The King's Arms, he rested in a downstairs room which can be seen if one calls in for a pint or meal to this day. He then dined with two commissioners of the Scottish army and when the meal was over revealed his true identity and formally surrendered.

Known to be an indecisive man who stood no taller than five feet four inches and spoke frequently with a stutter, the King obviously had to make that decision or become an outlaw, which was hardly his style. He probably knew that inevitably he would be caught and identified, even if

forged documents and the like were produced. That or someone would betray him.

Whether the villagers of Upton were aware of the small but distinguished prisoner being later escorted through their village is difficult to define, although they probably recognised the commissioners and officers of the Scots army, who by that time were passing through regularly to their headquarters at Kelham, which they nicknamed 'Edinburgh'. In these headquarters, close to the treacherous Trent and near Kelham Bridge, King Charles I was handed over to General David Leslie. He was then formally recognised as a prisoner.

* * * *

King Street, flanked by a wide variety of shops, not the least of which is a newsagents and stationers, is on a bend and here one is always aware of the proximity of pedestrians and traffic.

On the same side of the road as The Saracen's Head but separated from it by Queen Street is Bull Yard, a pedestrianised shopping centre where small businesses and specialist centres like holistic health treatments and interior design merge with sheet music, toys, food take-away, and flowers, fruit and vegetable shops.

All the premises are highlighted by free-standing advertising boards and to my delight on a recent visit I discovered the Bull Yard Art Gallery, which exhibits ceramics, glass and textiles alongside paintings by members of St Ives School and artists working within the East Midlands region. The gallery is small but compact. Paintings by the late Marjorie Arnfield MBE have been exhibited here, along with those of David Crouch and Sheila Wood. September is the month when the Bramley Apple Creative Arts exhibition attracts many young entries from in and around the area.

It was at this gallery that I chanced upon Raku, a specialised art that interests Ian Tomii, who was trained at the Fosse Ceramics Studio in Leicester. Ian began working on Raku pots in 1996 and is constantly updating his style and creations.

Continuing along Bull Yard to the junction with Queen Street, I noticed a cottage partially screened by apple trees and which I thought would have an interesting history. And well it may have. But on the Saturday morning of my visit, I discovered that it was the meeting place of the Women's Institute,

Paintings, basketwork and a variety of crafts are frequently displayed in The Bull Yard.

the local members of which were holding a meeting there that day, and so decided to delve into a little of the building's history on another occasion.

King Street hosts just about every necessary shop and business one can think of, including shoes, greetings cards, commercial photographers and a florist.

One place that I always make for is The Gossips Coffee House, which I first visited with friends in the grey, snow-slushed gloom of an afternoon in that relatively indefinable December week that links Christmas with the New Year. Most of the shops and businesses in Southwell were closed, and understandably. But The Gossips Coffee House was well and truly open and we were made to feel at home the instant we entered. Moreover, the warm portion of mince pie, with fruit and cream, was absolutely delicious. Consequently, I call in whenever I'm in Southwell.

A few yards down the street by the Saturday market is The Wheatsheaf public house, with its cosy bars leading directly in from the market place and a morning cup of coffee, if one is needing it, with two ginger biscuits, at the current price of 80p. 'In this day and age, can anyone do better than that?' I ask my friends.

* * * *

Mentally in tune with a wildlife and countryside artist who lives in Southwell, I choose whenever it is possible to walk the environmental paths to or from each point of interest. And Southwell certainly does have its environmental paths.

This fact I discovered one morning after crossing Harveys Field, which leads off from Church Street. The footpath directed me across a second field once I was on Shady Lane, after which I crossed Newark Road then rounded onto and through the housing complex of Greet Park Close and Marston Way.

Behind these modern houses the River Greet flows beneath the Upton Road Bridge. A left turn and one is then onto a footpath leading upstream and connecting the narrow waterway between the willows, alders and hawthorn thickets to the Greetmill Bridge on Normanton Road.

As I neared this bridge, I was pleasantly surprised to see that for a short distance the riverside leisure seekers were welcomed, there being several yards of lawned banks and public seats. Wild and feral mallard frequent the river forks here, along with. The ubiquitous grey squirrel makes use of the riverbank thickets and also the nearby gardens, from which they are fed.

I visited this place once on a late December afternoon when the reeds, haw thickets and widespreading willows were rimmed with the hoar frost that had not thawed in two days. The impression was that akin to opening a door to see one's garden undisturbed by a light snowfall. Freezing fog swathed the surrounding fields. For minutes, until a car was driven carefully over the bridge, I revelled in the silence and attempted to photograph some aspects of the winter starkness before me.

Across the road today, just to the rear of the mill, is the Mill Park Industrial Estate, as the kerbside notice informs the incoming vehicles, although traffic is by no means heavy here and were it not for the sign the industrial park would be barely noticeable.

The River Greet is regarded as a trout hatchery stream. It gauges a path out from Jenkin's Carr, a secluded tract situated about a quarter of a mile west of Farnsfield. My guess is that the Carr probably results from underground springs seeping down the gradual slopes from the east side of Kirkby-in-Ashfield. The river joins with the Trent at Fiskerton.

To complete a circular walk, and due to the fading light, I turned my back on the Greet and walked up Normanton Road to The Burgage.

Close to the Greetmill Bridge as one walks back into the town is The Newcastle Arms, its green and golden sign catching the eye before the Southwell Trail car park invites the walker, rambler and jogger on another cross-country route. A notice, designed and erected by the Countryside Department of Nottinghamshire County Council informs the trail's explorer that Kirklington is three miles away, Farnsfield five and a half and Bilsthorpe a further two, along this bygone railway track.

Beyond the crossroads is The Burgage. The name refers to land in tenure and held by the peers of a borough or the Crown, but which is still subject to rent and rate payments. This form of financial arrangement dates back to Saxon times, when such rents were called 'landgable rents'. The Burgage at Southwell was once a quite extensive acreage, about which full details can be obtained from the local studies section of the nearby library. On the left of Burgage Green as one walks back towards the town is a walnut tree. It leans back, is pale-barked and deeply ingrained. On the opposite side, splendid lime trees hide the houses, dependent on the direction from which one is approaching. I like to be strolling the gentle slopes here in the autumn when the yellow and golden flares highlight the foliage and the leaves drift to the grass unaided by the wind or frost.

By crossing to the right, I discovered the Manor House and Grenwood House well walled, the police house with blue doors, and a blue-and-white-fronted house that is now a physiotherapy centre.

Recrossing the road and returning to the walnut tree, the houses are all individual in purpose, style and design. The frontage of the Grey House is bedecked in the summer with flowers. This was, I learned at the library, built in Victorian times. And the young people of Southwell are obviously well catered for; the Burgage Youth Centre and the Youth Arts Office appear to be housed in the same complex.

Thinking in terms of youth, George Gordon, the 6th Lord Byron, when not attending the Harrow School and Cambridge University, would have frequently walked the slopes of The Burgage, for, as I mentioned earlier, he swam quite frequently in The Greet.

There is a pump beside the pavement as one tops the hill, beyond which stands the small, compact library where well-priced publications on Southwell's history are always on sale. One morning in early March, I walked the pleasant roads at the back of the library while noting the aptly named Canon's Close to my right.

Besides the cock blackbirds swishing darkly through the gardens or fluting on or around their territorial boundary posts, the season was highlighted further by the masses of yellow and purpose crocuses flowering on the pavement side grassy banks. Whether these crocuses were planted privately or at the expense of the local council, the scene, as intended, truly delighted the eye.

Still with the environmental paths in mind, I walked with a group one November day for a relatively short distance along the Southwell Trail before we swung from east to west over the stiles and fields to Norwood Park. Here we left boot prints on paths soaked by overnight rain, then bypassed the apple orchards, paddocks and ponds with the Georgian -styled Norwood Hall over to our right.

Looking at the fallen apples and wondering if it was worth 'scrumping' one or two, we were reminded of Mr Bramley of nearby Easthorpe who in Trafalgar year planted a cluster of apple pips from which a fine tree flourished to become nationally known by the grower's name.

One tree some distance from the footpath was Cludd's Oak. Edward Cludd was Justice of the Peace and Knight for the County of Nottinghamshire, a title he retained throughout the times of the Barebone's Parliament. Because of his status, Edward Cludd married many couples beneath 'a venerable oak' in Norwood Park. He lived in a hall close to the park and was buried at Southwell in 1678.

The ground rose as we walked north-west over the fields and negotiated the soggy, mud-coated planks placed across the winter borne streams.

There were, we agreed, some quite splendid parkland oaks. Tree enthusiast Mike Willars pointed out the field maples, their leaves by then tinged yellow, each shaped like a small version of a sycamore leaf.

Eventually, the minster came into view. We were still to the north-west of it, but could see in the distance the British Sugar factory at Newark, its trails of white steam rising conspicuously against the frosted blue sky. Mixed flocks of linnets, yellow hammers and green finches flitted through hedgerow thickets comprising of haw, elder and field maple.

Then thirty feet to our right, clamped firmly into the dark ploughland, a hare remained prone within its 'form'. The hare could have been taken for a stone, but ploughland at this time of year is criss-crossed with hare trails, direct lines of pale-sanded earth contrasting with the darker loam of the furrows and connecting one hedge gap to another. We ended the

walk by filing down a snicket or alley between cottages and houses, which I doubt if I could find again, then followed walks leader Peter Dawson to The Saracen's Head with the door bolts not long drawn back and a meal and beer in mind.

Like most buildings hereabouts, The Saracen's Head nurtures its secrets, but architects and historians seem fairly satisfied that the splendid black and white timber frontage, or parts of it, date back to around 1463-65. Here coaches bound for Nottingham, Mansfield, Newark, Buxton and Lincoln pulled in, for horses were stabled and ostlers employed accordingly. In comparatively recent times, wall paintings have been uncovered and one wonders if there is a great deal more to this interesting building than meets the modern day eye.

Opposite The Saracen's Head is The Crown Hotel. While enjoying the lunchtime peace over a pint in the lounge there, I couldn't help but notice how much traffic comes through and turns on the corner of Market Place and Westgate, with Queen Street almost opposite. This traffic doesn't in any way detract from the pleasant atmosphere in the pub, but it does have me marvelling at the fact that an articulated lorry hasn't yet sheared off a corner section of The Crown Hotel or demolished the historic frontage of The Saracen's Head.

EXPLORING NEWARK

I know of no one who dislikes or appears indifferent about the historic town of Newark. The residents obviously enjoy wandering through the back streets and beneath the colonnades, in the same way as Newark's many weekly and monthly visitors.

Certain people go on specific days —

'I've been coming on Wednesday for the past fifteen years,' explained one woman shopper to another when I eased between them and one of the market stalls recently.

My first coach trip to Newark occurred in the early 1950s. It was a Sunday evening outing organised by the previously mentioned Harry Philips. On that trip, for which I was grateful for being invited, we also visited Southwell Minster. Like most youngsters, without giving a thought to the history of either place, I decided that I had 'done' both and never need visit them again. Consequently when, like many families, Jean and I in later years drove through on our way to or from the east coast with the children, we pointed out the castle but never stopped to explore it or the surrounding streets.

I then made what could be called an exploratory visit when I was in my late thirties and since that visit, I have succumbed to the addiction.

As usual, I began my exploration with a tour of the town's bookshops, in Newark's instance two bargain bookshops and W H Smith, then in the rawness of a February blizzard I cut through the Saturday market to The Buttermarket Restaurant, where I enjoyed a coffee accompanied by a spell of meditation.

The town is set around the Market Square and the busy periphery roads connected by blocks of shops and businesses, similarly built

around the square but with interesting side streets linked by Dickensian snickets and alleys leading off towards the castle ruins, church, or an interesting old pub or two.

When later I sheltered from the driving snow beneath the colonnades while sampling a jacket potato, the vendor conversed about the state of the land and potato harvesting in particular, as if he assumed I was a fellow farmer or student at the Brackenhurst Agricultural College. He set his seed potatoes at a depth of around four inches and each about a foot apart, with the rows set about two feet apart. He was fortunate. The land on which his family farmed was rich and moist and like his father and grandfather he was always careful to ensure that the soil was well-manured. Potatoes should be planted in the spring when the soils are warm. They are harvested in the autumn and thereabouts, and he could usually count on harvesting eleven or twelve tons to the acre.

I was surprised to learn that there are hundreds of potato varieties from which to select, but the farmer needs to check them out because some varieties are more prone to disease than others. But the young man and his family had it worked down to a fine art, especially when it came to selecting the best for autumn harvesting.

Before leaving my enthusiastic informant, I thanked him while adding that at least I had learnt something that day, then assured him that I would call on him again when next I visited Newark.

The potato vendor was just one of the many interesting and variable people who, as business people, consumers, historians or town explorers, flock into these East Midland country towns at the weekends, weather regardless.

I also picked up much interesting information from the smiling, raven-haired girl on duty at the Tourist Information Office, and on my second visit, in much brighter weather and armed with maps and leaflets, I embarked upon a historic tour of the town.

* * * *

Excavations have long proven that varied forms of human settlement have occurred in and around the town of Newark, probably since time immemorial. The name originated due to the town being rebuilt following the Danish invasion around AD 950. Probably spelt as 'Nev-Werc', the name indicated the whereabouts of the rebuilding or 'new workings'.

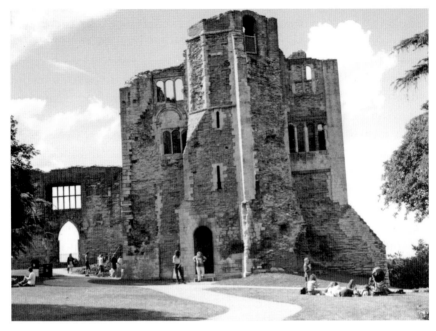

Newark Castle, a majestic ruin today incorporating a museum and tourist centre.

That a Scandinavian or Viking settlement once existed here became evident to local historians of the nineteenth and twentieth centuries from the street names, a good proportion of which ended in 'gate'. Only York, they pointed out, has more 'gate' place names than Newark and here they were referring to all the towns and cities in England.

The Romans moved in from AD 50 and remained for 400 years, and so in retrospect I am suggesting that the ancient Britons who built the earthworks around Farnsfield and Oxton perhaps did so with good reason after all.

Before the castle was built, there was on the site a settlement of Christian Saxons who may also have been linked to the early church at Southwell.

In Mill Gate, which is situated close to the castle, a cemetery believed to have originated in pagan Anglo-Saxon times was unearthed and, surprisingly, the legendary Lady Godiva enters the historical records around 1050. For although mostly associated with the City of Coventry, she was by this date the owner of some sizeable tracts of land here in the Trent Valley.

Although in ruins, the castle still retains a majestic image positioned at what might best be described as the head of the river. It is fronted today by lawns and garden plots, with seats in the summer where not a few local people and visitors relax with their lunchtime drinks and sandwiches.

From the *Newark Civic Trust Guide*, admirably researched and on sale at the Tourist Information Office, I learned that although the names and images of King John and Charles I flood in subconsciously when one is exploring hereabout, the castle was planned and the building of it negotiated by Bishop Alexander (1123-1148).

It was he who also planned much of the inner town as we know it today and included in these plans a series of defensive earthworks should the residents of the town find themselves facing an invading army. Bishop Alexander was also responsible for the siting of the bridge across the Trent, and the market place, thus linking both places with a prehistoric trackway that in his day became known as 'Sewstern Lane' but which since the 1700s and the introduction of the Turnpike Acts was renamed the Great North Road.

King John, I should add, is certainly associated with Newark Castle, for it was after his disastrous crossing of the Wash that he became ill at Swineshead and was conveyed to Newark. Here, probably in the Bishop's quarters, he died on 19 October 1216. The cause of his death several historians have recorded as 'complications due to over-eating', but the truth is no one could or can say for sure.

One king who was aware that King John died at Newark Castle was Charles I, to whom most of the town's residents proved local supporters.

The town's civil Royalists, along with troops and regiments, maintained relatively secure positions throughout all three occasions that the battlements were under siege. They surrendered only when King Charles gave the order. The troops left, but the townspeople were ordered by the Parliamentarians to pull the castle down until it could no longer be regarded as a local defense or garrison.

There is much interpretative history relating to the castle, not the least of which are explanations appertaining to the gatehouse, which has undergone several alterations, and the floors above. These probably housed a succession of bishops.

After the battle of Stokefield and The Red Dyke in 1487, Henry VII stayed with his entourage and surviving troops at Newark Castle, which is about four miles along the Fosse Way from the battlefield.

Occasionally members of 'The Sealed Knot' muster outside The Butter Market
to commemorate the Civil War battles that were fought in the surrounding
countryside.

There is an oriole window in the Great Hall that looks out upon the
River Trent today, with its moorings, weirs and mill house ruins. To some
extent bottlenecked, the outlook here was referred to as 'Water Gate.'

If for a special school project a boy or girl chose Newark Castle,
he or she need only make two or three visits here, for the material in
the museum and interpretative centre is all to hand. In fact, for an
interpretative centre housed in a relatively compact place, I doubt that
the one at Newark could be bettered.

In due course I will return to the castle, its riverside and nearby museums,
as I do when exploring. Meanwhile, I think a tour of the town is in order
and to some extent necessary if one is attempting to capture the essence of
place and mood. The mood is that of exploring a large historic seaside town
but situated around, indeed surrounded by, an agricultural community.

On leaving the Castle Information Centre, I usually cross the main road,
Castle Gate, and head down Kirk Gate, Boar Lane or Stodman Street to
the Market Place. Stodman Street alone proves that Newark, so far as
a variety of shops, supermarkets and small businesses are concerned,
lacks for nothing. The pavements are narrow, the shop windows many

and variable. There is a saddler's and riding tack shop, florist's, tandoori takeaway and travel agents, to name but a few. Strangers meet and drift into conversation not only in cafés, pubs and alongside market stalls, but at bank and building society cash points.

Where Stodman Street levels on the opposite corner to the Buttermarket and on the right-hand side with one's back to the castle, a splendid black and white timber-fronted building carries a plaque informing the visitor that Prince Rupert, nephew of Charles I and local commander of the Royalist troops, stayed there. Nor was he alone. All the Royalist governors lived in these spacious premises during the three sieges of Newark. Not surprisingly, it was called the Governors' House. Here, while the third siege was taking place, the governors decreed that the troops would be paid with specially minted coins.

In a nearby house, marked by a plaque and situated by the bank at the side of the town hall, lived Hercules Clay. The informative leaflets I earlier obtained recorded that during the Civil War, Hercules dreamt three times that his house was on fire. It was due to these dreams that he moved out. Sometime later, a mortar bomb fired by the Parliamentarians exploded upon the vacated premises and true to these dreams the house of Hercules Clay went up in flames.

If the visitor looks across the cobbled market square, perhaps on a day when there is no market, he or she will see the pavement that extends from the Governors' House to the church of St Mary Magdalene and was used by the Governors accordingly. There is, in the tower of this church, a hole which, according to the man who pointed it out to me, was made by a cannon ball during the Civil War.

But returning to the market place, or 'Market Stede' as it once was known, almost every building has a link with Newark's colourful past.

At The Clinton Arms Inn, the poet the 6th Lord Byron stayed. The year was 1808 and, not surprisingly, he was impatient and waiting for his first book of poems to be printed in that or a nearby building. The printing press is on show today at the Appletongate Museum.

The Sir John Aderne public house is named after a local resident, who was a pioneering surgeon. The Old White Hart, along with The Clinton Arms and The Saracen's Head, was a coaching inn associated with the coach-owning firms and the passengers travelling the Great North Road.

The Old White Hart was built in the fourteenth century. A timber-framed inn, the name derived from the emblem used by King Richard II.

The yard of The Saracen's Head, like many coaching inns, still has the archway through which the coaches and their teams of horses arrived and left. Sir Walter Scott the novelist stayed here on more than one occasion, as did a central character he chose for the novel *Heart of Midlothian*, Jennie Deans.

The impressive Clinton Arms once comfortably stabled ninety horses. From its balcony William Gladstone, later to became a local MP and then Prime Minister, persuaded those members of Newark society who had the time and national interest at heart to hear what he had to say.

I like to wander along Kirkgate, careful to avoid the busy shoppers but at the same time studying the timber-framed houses and shops dating from medieval times. There is a splendid coffee and card shop here with so many cards to choose from that one could spend an hour there without once glancing at the time.

The church of St Mary Magdalene has four piers and a crypt dating from 1180. It also contains a memorial brass, erected around 1363, to Alan Fleming and twentieth century works donated by Robert Kiddey, a local artist. Close to the church, I seek the shade in exceptionally hot weather and eat my lunchtime sandwiches on a seat beneath the trees. I revel in the sense of peace that exists here in what I now fondly refer to as being 'Newark's quiet and shaded corner'.

If I were taking you, the reader, on a tour of the town, I would suggest next that we retraced our steps to and across the market place to the Town Hall. If it is a market day – usually on a Wednesday, Friday and Saturday – I may well enthuse upon the variety of traders, and items that can be bought here: alarm clocks, bedding, carpets, mats, curtains, framed pictures, fruit and vegetables, records, compact discs, videos and second-hand books, just to name but a few.

Rain and sleet make little difference; the customers are there, looking, buying. And the people themselves, their expressions, forms of body language and general and natural portraiture, I consider interesting in any market or casually formed crowd. As can be expected, the Town Hall is recognisable by the frontage of high steps.

Designed by the architect John Carr of York, this Palladian-style building was opened in 1773 and is the administrative centre for Newark and its periphery villages to this day. In the seventeenth century, several buildings described as 'butchers' shambles' stood at the rear of the Town Hall and were probably slaughterhouses and tanning yards, as well as

the general butcher and poulterer businesses which were probably based within a customer's scrutiny of the pavement.

A century later these buildings were demolished and a market hall was built and opened in 1884. Here both livestock and dairy produce were bought and sold. The daily scene would probably have resembled a Roman market, particularly with the fronting pillars and paved walkway, which the architect Carr adapted from that of his Italian peer Andrea Palladio, who greatly admired and was inspired by early Roman architecture. The interior, reworked and as we know it today, was completed around 1984.

In the Buttermarket at the rear, I usually spend some time browsing the many and varied bargains in the cut-price bookshop, then climb the stairs to the Buttermarket Restaurant where, accompanied by a coffee, I enjoy a portion of apple pie topped by lashings of delicious cream.

From the Buttermarket, the narrow streets branch towards the main roads, castle and riverside, to which I usually return because the adjacent museums and old mill buildings are worth including in the itinerary.

There are several walks leading off Mill Gate and down to the Riverside. One is by way of a snicket, so narrow between the houses that people are obliged to walk single file. This snicket is to be found almost

Newark Lock on the River Trent viewed from the castle ruins.

193

opposite the corner of Lombard Street. But the best-known is a council-created walk, partially of steps but with a wide ramp provided for the disabled, which leads down from Castle Gate where the wall corner and castle entrance indicate the fortress boundary.

Pleasure boats set off down to Farndon from the riverside here, where neat little homesteads fronted by beds of roses appear to be tucked into every corner. By the seventeenth century, these wharves and loading bays were collectively regarded as the dockland district of Newark.

Today the lock gates here allow access by way of the metal footbridge unless a red light is flashing, which indicates that a boat is about to come through. Prominent beside the locks and quayside are the bollards, white-painted and needed by the boat people, who use non-slip knots to secure their respective crafts to the waterside. The boats travelling upstream halt here until the lock gate combinations, now worked by electric motors, raises them to the upstream level beside and below the castle.

The white house on the north bank was for many years a lock keeper's residence. He had always to open and close the lock gates by hand and windlass, as the movement of river traffic demanded. Nearby is Kelly's pub, which for 200 or so years obviously maintained a thriving trade, the area being well-populated and more built up than that which we familiarise ourselves with today, but which still retains the name of Cuckstool Wharf.

Usually I walk by the dry dock and boat-engineering yards to the ruins of the old watermill and the weir, which plunges the water over the sills between the islets and overgrown banks fringed by the willows and alders, then rejoins the main flow of the Trent just across from the castle.

The sections of the waterway are all bridges and connected to the main car park situated within a stride or two of the cattle market.

There are several paths leading across the fields and over to the island hereabout, where one can study the history of the old mill house and the adjacent wharves while dragonflies hover and grey wagtails flit colourfully through the reed stems. Round the river bend and through the field gate, a boat builder's yard, marina and chandler's business stand at the mouth of the River Devon [pronounced *Deevon*] and can be seen as one walks or drivers into the town along the Fosse.

If one retraces the route and crosses by the locks to the south bank of the Trent, one can hardly fail to notice the wharfside warehouses,

some of which have been converted into pubs, cafés and various modern commercial buildings. Here, too, is the Millgate Museum of Social and Folk Life. Housed in a mill built specifically for crushing seeds, local works of art are displayed in a mezzanine gallery, and one can stroll into reconstructed cottage parlours or a period kitchen and a shop.

During one August visit when the children were off school, a friend and I uncharacteristically allowed ourselves to be ushered into a wartime air-raid shelter reconstruction, where the museums officer explained something of the atmosphere created when in the Second World War an air raid took place. As we sang 'Ten Green Bottles' and the children donned the uniforms of nurses and air-raid wardens, I was once again transported to the garden air-raid shelter of my formative years, except that there was no mother or father's lap to snuggle down into while the enemy aircraft fleets droned across the memorable starlit sky that had prompted the raid.

Just as the City of Nottingham has its Trent Bridge and Beastmarket Hill, so too does Newark. Beastmarket Hill connects Trent Bridge with Castle Gate. As the name implies, a cattle market was established here and as at Wilford, which I have mentioned in a previous chapter, a toll keeper lodged and spent his days collecting a bridge tax from each farmer or drover.

The present Trent Bridge was built on the site of an original Roman and later bridges. Built in 1775, this five-arched structure has until comparatively recent times withstood many years of winter flooding. But without entering in the technicalities of bridge building, one can see that it was a bridge built to last. Whether the side paths and railings were included into this latest construction I am unable to say, but the local studies department of the town library should have such information to hand.

Before crossing the bridge, it is worth looking at the white-fronted building with the arched front and eighteenth century bays built into the roof. This was built at the expense of Viscountess Ossington in 1882. Seeking a drinking person's alternative to gin and beer, she opened the building as a 'Coffee Palace" in a successful bid to make coffee drinking locally popular. But businesswoman though she was, The Viscountess ploughed all the profits of that business into additional funding for the Newark Hospital, a truly worthwhile cause.

If after crossing Trent Bridge one turns right, one can hardly fail to notice the long white-fronted building facing the river. Built towards the

end of the eighteenth century, this was, like several nearby buildings, a maltings unit, and locally unique in that it is one of the first concrete buildings to be erected throughout the United Kingdom.

Close by, and incorporated within what appears to be an estate of Housing Association homes and flats, is a clock tower. On this site stood Nicholson's Foundry. The Nicholsons were makers of agricultural machinery for just over a century. The firm ground to a halt in 1968. The artist Sir William Nicholson was a member of this family.

The river path skirts a small but compact marina with a grassy island frequented by gulls. As the river meanders to the right, a water meadow spans the embankment of the A46 bypass to the left.

A series of arches guides the Trent beneath the A46, but the water meadows beyond are rightly regarded as private land owned or leased by the British Sugar Corporation.

Angling clubs rent or lease the tracts of water, which are best seen from the passenger seat of a car as one is travelling north. Therefore it is advisable for the local explorer to cross the Trent back into Newark's town route by way of the ornate New Millennium Bridge and onto Brewer's Wharf, close to which is the new and updated *Pizza Express Restaurant*. Crossing the road at Bargate if one has shopping to do, there is a superb Morrisons supermarket built into the side of Slaughterhouse Lane. All the medieval linked streets from thereon lead back to the marketplace.

* * * *

With the intention of walking an environmental path into Newark, perhaps twice a year, I travel by bus out from Nottingham and alight at Farndon Post Office, situated on Main Street. From there Church Street, straight ahead, links with Wyke Lane and a turn to the right to the lane's termination point with the public house, which I'm told was once called The Lazy Otter.

The name 'Wyke' would have originated in Roman times, denoting perhaps the whereabouts of a Roman settlement and in this case beside the Fosse Way. Or it could merely imply that a dairy farm was established close to the river.

The Trent curves memorably here where lawn and grass bank slope to the water's edge. There are boat ramps and slipways on both sides of the

river, and for my friends and I the environmental path begins when we pass the public house, proceed through the white swing gate ahead, then bypass Farndon Harbour on the right.

Occasionally, we divert along the path that cuts across to the north end of this picturesque marina and bypasses two small but well-thicketed gravel extraction lakes that today attract members of the local coarse fishing clubs. The path swings around in a horseshoe shape and joins again with the river path.

The Trent here is wide, with banks that miraculously appear to hold their own against winter floodings, at least those experienced in recent times. The surrounding fields along the south bank are used for arable farming but revert to grazing as the town of Newark meets the eye.

Water meadows threaded with dykes, and in particular the alder bordered Newark Dyke, revert to pony grazing on the north bank and attract flocks of lapwing, geese and smaller grazing groups of swans during the winter months, and 'wisps' of snipe at almost any time in the year.

Stands of reed and willow provide sanctuary for reed warblers, and grey and yellow wagtails. On more than one occasion, friends and I while sitting with sandwiches on the riverbank have glimpsed a kingfisher. Herons are a foregone conclusion.

As the river meanders towards the A46, short fields and boundary hedgerows remind one that all was not lost to the early ideas of 'prairie farming' as tracts of the arable land throughout some parts of the Trent Valley suggest. On passing under the A46, the path cuts across and between the gardens of private houses, part of the estate that separates the river from Farndon Road. Eventually the footpath bears right onto Dorner Avenue, then left and onto Farndon Road, with the Devon Bridge, the splendid marina and bustling, traffic-thronged Mill Gate providing a psychological gateway into Newark just ahead.

CHAPTER NINETEEN

A CHOICE OF DIRECTIONS

From Newark roads lead off abacus fashion to seemingly all points of the compass, linking towns, villages and hamlets as in the days of the coach-and-four.

To the south-east, villages and church towers preside between wide wold-like fields, well hedged and tended. Both arable and dairy farming continue to prosper, despite several national setbacks, not the least of which was the foot and mouth outbreak of the year 2000. For the occasional footpath explorer such as I, the routes, while winter-muddied, are never tiresome. For each parish nurtures its group of local historians, its boundary expert and pub alcove raconteur, all of whom add touches of parochial colour to the canvas of seasonal change.

Cutting down the A46, then turning left or east at the A6110 roundabout, brings one into Bingham, bypassed on the southerly edge by the A52 leading to Grantham and the A1.

It was to Bingham marketplace that I was taken by bus on that previously mentioned Boxing Day morning in wartime by my father. We journeyed there in order to be at the traditional meet of the South Notts Hunt, which assembled by the Butter Cross.

As I mingled with the horses and foxhounds, I was aware of the town having been built long before I was born, although I thought only as a shopping centre for the local farmers and farmworkers. I had no idea that people lived in and hunted around Bingham some 14-15,000 years ago. Artefacts, and flints in particular, have been identified with this period, which was surely the time of the Iron Age. Archaeologists have gained evidence of a village on and around Parsons Hill, along with further proof that the Romans were also established thereabouts, the

The Butter Cross enhances Bingham's town square.

site being on or close to the Carnarvon Primary School which was the town of Margidunum.

In all probability Bingham then became the settlement of Bynna, an Anglo-Saxon chieftain, or 'homestead of Bynna's people', but Adrian Room also points out in *The Penguin Dictionary of British Place Names* that 'bing' would also denote 'hollow'.

The meeting place of the Bingham District Court, or 'wapen take', is still in evidence, and in Crow Close, foundations of medieval cottages and a farm are now protected according to the Ancient Monuments Act.

After the Norman Conquest, Bingham had an overlord called Roger de Busli, according to the *Domesday Book* of 1086. In later years the leading village families were the Rempstones and Stapletons until the Stanhopes acquired the land, which remained in their possession from 1590 until 1871. The Stanhopes held the peerage titles of Earls of Chesterfield. By the eighteenth century, the earls of Carnarvon owned the land.

A guide taking a coup on a tour around Bingham will point out the oldest building, which is St Mary's church. The spire and stone tower give this place of worship the desired monumental effect and there are

gravestones bearing the marks of the true craftsmen. The oldest house dates to 1615.

There is no mistaking the Market Place; tree-lined, spacious and with a shopping precinct on the west side. A market charter was granted in 1314 to the Lady of the Manor, Alice de Byngham, although a market or trading centre may have existed before that day. There was in medieval times a guildhall and market cross. Today the Butter Cross enhances the town square. Here 200-300 years ago, the farmers' wives and daughters presented, on market days, the various cheeses and butter products made in the home farm dairies.

The splendid Butter Cross, where people meet, and around which they are occasionally photographed, was erected in 1861 to the memory of John Hassall, an agent employed by the estate of the earl of Carnarvon.

The majority of the buildings surrounding the square date from the seventeenth and early eighteenth centuries.

White Lodge is an imposing town house of the late Georgian period. It retains a fanlight over the door.

The Chesterfield Arms was built in Georgian times as a coaching inn and the Old Court House, used today by the administrators of the Bingham Town Council, was in 1852 built as a courthouse, prison block and police house combined.

The architect Sir George Gilbert Scott also established himself in Bingham by designing the Elizabethan-style Church House, which in 1845 was purposely built as a school. The same architect is known, particularly to railway enthusiasts, for his shaping of and designing the splendid St Pancras Station in London.

In comparatively recent times, Bingham market fell into decline, but was reopened by traders, enthusiasts and town council planners in 1975. Bingham has its sports fields, rugby union and cricket clubs, and most local sports hereabout thoughtfully involve youth teams. There is a leisure centre with swimming facilities, a gymnasium and multi-activity rooms. There is also a library and a health centre, all catering for a population of close on 8,000-9,000 people.

* * * *

Across the A52, in the green lush countryside just south of Bingham, nestle the still relatively unspoilt villages of Cropwell Butler, Tithby,

A friend, Denis Astle, spotted this unusual sign at Tithby crossroads.

Cropwell Bishop, Colston Bassett and Kinoulton, a land mass with histories worthy of a separate book and to my mind suitably adrift from our present-day towns and cities.

During wartime my father journeyed six mornings a week by catching two buses to the airfield at Langar. It was here or over the border into Leicestershire that he dreamed of buying the farm and on our Sunday walks tripped off the name of each village, possibly as the workday bus filled with airframe fitters like himself passed through them. Deep, lush countryside, and the fact that the Leicestershire border was definable to the south and south-east of these villages, meant little to my father. Nottinghamshire or Leicestershire countryside for those who never tire of seeing belts of woodland, grazing cattle and to whom no two fields are the same was worth mulling over, as was the prospect of perhaps one day settling there.

Whenever I travel the narrow road between Colston Bassett and Elton, he is in my mind long before I reach Langar, his hair white and blue eyes creased by a smile as he similarly lists Long Clawson, Hose and Harby, three villages in Leicestershire to which he was attracted and always on the lookout for that never to be had country cottage.

* * * *

201

On the sun-sparkling Good Friday of 1989, a friend and I caught the early bus out to Plungar, a village situated just over the Leicestershire border and close to the Grantham Canal, the towpath of which I had explored over many past summers.

Fortunately, the bus was a double-decker. We were its only passengers and sat on the front seat upstairs in the manner of schoolboys intent on being the first to see something of interest.

At Cropwell Butler, with the Hall conspicuous in the background, we remarked on the foreground paddocks holding the black and red strains of Highland cattle and beyond the hedgerow, stilting cock pheasants. In the roadside fields between Langar and Harby members of one or two farming families stood around a field corner section of lambing pens while over the next field, approaching the road and passing bus, loped a large dog fox flushed from the dividing hedge by the scents and disturbingly close voices. His coat burned sleek and deep red in the sunlight. His chest carried a white blaze. His legs, or 'stockings' as some hunt members call them, were black, and his white-tipped brush about the same length as his body.

Such were the contrasts in just a few miles. Walking the Grantham Canal towpath between Plungar and Barkstone, we were, strictly speaking, over the county border and in the scenic Vale of Belvoir.

As expected, we never encountered a soul until, each needing a pint of bitter, we called at The Peacock, a delightful hostelry in the village of Redmile. When we returned to the canal bridge it was to discover the two-hourly bus had left five minutes ahead of us. Undaunted, we continued along the towpath to Bottesford and passed Toston Hill. Here in the fields grazed twelve swans and an Australian black swan, obviously an escapee from a waterfowl collection. Immediately the swans sighted us, they were on the alert, and took off towards the Trent Valley, leaving the black swan on the field still grazing but wary.

Abandoning the canal at Bottesford Bridge, we discovered again that the two-hourly bus had left ten minutes previously. Still in good humour, we continued down the A52 towards Bingham, then realised that by cutting through the then unfamiliar village of Whatton we could possibly catch a train at Aslockton, where our luck changed. The train was due in ten minutes and I was home with the family by 2.00 p.m.

Being older and wiser, I now carefully check bus and train timetables beforehand, as do my friends, and a wad of timetables I have stowed into a side pocket of my rucksack.

The locally famous horseshoe pile at Scarrington.

Within walking distance of Bingham and Whatton, in what might be termed the backwater lanes, is the village of Scarrington.

The main thoroughfare winds between pleasant cottages and front gardens, neatly hedged and latch-gated. The bygone dovecote has been converted to garage premises and needs pointing out due to its location being, not surprisingly, beside the stockyard of a manorial farm.

On the grass verge to the left – if one is heading in the direction of Car Colston – stands before the old forge a pile of horseshoes. As a pile reaching to seventeen or so feet, the horseshoes are tightly packed, neat and preserved, and held in place by wire netting. If she sees one studying the horseshoes, a woman, beaming and informative, is likely to leave a nearby cottage and present one with an explanatory postcard. From this

one learns that the pile was built by Scarrington's blacksmith, George Flinders, and that the number of shoes positioned weekly from June 1945 until 31 March 1965 is estimated to be around 50,000. The postcard emphasises that the base circumference is nineteen feet six inches and that the pile is in no way supported by a post or column. Collectively the horseshoes are estimated to weigh in the region of ten tons.

To my mind the work commemorates the skills of all blacksmiths, those many past and comparatively few of present times. A boy who decided upon leaving school to become a blacksmith was destined to serve a four-year apprenticeship in George Flinders' time. The horseshoe pile is now owned by the Bingham Rural District Council.

Scarrington covers an area of less than 1,000 acres, about twice the size of Nottingham's Wollaton Park.

The population according to the Census of 1801 stood at 152 souls. The 2001 Census showed little change, there being fifty-six populated homes housing 150 residents.

Aslockton railway station is situated a mile or so away and the entwining lanes, extending for just over two miles, connect the daily traveller with the A46 Fosse Way.

For those interested in listed buildings, there is the eighteenth-century smithy by the pinfold. As the information boards indicate, the three-storey Old Hall is built like the surrounding houses of red brick and the fourteenth-century church of St John of Beverley. The village also maintains a small Methodist Chapel with quite a prominent porch.

Car Colston, the next village and slightly northwards, is comparatively widespread. Not surprisingly, its centre points are the Old Hall and the two village greens, where local hunts have met many times in the past and cricket was enjoyed by seemingly every villager's father and grandfather.

There are some splendid Queen Anne-style houses to be seen, although I shouldn't overlook the basic history of this one time ancient settlement.

Some 40,000 years ago there was a Bronze Age settlement, relics of which were unearthed in 1890. Then the Romans, who built the nearby Fosse Way and were involved with the fortress of Margidunum, which was in turn a stage post for the Fosse way building teams, moved in. On this site Roman lead coffins, or the remains of such, were excavated. Further excavations, staged in 1968, laid bare the foundations of a Roman villa close to the Royal Oak Inn.

Car Colston, like Scarrington, has always remained an agricultural village, as was probably pointed out by Dr Robert Thoroton, who published *Antiquities of Nottinghamshire* in 1677. A local man, who wished only to be described as wearing 'a ratting cap and having terriers at his feet', pointed out that Dr Thoroton's house in all probability existed on, or close to, the site of Old Hall Farm built around 1837-38. The most ducal figure who resided there was a captain in the 6th Dragoons. Entered in the Census of 1901, his name was James Jeffcock, married with two children. The domestic affairs of the hall were at that time attended to by six servants.

Before leaving Car Colston, my friend, by then wearing glasses beneath his ratting cap, showed me the whipping post situated by a footpath connecting the two halves of the village. He also pointed out that the telephone kiosk was still in use, intact, and that the Wesleyan Chapel alongside it had been converted into a private homestead.

In such villages, not just edging onto the Vale of Belvoir but throughout Nottinghamshire, people were employed as maids, servants, grooms, ostlers, cowmen, shepherds, horse carers or dray men, cart carriers, carpenters, joiners, bricklayers, blacksmiths, gamekeepers, hedgers and ditchers, market gardeners and cattle, sheep and pig dealers. Many of the latter occupations were listed under the headings of 'contract workers' or the 'self-employed'.

My rustic informant also mentioned two further Car Colston historians who moved there in 1743. They were the Blagg family: one Thomas Matthew and his son Robert Colston. Once settled in, they wrote prolifically about incidents in and around the village.

Before departing, he also pointed to a group of cottages across the large green and told me that they were built by outsiders – 'squatters' – whose rights were deemed legal because they remained for years unchallenged and no one stepped forward to collect rents or related monies from the properties. Finally, he pointed out the sign in St Mary's churchyard:

Sheep Grazing in The Churchyard.
Please Close and Fasten Gates
AT ALL TIMES.

* * * *

The foregoing, then, are villages of this south-east corner and the eastern boundaries of Nottinghamshire. To list and visit each one would convert this intended autobiographical ramble into a gazetteer, several of which can be found in the libraries and bookshops of most of the county towns and city suburbs.

Leaving Car Colston, but still with exploration in mind, we will move in the easterly direction for just one further chapter at least.

ASLOCKTON
AND WHATTON

Spelt 'Aslocketune' in the *Domesday Book*, the village today is beginning to bear the suburban look, except that the many old and colourful buildings retain that sturdiness of character and individuality that is typical of a relatively unthatched Midlands village. From the corner of Abbey Lane, by the Old Greyhound pub, the styles and heights of the cottages interpret change and in some cases bygone renovation; all look well-tended and secure.

There are buildings in red brick with pantiled roofs, different chimneys and window designs alongside tall white or cream dwellings with greyish-looking roof tiles, which I expect have a name, but one that I have still to learn.

Over a pint of bitter in The Cranmer Arms, a man who claimed to be in the farm shop business told me that Aslockton was once indeed a village where thatched roofs were to be seen from every direction. He had been told that the walls of these cottages were seven or eight inches thick but made, he insisted, of mud.

Most families kept poultry and pigs thereabouts when he was a boy, and he was sent out along Main Street with a bucket and dustpan (every day he wasn't at school) to collect horse manure for the garden plots. 'It was a case of whose kid could get to the horse manure first and believe it or not I've known families in this and other villages that have fallen out over their considered rights to a bucket of horse manure.'

It was a village of tradesmen, there being no work readily available except on the farms and the railway unless you managed to get a lengthman or reed cutter's job along the Grantham Canal. 'And to do that you needed a bike, which surprisingly all of us didn't have,' my bar side raconteur continued.

A corner cottage, Aslockton.

Without the railway – the Nottingham-Grantham line which was opened in 1850 – the bygone residents of Aslockton would have had the feeling of being cut off because the town with any form of social substance and varied communities was Bingham, which according to the signpost I bypassed as I came in from Whatton was, I believe, four miles away.

Taking the man's advice while thanking him as I left the pub, I walked the pavement of the relatively deserted Main Street and saw the sign 'GOOD STABLING' painted on the wall of a brick building, which was once obviously stables but has perhaps since been converted into a barn.

I also saw the tall, black-painted doors to a barn fronting Main Street that were well above average height, thus allowing hay carts to enter directly from the pavement frontage.

Most of the new properties have been developed to the west side of Main Street and while noting this I was stopped by a man I took to be a retired farm labourer and he, too, was keen to talk.

'Oh we get by; we get by. I always used to say to the missus, "If yer can't get by in Aslockton, yer can't get by anywhere." I mean there's always been food aplenty. Straight off the land. None of that pre-packed

supermarket stuff. And it's nice to have the trains come through, yer know; real nice. Yer can get to Nottingham or Grantham of a Saturday if yer want a change. Aye, it's all right livin' 'ere. I've always thought so, anyway.'

Still on the subject of railways, the man told me that at 8.30 every Sunday evening, quite a crowd gathered at the station to see off the last train to Nottingham. Whether this was in the man's time or that of his father I missed noting but imagined the scene as I continued along Main Street nevertheless.

<p style="text-align:center">* * * *</p>

The suggestion of how the original place name occurred embraced the name Aslaker, whose farmstead the village may have sprung from. The name, whether it be the foregoing or Aslocketune or Aslecker, is known to be Scandinavian.

As archaeological digs relatively close by have shown, both people of the Bronze Age and Roman British were established here.

In medieval times there appears to have been a significant family in residence from which the Cranmers of Aslockton may have originated, although of that I believe there is still much to be researched if such records are, or were, in existence.

The Cranmers' son, of future prominence, was born in 1489. He became an English clergyman, indeed the Archbishop of Canterbury in 1533. He had already made the bold suggestion that the marriage between Henry VIII and Catherine of Aragon be put before the European universities as opposed to the Pope. By 1533 he had declared the marriage officially over. In 1536 he repeated the process between Henry and Anne Boleyn and in 1540 annulled the marriage between Henry and Anne of Cleves.

Thomas Cranmer was a Protestant convert who, under Edward VI, was partially responsible for shaping the doctrines of the Church of England.

In 1549 and 1552, the issue of prayer books was deemed his responsibility and he made no bones of the fact that he supported the swiftly curtained succession of Lady Jane Grey in 1553.

In 1555/56 he recanted before the Catholic Mary I but was condemned and branded a heretic. When he discovered that he was to die, Cranmer reverted to his former position.

In 1556, having been escorted to the stake, he held out to the fire the hand with which he had signed the recantation before he himself faced the flames. Cranmer's Mound, where it was said he sat meditating and looking out onto the countryside while on Sundays listening to the Whatton church bells, is now well-featured in the village with a local authority notice interpreting the bygone archbishop's association with it.

* * * *

Seven years or so ago, I explored the reaches of the Smite between Aslockton and the sequestered village of Orston. I had with me several friends and it was agreed that we set off just over the Aslockton railway crossing.

From there we swung right by the farm shop and crossed arable farmland, as the footpath marker indicated. Eventually the path curved north-east and the Smite was on our right. Here the alders were prolific; the type of habitat to attract kingfishers to breed.

The month was early September. Consequently, the elderberries had ripened or were close to ripening.

As we crossed the fields, flocks of starling flew in and grabbed the berries from the branches, while hovering, fluttering, and remaining on the wing, whereas the few blackbirds and song thrushes we disturbed perched in the lop branches and plucked then swallowed one berry at a time.

Eventually we topped a stile and found ourselves in a village that we took to be Orston.

One of our number suggested that we rest on a bench in the church porch. And so began our round-the-porch conversation, which developed and became a gentle and political discussion. Those restless, like myself, suggested that we move on while thinking it better left as a discussion than it develop into an argument.

From Orston we followed the footpath across several fields, then descended sharply into a farmstead. The footpath cuts directly between the stables and stockyard. While I glimpsed the variations in tiles, brickwork and such, interests ceased when my friends and I were faced with a sizeable notice explaining that caution should be exercised if we were confronted by the farm dog. Fortunately, the dog failed to materialise.

'Border collie, or collie and German Shepherd cross,' I suggested, out in the fields with the livestock or riding with the farmer in his tractor? But not a single member of the group elected to stay behind to discover if I was right, myself included.

Where the steep railway embankment came into view, two long reedy ponds or small channelled lakes proved reason for comparing the bird and small mammal tracks in the mud before we returned to the path and passed through the embankment tunnel.

A third stretch of water enhanced a stubble field here and eventually we topped another stile and followed the lane between the hedgerows into Whatton and over the Smite bridge, which, before that time, I had earmarked as my kingfisher-watching point. Turning right onto the main road, we walked for a further three minutes to Aslockton station then trooped into the low-beamed comfort of The Cranmer Arms.

* * * *

The River Smite joins the Devon, which is a true nature reserve in that it burrows through and across miles of private farmland before entering the Trent at Newark.

The Smite, a field-drain watercourse by my reckoning, cuts attractively through Whatton but has, during wet seasons, caused flooding problems to the extent of the Water Board and Environment Agency staff attending meetings held in the village hall with local residents in a determined bid to put matters to rights. For me, as previously stated, the bridge across from Dark Lane served as a birdwatching opportunity; a superb vantage point.

Pied and yellow wagtails can be seen in the summer, grey wagtails in the winter. And because the overhanging willows and alders provide satisfactory perches, kingfisher are to be glimpsed frequently and probably nest in holes made in the relatively steep bankings either side. Several of my longest kingfisher sightings have occurred when on, bright, sunlit mornings, I have lingered at this bridge.

The adult kingfishers perch on the lower branches and peer into the water, looking for shoals of small fish like minnows and sticklebacks before making that colourful and swift dive to secure one.

I was explaining to someone one morning that they might see a kingfisher here when, giving out its singular piercing whistle, a kingfisher

flew downstream, lifted above the bridge the two of us were standing on. My colleague was amazed and asked, 'Can yer walk on water?' As kingfishers are non-migratory, it is also possible to see them here in the winter. But quite often a sighting entails a wait since long stretches of the river are explored. But to see just one is surely to see the jewel of the morning.

* * * *

The name 'Whatton' may well denote 'wheat town' or 'wheat place'. To a newcomer, as I have been in recent years, the Norman-built church – St John's – stands out against a setting of water meadows and the remains of a watercourse that could well have been the Smite.

Strolling the footpath and overseen by varied breeds of cattle, the stonework of St John's looks splendid in the low evening summer light, and quite often I find myself resisting the temptation to stay well into the deep dusk and watch the pair of barn owls that I instinctively know must hunt here.

This is the church used by the Cranmer family, particularly Thomas before he left to study at Cambridge. It was restored under the directional eye of Thomas Butler, the rector of Langar, in 1860-70. The beautifully crafted stained glass windows, some I'm told of William Morris design, were added in the latter part of that century. The Halls were, also in the eighteenth century, the prominent family of Whatton, their original trade being that of butcher with a well-established reputation in the City of Nottingham.

Eventually, and in keeping with the times, the family invested in various aspects of the hosiery business and then went on to become property developers. Around 1828-29 Thomas bought a tract of land at Whatton from the estate of the earl of Chesterfield and the family moved there accordingly. Thomas decided upon a plot just beyond the main village and had a sizeable Victorian mansion built. He financed the building (or rebuilding) of the chancel in the church, and also had the village school rebuilt.

Today many of the estate houses thereabouts are white-painted and stuccoed. It is 'roses around the door' country and there still appears to be an orchard or two maintained behind high walls or modern and subsequently adequate fencing.

Whatton's Norman-built church is pleasantly surrounded by water meadows.

One lady – 'No, I'd rather not give you my name, if you don't mind' – recalls the days when the Second World War broke out.

The village shops sold everything in those days. If one shop didn't sell it, the other did. We hardly ever had to go to Nottingham, except for clothes of course, and we enjoyed shopping for those anyway. Mind you, we didn't have much time for wandering around cities like people seem to do today. But I'm not grumbling. Not a bit. Over there in that gateway and other gateways along the village roads and streets, the dairymen used to stand their milk churns. There was a low table and a ladle at the side and you just took your jug and measured your milk, then put the coins – the coppers – into a saucer. And we youngsters, we thought we'd be doing that all our lives, you know ... And I remember the old ice-cream man, Edgar I think his name was. He used to come

213

Village residents can well recall seeing milk churns stacked at farm gates, whereas today, most churns are displayed in cafés and farm shops.

cycling along ringing his bell and his bike had a STOP ME AND BUY ONE sign on the side.

We used to buy blocks of ice off him, too, then stand our milk jugs in a bowl full of ice cold melted water in summer.

We had some smashing trips from Aslockton station to Skegness on the train. And in the harvest we girls used to go out 'gleanings'. That's taking a rake onto the harvest fields when they were all stubble and before they were ploughed, and we'd spend hours racking up ears of corn and corn seeds, then shovelling them into a sack to feed to the hens. We had to work at it, mind you, but I'd have a bottle of lemonade or dandelion and burdock wrapped in the sack or tucked into my apron pocket.

There were hens everywhere in the villages in those days. And after the harvest, and with them being fed on the gleanings, my goodness there were lots of eggs!

On Friday nights there'd be a film show in the church hall. It was usually full of lads because they showed a lot of cowboy films. Sixpence I think we had to pay for two hours.

A little fair would come after the harvest and stay for a week and every Saturday night there was a dance at the Jubilee Hall. I met my husband there. He didn't think I wanted to go out with him at first because I didn't go to the cricket club dos like he did. But we got together in the end. And I *still* didn't go to the cricket club dos.

I used to have to stay in on Thursday nights anyway and look after my younger brother while my parents went to the whist drive.

The nearest grammar school that we knew of was at West Bridgford. Those who went had to catch the train. I can just about remember the gaslights and some nights we walked over the footpaths to the church, particularly at Christmas.

If the cattle were out, which they weren't always thank goodness, they used to follow us and I can tell you it was really frightening in the dark. Our dad used to say that the cows, if they were out, could hear the hymns and carols being sung and they used to stand listening to the organ music.

* * *

Only in recent years have I become acquainted with Whatton, due to a friend having moved there from Long Eaton.

Usually several friends, my eldest son, and I, spend the half of Christmas Day at his bungalow after having explored the birch woods and lakes at Swansholme and Hartsholme near Lincoln.

Understandably, on arriving at Whatton we are pretty well famished and looking forward to the main meal of that festive day.

The bungalow kitchen looks out onto the road and it was from the sink while discussing the meal that on my last visit I noticed a flock of redwing pass over and settle in the winter-etched branches of the trees opposite. They were followed by a sizeable flock of fieldfare, recognisable in silhouette due to their habit of all perching while facing the same direction. At the end of the road was the village sports ground where, no doubt, these two species of migratory thrushes would probe in the waning light before settling to roost in a box or yew hedgerow.

Besides the expected garden birds, male tawny owls flute within earshot of my friend's home on frosted nights and while putting the car in the garage on the occasional moonlit night in winter, he has heard the wing beats of swans flying from the direction of Grantham Canal or

Rutland Water. They may also fly from the Welland Valley, from where I have long suspected that swans extend their flight line to the quiet feeding grounds of the upper Trent and the lakes of the Nottinghamshire Dukeries.

It is usually after midnight when we leave Whatton and there is surprisingly little to be seen on the roads except a pebbledashing or two of car headlights. When we reached Gamston and the Lings Bar Road around 12.45 a.m., in 2005, my son, at the wheel, enthused at the sighting of two barn owls gliding by the A52 gravel extraction water. Our friend Tony and I caught sight of one as it followed the hedge-line. A memorable sighting with which to end Christmas Day.

CHAPTER TWENTY-ONE

THE INNER CORE COUNTRY

Situated to the north-east and south-east of Mansfield lies the wide and variable land tract I think of as being the inner core of Nottinghamshire, the countryside surrounding the villages of Blidworth, Rainworth and Old Clipstone.

Like most of Nottinghamshire north of the Trent, this countryside consists of arable and dairy farms, belts of long-preserved deciduous woodland and tracts of landscape darkening Forestry Commission pine.

This is ancient land, divided into many enclosures of ownership as the name 'worth' in Blidworth and Rainworth denotes.

There was a Roman camp situated at Blidworth. If not fully excavated by local gentleman landowner Major Rooke in 1789, then it was at least assessed and described by him. Blidworth as we know it today was spelt 'Blitheworth' in the reign of King John, who had a hunting palace built at Old Clipstone a few miles to the north.

For the archaeologist and historian this is exciting country – both from the excavation and research point of views. Robert Thoroton, in his works *Antiquities of Nottinghamshire*, extensively researched this area in respect of land and family ownership. Norman kings, barons and all such people who inspired the novelist Sir Walter Scott have hunted, conferred and laid down the laws of forest and vert hereabout. Local historians, from the Norman Conquest through to the twentieth century, recorded much of what happened here from the appointments of parish clerks to the farmers who, during the Napoleonic Wars, drilled their labourers from 9.00 until 10.00 a.m. each day on the forecourt of The Bull Inn.

One local historian I met, my diary explains, on a Sunday morning in May 1974, when with friends I travelled by car to meet the now-late Wilf

217

Wild, a genial raconteur who had compiled and self-published a book titled *A Brief Recorded History of Blidworth – Including Newstead and Clipstone*.

So far as I am concerned, the title word 'brief' was a misnomer because the 100 or so pages were crammed with 'Forest Folk' type information, extracted from parish records, land sales, country fairs, ploughing events, and brief but colourful incidents. The book was illustrated with early photographs, maps, an occasional drawing, translations of countryside terms such as 'bovate', 'conery', and 'chiminage', and tables.

It was produced, the author admitted, as a labour of love. Having spent a morning in the company of Wilf Wild, suntanned and silver haired, I was soon of the opinion that the labour was borne out of a deep love of the land, particularly the hollow in the silver birch woodlands where his home was situated and which has for long been given the romantic name of Fountaindale.

Out in this, the 'inner core country,' the birch woodlands were legion and pleasing to the eye. Turning left at a Blidworth sign, we drove between high hedges, a winding route with several small quarries either side. While checking crossroads we almost missed the turn and the drive leading to our destination, Cave Wood Lodge.

Here in a house surrounded by twenty-seven acres of land lived Wilf Wild, with his wife and their German Shepherd, 'Tick'. This was an outcrop valley comprising of birch woodlands, young pines, bracken and rough pasture. We bypassed a ruined cottage, perhaps a bygone gamekeeper's dwelling, and I noticed in the grasses the broad trails or 'trods' of badgers and the comparatively slender trails, or 'foils', travelled by fallow deer.

Wilf Wild, his wife, and son, welcomed us to the bungalow with Tick sprinting through the trees to investigate accordingly. Wilf had soon ushered us inside, where over coffee he showed us his library comprising mostly of local history volumes and an enviable collection of Thoroton Society publications.

Connected closely to Cave Wood Lodge were the works of naturalist and field sportsman Joseph Whitaker (1850-1932), who lived at Rainworth Lodge 'across the lakes at the back'. Two of the books were related to the immediate locality, *Scribblings of a Hedgerow Naturalist* and *The Jottings of a Naturalist*. Joseph Whitaker was the owner of a sizeable lake shaped like the letter 'L' and therefore known to the locals

as 'L Lake', or formally as Rainworth Water. This was fed by the little forest river the Rain, according to Wilf, and the chain of smaller ensuing lakes, one of which bounded his property, were used as feeders or part of the irrigation system which allowed for sluices to be opened so that the water flooded out onto the surrounding meadows and paddocks, and provided lush grass and grazing for the livestock.

How far this form of irrigation system dated back no historian could say exactly, but why the name Cave Wood Lodge? I asked. With the coffee finished, Wilf led my son and I outside and down to the lake, situated 100 yards or so from the bungalow. He pointed out his neighbour's land to the north-west and told us that where the lakes ended at Cave Pond there was a cave in the sandstone that was given the name 'Robin Hood's Cave'. The outlaw and his band are said to have collected water here.

As for present times, Wilf doubted that the cave still existed or was as prominently featured as in the days when Joseph Whitaker explored it.

As we stood, my son and I logged the birds singing from the glades on that memorable morning. Birds not specifically to do with Cave Wood Lodge but the surrounding and extensive habitats – cock chaffinches, yellow hammers, chiff chaffs and willow warblers – were in full song. A male greater spotted woodpecker flew to and from the bird table, while from the inner thickets we heard the sonorous yet soothing cooings of turtle doves. A moorhen stilted from the lake margins and up to the bungalow door, where it was fed grain by Mrs Wild. Moorhens bred in the deep aquatic wilderness.

My son and I flushed two snipe from the lake margins and attempted counting the ducklings being escorted by two totally wild mallard ducks which ferried the youngsters swiftly to the reeds.

Wilf's son had three brown trout in a landing net and was guiding the small boat out with the hope of catching more.

Fascinated with the tree belts and chains of water now secured within the ancient land tracts of Fountaindale, I asked if Joseph Whitaker was a son of the landed gentry, as his bearded, Victorian, shotgun-carrying image implied.

He was born on 14 August 1850 to Mary Long Whitaker of Ramsdale Farm Arnold. Whitaker junior was aware of livestock, ornamental poultry, wildfowl, cattle and sheep breeds from an early age. Like all of his generation, horses and dogs were second to humans. One can also assume that when he was of age he accompanied his father on game

An outlet of the River
Rain leaves Rainworth
Water, once owned by
Joseph Whittaker.

– and pest – shooting forays across the 700 acres at Ramsdale. He was
formally educated at Uppingham.

At the age of twenty-two, Joseph married Mary Booth Eddison, the
third daughter of the family who resided in The Park, Nottingham.

Joseph's father died in 1874 and Ramsdale Farm was sold and
included in the estate of local landowner Colonel Seeley a year later. In
that year of 1875, Mary gave birth to a son, Joseph Randall Whitaker.
Joseph Whitaker senior, whom I shall be describing from hereon, was
by this time vice-president of the Selbourne Society and a fellow of the
Zoological Society. He was also residing at Rainworth Lodge surrounded
by parklands covering some eighty-six acres.

In November 1874, he had a window installed adjacent to the south
aisle in Blidworth church, commemorating the memory of his daughter

Ethel Mary, who died as an infant in the February of that year, and his father.

Whitaker's wife died in 1900. His daughter Vera married Harold Bowden, founder of the Raleigh Cycle Co. Ltd, in 1908. They resided at Beeston Fields; therefore it would not be unreasonable to suggest that Whitaker wrote to the Lord Middleton of that time and was probably shown around the walled deer park.

That an occasional black fallow deer is born to the herd of normally common coloured and menil fallow deer at Wollaton may have something to do with Joseph Whitaker introducing a black fallow from Lord Savile's herd at Rufford to Wollaton.

There was not a 'Herd Book' kept at Wollaton, so far as I am aware, but Whitaker was certainly in touch with the Middleton family and all the owners of Nottinghamshire's deer parks.

To his delight, Whitaker discovered that fallow deer, and later sika, fared well in the deer park situated adjacent to his home, Rainworth Lodge. At the homes of a naturalist friend and also Wilf Wild, I was shown Whitaker's books, all of which are locally established book collector's items in present times.

Joseph Whitaker was by then still a horse racing enthusiast, a patient angler and keen rifle or shotgun sportsman. In addition, he also became a justice of the peace, churchwarden at Blidworth church and a member of the Notts County Cricket Club which he joined in 1867. Most of the trophy heads and animals he shot in and around his Nottinghamshire home and the Sherwood Forest country he had set up for display at Rainworth Lodge by taxidermists, several of whom were self-employed and advertising from premises in the centre of Nottingham.

Both in his book and at Cave Wood Lodge, Wilf Wild emphasised Whitaker's obsession with shooting albinos.

Whitaker shot, or acquired cabinet cases, containing two albino hedgehogs, a white fox, which may not have been an albino, and a white otter, which most probably was.

Eager to see these specimens, which I heard were bequeathed on Whitaker's death to Mansfield Museum, I made a visit soon after meeting Wilf Wild, but the curator at that time claimed to know nothing of them.

Also on display was the cabinet skin remains and a small but impressive diorama featuring the locally famed Egyptian Nightjar, which

Wilf Wild was shown in 1970. I was delighted to be viewing it, still in good condition, some twenty-five years later.

I was not aware of the Egyptian Nightjar until Austin Dobbs, the 1970s recorder of the Trent Valley Birdwatchers, sent me a postcard asking if I knew whether the memorial stone Joseph Whitaker had erected in Thieves Wood was still intact.

Curious as always, I ventured out that way but drew a blank. The Bessie Sheppard stone was intact but throughout Thieves Wood I located no such memorial relating to an Egyptian Nightjar.

When I told Wilf Wild this, he smiled and motioned again for me to follow him.

The stone, he told me, had long been destroyed by vandals but he, too, went to Thieves Wood and collected every broken piece of it but the bottom right-hand corner.

On a bench in his woodshed Wilf showed me the stone, stained with green mosses from the woodland floor. That he had searched diligently in Thieves Wood was evident. The inscription on the stone read thus:

<div align="center">

THIS

STONE WAS PLACED HERE

BY

J. WHITAKER

OF RAINWORTH LODGE

TO MARK THE SPOT WHERE

THE FIRST BRITISH SPECIMEN

OF THE

EGYPTIAN NIGHTJAR

WAS SHOT BY A. SPINKS

GAMEKEEPER ON JUNE 23

1883. THIS IS ONLY THE SECOND

OCCURRENCE OF THIS BIRD IN

EUROPE.

</div>

Albert Spinks the gamekeeper lived in a cottage situated in Harlow Wood. Joseph Whitaker obviously located the man, who probably mistook the nightjar for an owl or woodcock, and perhaps paid the gamekeeper handsomely for it because the nightjar, or its remains, came into Whitaker's possession and was, like much else, set up for display by a taxidermist.

In his books Joseph Whitaker logged some unusual, and therefore interesting, wildlife occurrences. I recall a photograph taken by him of three mute swans and a collection bird – a black swan – on Rainworth Water, and several of his sika deer being fed from the hand.

Had I been born in Whitaker's time, I would have corresponded and probably spent some time out in the deer park and surrounding woods with this intriguing man.

Some considerable time after meeting Wilf Wild, I walked the complete L-shaped banks of Rainworth Water with my equally explorative companion Peter Dawson and came to Rainworth Lodge, situated beside the main road. <u>This is now, I stress, a private residence.</u>

We did, however, cross the road to the old iron gateway beyond which stretched Whitaker's long abandoned deer park. In his book *The Deer Parks and Paddocks of England 1892* he describes his own grounds as:

Acreage, 22 acres. Fence: part oak, larch rails, part iron.
Water supply, artificial. Number of fallow deer 21.
Average weight of bucks 110 lbs.
Ten four horned St. Kilda sheep, two Rheas and three emus range with the deer.
Soil sandy, undulating and well sheltered with belts of fir plantation.
Faces north and the deer to very well.

Rainworth Lodge Wilf Wild fittingly included in his self-published book *A Brief Recorded History of Blidworth*.

It is thought to have been built on the site of a forester's cottage dating back to the time when the king or overlord employed a 'border,' or bond man, who was supplied with a dwelling and food in return for services, which included the rearing and overseeing of the forest's game, particularly deer. I have read elsewhere, and in recent times, that a small monastery was thought to have been established there. Whichever is the case, there is no actual proof as to the exact identity. But the fact remains that some form of dwelling existed on the site before Rainworth Lodge was built.

The lodge, which was formerly described as 'a cottage', was enlarged in 1903. Joseph Whitaker emphasised in a letter that the ivy had proliferated 'at the New End of the house'. He then stated that the ivy would keep the place cool in the summer and the new wall dry and warm in the winter.

The replacement memorial was known as 'The Bird Stone'.

On the morning of Friday 27 May 1932, Joseph Whitaker died. He was aged eighty-two. After his cremation, his ashes were scattered throughout the grounds of his beloved Rainworth Lodge, and fittingly so.

* * * *

Intrigued by Wilf Wild's account of King John's hunting palace and its remains at Old Clipstone, I first ventured to the field's edge on a Sunday afternoon in the 1970s as a passenger in the car driven by my late friend Eric Spafford.

Surrounded by an agricultural crop, the ruin holds at least five tower-type abutments, and walls that at a distance appear quite impenetrable.

Again I have heard that there was a dwelling at the site before King John arrived and ordered the building of the hunting lodge. This is likely because the Saxon lords Ulsi and Osbern were in manorial residence, having one manor each, when King John was earl of Mortain.

The monarch is said to have first visited Clipstone on 19 March 1200. From the hunting lodge he and his advisors signed and confirmed land grants made to tenants in the King's sealed charter to Nottingham.

A truly historic site. A section of King John's hunting palace.

Disregarding the Saxons Ulsi and Osbern, William the Conqueror awarded their lands directly to one Roger de Busli. By 1205, the men appointed as foresters for the region were Richard de Lexington and Ivan de Fontibus.

Between then and 19 October 1216, when King John died at Newark Castle, there would have been colourful retinues of men, most appointed as officials, others being huntsmen, leaving and returning to the site in the quiet roadside fields of modern times.

* * * *

Another tract of land associated with King John and the manorial divisions formed after the conquest was The manor of Haywood Oaks. *Wright's Directory* of 1883 states that the land tract was owned then by Lieutenant Colonel Seeley MP. To my delight there was a reference to the oak trees, which according to the directory were planted shortly after the conquest.

When I journeyed out that way along the A614, I was always aware of a farmstead in the fields to the left as I bypassed Haywood Oaks Lane.

There was a gaggle of geese in the field and I wondered how far away was the fox laying up in the surrounding tracts of birch woodland that visited while scenting out the poultry trails after dark.

In recent years I have explored the walk paths and plantations either side of the lane, expecting to see a spinney of oaks – the Haywood Oaks to my mind – providing the centrepiece to a field. I have in my mind gone so far as to see and photograph these oaks swathed in autumn mist, except that so far as is known there is no such field and no such oaks. Thus the oaks to which I think the historians referred are those planted in two or three lines on either side of the lane. Some of the originals are still standing, some not. Some are wide-spreading and still fruiting, some not. The name Haywood Oaks, however, denotes the location of a manorial estate, as I have previously mentioned. Within this estate are, or have been, tenant farms and twenty-odd acres of allotments.

The original owner of the manor was Sir Richard de Bingham who was awarded the land tract by the son of William the Conqueror, if not the warlord himself. It was held by the de Binghams for several generations.

The word 'hay' or 'haye' denoted in those times an enclosure, within which deer were quite often kept as an alternative to hunting them throughout the surrounding forest.

In the reign of King John, the annual 'Wapenstake' or 'Weapontouch,' was held at Haywood Oaks and it is thought that the king himself attended. At such events the knights had to prove themselves as worthy of protecting the Royal household and the swordsmen and archers had similarly to prove their worth, especially if they were paid an annual income from the Royal purse.

Tournaments were staged and the meet held in 1212 was described as 'a great meet', which suggests that King John was indeed present.

Today the recreational paths through the birch woods on either side make for a pleasant hour or so's walking. But would any knight or valet from the year 1212 recognise this tract of ancient and colourful forest country if, like Clint Eastwood's character in *Pale Rider*, he was spiritually transported back? I doubt it.

CHAPTER TWENTY-TWO

DUKE'S WOOD AND INKERSALL MANOR

Duke's Wood remained unknown to me until the mid-1970s, when I first viewed it from the seat of a coach travelling to Nottingham following a tour of the Dukeries.

We were coasting one of the several narrow lanes that link Eakring with Kirklington or Bilsthorpe and from one angle the rounded periphery of the wood suggested 'a hanging wood' that, due to land contours, gave the impression of being on a slope or tilt, but only a temporary impression. I glimpsed nearby a cottage with neatly tended lawns and told the children that in all probability the people who lived there fed the obligatory foxes and badgers by floodlighting.

This was confirmed when I next met Jim Bark, the Forestry Commission warrener, at his Deerdale home. Moreover, one late April dusk he drove my son and I out to Duke's Wood, where we settled in to watch the territorial flights of the male woodcock, several of which were patrolling bat-like above the thickets and rides. This form of territorial display is known as 'roding' and takes place at dawn and dusk during the breeding season.

We had earlier visited George Turton who was gardening at his cottage on the edge of Sansom Wood. As we conversed, George, one hand resting on his spade handle, glanced suddenly at his watch and said, 'There'll be three woodcock over in a minute.' Nor had we long to wait before these intriguing and comparatively large wading birds passed overhead, three males most likely, beating the bounds of their respective breeding territories.

On a ride in Duke's Wood, I next watched with Jim and my son, and while the sun still slanted low through the thickets, a woodcock male

Corner section of Eakring village

sweeping so low that not only did we reacquaint ourselves with the deep russet plumage and darkly barred underparts, but also the liquid eye set high on the head and the long bill evolved to probe the ditch side and leaf litter of the woodland floor. When the woodcock swept low and within eight feet of us the second time, it gave out its 'wisick, wisick' whistle-type call, and we assumed that the hen bird was close by incubating a clutch of eggs.

Thanks to Jim we had seen our first woodcock's nest that year in Wellow Park, near Rufford. Laid in a ground scrape nest, the four eggs were arranged pointed ends inwards, greyish-white in colour but blotched with ash grey and splashes of chestnut.

Whenever I hear mention of Duke's Wood today, I remember that closely roding woodcock and with good reason.

Besides the usual woodland birds and the three British species of woodpecker, Duke's Wood in those times also hosted four or five pairs of summering nightingale, the cock birds of which we heard competing with slowly rising and memorable crescendos of song shortly after the several woodcock had ceased their 'roding' flights.

* * * *

228

Duke's Wood once belonged to the Duke of Kingston, who, so far as I have researched, resided at Thoresby. Since before the Second World War this twenty-acre nature reserve of modern times has provided a rich source of much-needed oil with which the Germans couldn't tamper. Nor could they attempt sabotage by bombing because the small oilfield was among the few listed as 'Britian's Best Kept Secrets'.

Today a portacabin serves as the Oilfield Museum from which such information can be found. The oil from Eakring was of a quality best suited to such aircraft as the Hurricanes and Spitfires.

The oil was surrounded by a casing of millstone grit and once it was discovered, buses daily transported some 1,200 or so employees from the towns of Manfield and Newark, and perhaps picked up at the villages in between. The relatively quiet village of Eakring had never before seen the like.

There were many skilled personnel involved: geophysicists, geologists, drillers, tool fitters, riggers and derrick workers who, to some extent, were advised and trained by the professionals.

Huge oil-collecting tanks were installed in Duke's Wood and the oil was tested for water content and selected for quality. Watered oil needed to go through a separating process to refine it.

The oil from Eakring was used in the Second World War for aircraft such as Hurricanes and Spitfires.

Statue to remind us that forty-three oil workers from Texas and Oklahoma worked on the Dukes Wood oilfield.

The main refinery was situated 250 miles away at Pumpherston, near Edinburgh. Consequently, a colliery railway line was extended from there to the nearby Bilsthorpe sidings in Nottinghamshire.

The twenty or so tankers filled with crude oil were painted dark grey or black, as was much else in wartime, and the operations from stage tanks to the Edinburgh refinery continued day and night. Miraculously there were no bombing raids.

Eventually, faster drilling equipment was needed and negotiations proved that only the Americans could provide it. The company selected, however, would not part with the equipment unless a team of experienced operators from the company accompanied, installed and operated it.

Thus forty-three Okalahoma and Texas oil workers or 'roughnecks' appeared in Nottinghamshire and remained for a year. They wore

230

Stetsons, leather boots and spoke 'with a John Wayne-type drawl', so my late friend Eric Spafford remembered.

Eric also remembered the Italian prisoners of war working on this small but all-important oilfield which in War Department parlance was termed 'a secret operation'.

All such information can be gleaned from the museum, which is run by a curator and a band of volunteers with experience in the oil industry.

Duke's Wood, I should add, is now also a nature reserve managed by the Nottinghamshire Wildlife Trust.

* * * *

In the late 1960s that I attended a local meeting of the British Deer Society. The meeting was to be held in the spacious country kitchen of nearby Inkersall Manor, as previously mentioned, but of which I knew nothing. Along with another wildlife enthusiast, I was due to give a slide talk on forest and woodland birds and mammals. Then we were to embark upon a guided tour of the Clipstone and Rufford Forest. The guide was Jim Bark.

Not knowing the exact whereabouts of Inkersall Manor, we met on the forecourt of the Limes Café, where introductions were made before we covered the short distance up the lane to where our hosts were waiting. This country house was the home of prosperous brewer and country gentleman, Tom Loscoe-Bradley. It was built in 1938. The name Loscoe-Bradley is written in the Game Books of all the prominent Nottinghamshire estates. A keen sportsman and shot, he attended shoots on both sides of the Trent and his invitations extended to the estates of Clumber, Rufford, Welbeck and Thoresby in the Dukeries.

I first came across the name when I perused the game books of the Middletons' Wollaton Park estate, then later when I read the accounts of hare, pheasant or woodcock shoots, or 'days', over the fields of Aspley Hall close to where I was born.

Married to a lady called Mary, who bore him six children, Tom Loscoe-Bradley purchased the land from the Savile estate. He then commissioned a reputable Nottingham architect to design the house and make it a first-degree country house whatever the cost.

At the warm invitation of the host and hostess, we filed in, having first noted a muster of peacocks on the private drive. The house was gabled, the entrance hall prestigious, the dining room elegant.

I could have spent all day beside the ornate fireplace. I was shown the wide traditional English staircase made from English oak. This staircase supported a half stage landing, from which the five bedrooms led off.

The kitchen overlooked a courtyard and lawned grounds. There was an oil-fired central heating system, or log fires with flames roaring up the chimneys on freezing winter evenings.

The outer grounds comprised of around seventeen or eighteen acres, including a four-car garage block and workshop.

We were, on being escorted around, smitten.

On either side, belts of deciduous woodland and Forestry Commission pine gave shelter, seclusion and privacy. When eventually we thanked our hosts for the courteous and extended welcome, we had only to enter a lane and we were in the Clipstone and Rufford Forest.

Rain settled in, but we glimpsed parties of black fallow deer does and their followers crossing the rides or feeding in the glades.

Jim pointed out the magnificent antlers of a mature fallow buck positioned on the veranda of a cottage that was owned by the Forestry Commission. The antlers were wide in span, beautifully palmated and conspicuous in that they had been painted white. That particular fallow buck had been a road casualty Jim told us.

These deer were descendants of Lord Savile's herd, that were enparked at Rufford Abbey until the forerunners made use of the weak links in the fencing. In groups, they crossed the A614 to set up territories as wild deer in the then new plantations around Bloomsgorse Farm and the centralised lane that, since the war and the colonisation of the deer, has become known as Deerdale.

Please note that today Inkersall Manor is still a private residence and not open to the public.

CHAPTER TWENTY-THREE

THE MILLS AND THE MILLERS

The first impression one gains of a windmill is that of a towering upright structure, usually situated on a hilltop or raised ground, with four sails designed to catch and face the winds.

Windmills are said to have been designed and developed in Europe during the twelfth century. They may have been introduced by the Crusaders. Their purpose was to dispense with animal power, used frequently on the grinding machine, and well-maintained windmills were indeed economically viable here in Great Britain. Consequently, there was an estimated 10,000 or so windmills grinding corn and wheat in England throughout the fifteenth century. The existence of a windmill became synonymous with the words 'wheat fields' and a fair proportion of those fifteenth-century mills listed were to be found in the arable wealth contours of the south-east.

Today, though, relatively few remain. The bygone importance of a mill in a town or village is signified by such street names as Millgate, Millfield and Mill Lane. The mills and the millers became an integral part of a village community. Around a windmill or a water mill was to be found employment, especially for those millers who did not have a family.

The blacksmith, the wheelwright, the landlord of a coaching inn, a basket maker and thatcher perhaps, lived and worked close to the church and the mill.

The first known windmills could only be operated in a primitive form if the wind was blowing from a direction conducive to that in which the sails were set.

Designers intent on improvement then produced the post mill, the main structure or body of which was structured from sections of

weatherboard. A firmly set centralised post was positioned in a manner designed to hold the sails. A wheel and tail pole was then fixed to the back or rear of the mill by hand.

Such a method ensured the much sought-after equilibrium and in later stages a flight of side steps was added so that the millers could enter several floors without using the interior steps or ladders, especially when hauling sacks of produce. Two cross trees were used to secure the central post and these were dug or embedded into the mound that served as the foundation. Such mounds have in the past, and with the mills having long fallen into disuse, been regarded as tumuli until the local groups of archaeologists inspected the sites and recorded otherwise.

The machinery was geared to motivate the grinding stones, and in later years of improvement the supportive trestles were protected by building in a storage space unit or roundhouse. With the end of medieval period, the average roundhouse was extended, built upwards to meet the rigid top and conical cap to which were affixed the sails.

These became known as smock mills. The sides, made from wood, were designed octagonally. Design-wise, we are now talking of the seventeenth century. Tower mills were also constructed around this time. Some were octagonally designed, others tower-shaped. The main materials for their construction were stones, boulders and bricks. An improvement created by designers, whose names, I suspect, have gone the ways of the hay wain, was the semi-spherical shaped revolving caps. By 1745 both gears and fantails were introduced to the smock and tower mills. By adding these, the caps could be automatically turned. The sails were then beneficially subjected to the play and direction of the wind.

The sails of a windmill were similarly improved, beginning first with those known as 'Common sails'. These were made from sailcloth stretched across the wooden frameworks. The 'spring sails', with movable shutters, were fixed angularly so that the pivots, rods and springs connected could be adjusted by a miller. Thus the shutters opened when the wind velocity reached a favourable pitch. From 1807 'patent sails' became popular with the millers. The reversible shutters on these were more complex and literally geared by an arrangement of pulleys, weights and blocks.

Around 1784-86, several English towns saw the introduction of milling engines powered by steam but which failed elsewhere to succeed the commercial and long standing methods of milling.

After the First World War less than 360 windmills were standing, let alone working. As these in turn faced redundancy, they became regarded as relics of the past and fell into disrepair.

* * * *

The windmill that I looked over in the 1980s was not situated in Nottinghamshire but in the Buckinghamshire village of Quainton. Nevertheless, I made use of the invitation by a member of the Quainton Windmill Society to look around, and surmised that most of the comparatively few mills built around 1830 must have worked as, and been designed on a similar principle to, those that were built a 100 or so years before.

A steam engine was installed and this guaranteed that the mill was operational for every working day rendering it not solely dependent on the wind. What I found particularly interesting were the facts that each sail was twenty-nine feet in length and was fitted with forty-two shutters. Such statistics must have applied to the average mill, including those in my native Nottinghamshire I decided.

The first Nottinghamshire windmill that I photographed was, by the 1960s, bereft of its sails – but impressionable for all that. In present times it has been incorporated within a splendid private residence and is situated at East Bridgford. The brief connecting history of this working mill begins in '1828 for H. S.', whose full name I later learned was Henry Stokes.

While the mill was being constructed, the two Ingledew brothers, who were the millwrights, were killed in separate incidents.

At nearby Shelford an early wooden post mill, encased within a roundhouse built of brick, stands prominent in the centre of a field. It can be seen from the road or the public footpath. To some extent it reminds me, in shape, of a gigantic water butt.

The Elston windmill has been converted and become a private residence. Built in 1844, it was throughout its working life called 'The Black Giant of Elston'.

The ruins of the tower mill at Farndon still bear a date stone, which indicates that it was built or completed in 1823.

The tower mill at Kneeton is believed to be the oldest of its kind in Nottinghamshire, and has again been converted into a private residence.

Originally there were two windmills at Tuxford known as 'the Tuxford Twins.' In present times only one remains.

Built in 1830, the brick tower mill at Gringley-on-the-Hill is always pointed out to the village visitors. Tuxford, the village name I learned when daily in boyhood I saw the cattle transporters or 'cattle trucks' being driven along the Nottingham boulevards to the abattoirs or cattle market, has a restored tower mill and was known for its two such mills – 'the Tuxford Twins'.

As equally elegant in appearance, and probably the best-known restored windmill in the county, is the one towering above the fields of North Leverton. At the time of my visit in the 1980s, this windmill was open to the public and in working order. But I am told that although it is still in working order, the public are no longer admitted.

A tower mill at Eakring was built in the 1840s and the miller was George Mettam. He was also the owner, which wasn't the case with every

miller working the wind and water mills at that time. The Mettams are a long-established family of millers, as is interpreted at the splendidly restored Ollerton Water Mill, into which is also incorporated one of the best and much patronised teashops in the county.

* * * *

In December 1989 a friend and I drove north to the windmill at North Leverton. Due to the Christmas holiday, the mill was closed to the public but an enthusiast who claimed to live locally accompanied us as we viewed the mill's exterior.

At the time, the mill was deemed locally unique in being the only one of its kind still operating commercially.

Built in 1813 by five farmers, the foundations were begun a year earlier. It was therefore a shareholder's venture. They ground corn for their own purposes, but also for the farmers who had, of course, to pay a fee. The miller at the time of our visit was Mr Keith Barlow, whose great, great, great grandfather was one of the five pioneering shareholders. I should add that in 1989 this was still a shareholders' mill.

What the mill achieved for everyone concerned in those early days was prosperity; very often the lane leading to the mill was blocked by files of horses and carts loaded with grain that was eventually to be ground into flour.

The sails of the mill came closer to the ground than those of the average mills, and were therefore considered dangerous. But it was not until around 1884-85 that a further nine feet was added to the structural height of the mill, and types of sails known as 'patent sails' were fitted.

By 1919 the mill was in need of urgent repairs and the millwright of that time decided to change occupations.

In 1923 two sails needed replacing, but another millwright, Mr Foster, designed and made them himself in the millyard.

With a declining income threatening closure, the home manufactured sails cost the company £30 each to make. In present times, the costs would be closer to £3,500 or £4,000. Having put so much time and effort into the restoration of the mill, Mr Foster became its hiring and firing manager until in 1955, when still working, he died. He was in his seventies.

A year later the original company split up, but a new limited company, the majority with the original shareholding rights, was formed.

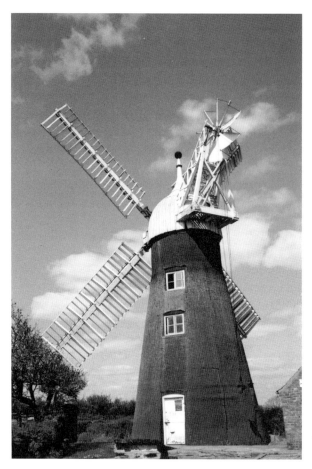

The North Leverton windmill.

They were grateful of the help from a group of interested local folk who called themselves 'Friends of the Windmill' and raised money when costly repairs were needed.

In July 1959, one of the sails was struck by lightning but people were soon to hand and the much-feared fire was put out without damage spreading to other parts of the structure.

Two years later the mill was bereft of a miller and a local man took over to keep the mill working and in goo repair. He was, I believe, the only applicant for the job.

In 1989 Mr Keith Barlow was recorded as following in the family tradition and on the day of our visit the North Leverton windmill looked splendid in the morning's frosted sunlight.

In more recent years I have visited the mill at Tuxford. Leaving Ollerton and bypassing the Laxton turn-off, the road climbs and forms a surprisingly long and fertile pastoral ridge that, speaking in terms of Nottinghamshire and Lincolnshire, seems pleasantly adrift from either county.

With the word landscape almost forgotten, it re-enters the mind as one eventually sees the village and the black and white structure of the mill striking up from it but dwarfed by the comparative sweeps of sky and April day build-ups of white cloud.

The road winds along the ridge top and the mill, in terms of wind dependency, is extremely well-sited. Situated in a field with picnic tables and ample car parking, the mill is privately owned but, at the time of writing, is open to the public. Tickets are obtainable at the nearby café and shop, where all forms of flour, including pancake flour, can be bought in the small bagged quantities of the type that can be found on supermarket shelves. There is, however, only one of the original mills known as The Tuxford Twins remaining. The site of a decimated mill is marked by a notice and sketch, beneath which are the words 'Post Mill'.

For their size and height, the two mills were built incredibly close together which is why, I suspect, they were known as The Tuxford Twins. Discernible on the skyline to the north-east stands a mill without sails. This is, a local girl told me, the mill at East Markham.

* * * *

Water mills are thought to have been introduced by the Romans, a theory strengthened by historians, who stress that the 'undershot' type mill used towards the end of the Saxon age was a Roman innovation. The *Domesday Book* recorded some 6,000 mills in Great Britain, most of which were owned and leased out to millers by the lords of the manors.

It is now a well-established fact that the peasants and employees of the ruling lord had little choice but to have their corn ground at his mill and they paid a toll, or fee, accordingly.

The landowner, the lord of the manor, was deemed responsible for the upkeep and maintenance of his mills but the millers were granted rights to a constant supply of water, a ruling that I am told is enforced to this day.

There were four water mill types, the earliest being of Saxon origin. Called 'the horizontal mill', the mill wheel was set horizontally over a

stream and the water scooped to the paddles by the aid of a chute. The grinding stone, built onto the storey above the mill wheel, was geared by the wheel's shaft.

Towards the end of the Saxon era, the 'undershot' mill was reintroduced to Britain. This was the form of milling initiated by the Romans.

The centre force of this mill was a vertical wheel with flat blades positioned at the circumference. The lower sections of this held the blades which ensured the water flow, that was in turn held in check by a leat fitted with a sluice gate or a small weir positioned within the leat.

The millers of the Middle Ages became familiar with the workings of the 'overshot' mill, which was again attached to a leat.

The circumference of the wheel held a string of buckets. The positioning of these ensured that the wheel, due to the weight of the water, turned in a clockwise direction.

The 'breastshot' mill, by contrast, was designed so that the mill wheel turned in an anti-clockwise direction.

By the early nineteenth century, the water mills of Great Britain were being challenged by the turbine innovations and steam power, and like the windmills, became local curio pieces, if indeed some fifty or sixty years later they were recognised for what they originally represented at all.

* * * *

Situated just north of Rufford Abbey, the village of changing times known today as Ollerton was listed in the *Domesday Book* of 1086 as Allerton, 'ton' being then a holding or farm situated within the alders.

The alders were the trees flanking the River Maun, which passed through the village and which are the forerunners of the fewer alders that rise sentinel-like from the banks of that same river in present times.

Three mills were listed at Ollerton in the *Domesday Book*. There would have been a woodhouse or meeting house situated thereabouts, where the commissioners, officials and administrators of the forest and land-owning laws met to ensure that the necessary warrants were served and the tolls, taxes and tithes were paid and received accordingly. The ancient tracks threading across and throughout the forest country gradually became cart hauliers and then stagecoach routes, linking the village or settlement locally to Newark, Worksop and Mansfield, or farther afield to York, Lincoln or London.

The two pubs, The Hop Pole and The White Hart, built strategically within strides of the village green, served originally as coaching inns.

Due to a late outbreak of the plague, or Black Death as it was known after 1833, the village became uninhabited. Although as tracts of land the Manor of Ollerton was taken over by the Nevilles, who were the earls of Westmorland. Further changes in ownership occurred until the land was owned and some occupations revived by the Savilles of Rufford, but in 1938 the ancient manorial tracts were divided into 'lots' and sold off to the coal mining companies.

A framed photograph on display in the recently restored Ollerton Mill depicts a group of what look to be Lincoln Red cattle, and belonging to the miller George Mettam, grazing the turf of what in present times is the car park. And it is only by visiting the mill and the adjacent tearooms that one learns of how family involved the mills were, as fathers and sons having mastered the craft remained self-employed throughout several generations.

Also displayed in the mill is an interesting family history, which informs the visitor that the Mettams are descendants of Marmaduke the miller who pioneered the windmill process at Kneesall in 1635.

In these comparatively early times the majority of the mills were owned by the Lord of the Manor, as already mentioned, but as millers the Mettams remained in business and moved to the Eakring Windmill where they remained until 1921. It was then that George Robert Mettam made another comparatively short cross-country move and signed as tenant of the Ollerton Water Mill, then owned by Lord Saville of Rufford. The rent was £80 a year.

When in 1939 the Rufford estate was sold, the mill was bought by Mr Frank Mettam and two local businessmen.

Frank Mettam tenanted the mill until 1957, when, still living there, he purchased the entire property.

On my first visit I learned much, particularly about milling in general. I made notes from the interpretative displays, having obtained the owner's permission, and spent time touring the mill, which is open during most April to September weekends and in the Bank Holidays appertaining to them. I discovered, for instance, that water mills work without brakes, due to the machinery being set in motion or stopped by means of a sluice.

In control of the grinding process was the miller, not surprisingly a man of unwavering physical strength, who could judge the texture of the wheat or corn as, when ground, it fell through the slats.

The beam supports linked to the intricacies of mill wheels and grinding machinery displayed at the restored Ollerton Water Mill.

The second floor, incidentally, was at Ollerton described as 'the heart of the mill', where the grinding processes took place.

There are interpretative notices explaining the functions of the Great Spur Wheel and the Crown Wheel, the frameworks of which were known as 'the horse'.

Throughout that quarter of Nottinghamshire, Frank Mettam and his father were recognised as millers who could tell on what farm or land tract the corn had been produced and by which landowner due to the texture and 'feel' of grains.

At the beginning of the twentieth century over 100 farms were using the Ollerton Water Mill to grind their products, which understandably for those times was considered quite an achievement, particularly since Ollerton was not the only working mill in the district.

A further delve around the mill led to the discovery that three sets of millstones were used at Ollerton. Two were hewn from stone quarried in the Peak District and were known as 'Derbyshire Greys'.

A second set, known as French burr stones, were made from a hard quartz, which was quarried in Paris.

The third set, installed some sixty or seventy years ago, were ancestral in that they were taken from the windmill at Kneesall when the mill fell derelict. One of these stones, worked by the bygone millers of the Mettam family, weighed in at exactly a ton.

The third floor is known as the bin floor. Here a displayed interpretative plaque explains the development of mills from Domesday to the relatively recent times when the trade in general quite literally ground to a halt.

By 1952 Ollerton Water Mill was involved with the production of animal feeds, while continuing to produce grain for local livestock farms until 1980. It was then that the demand finally ceased. Consequently, the machinery and the mill wheel fell into disrepair.

With the new business of tourism offering an alternative to complete redundancy, however, and due to the present owner's foresight, the mill, from 1980-87, received a number of worthy grants which aided strongly the restoration of the mill and possible seasonal opening as an interpretative centre and tourist attraction. Thus the mill, in its new role, was opened to the public in 1992. By 1996, as a plaque indicates, the restored Ollerton Water Mill and its owners had won the Harry Johnson Award 'For the best design with a village setting for the restoration and adaption of Ollerton Water Mill.' The award was presented by the Nottinghamshire Buildings Preservation Trust and Council for the Protection of Rural England. Thus the mill remains in the ownership of the family who have lived on the site for seventy years.

Employing four people, Ollerton Water Mill is now linked to the National Curriculum and many school groups visit and are shown around with the subject matter explained and displayed before them. Their guides will probably be John and George Mettam who are the mill's current owners.

* * * *

Standing between the mill entrance and the private living quarters of the Mettam family, I learned from John and George that the River Maun, which feeds the mill, is about five feet in depth. Then between us we outlined the river's interesting course. The Maun, we agreed, probably released its embryo flow around Kirkby-in-Ashfield, or perhaps the abutment contours of east Derbyshire. It then threads for mile,s between and across the fields, to the once delightfully quiet spot of Conjure Alders.

Here the Maun joins the Medan and becomes the single watercourse that creates the game shot's Mecca of Gosling Carr, beyond which the two separate as the Maun winds determinedly towards Ollerton and the mill that was reliant upon its naturally productive power.

CHAPTER TWENTY-FOUR

COACHING INNS AND OTHER EXPLORATIONS

Heading north and clear of the Dukeries, some faint semblance of landscape edges into the scene. Riverine valleys, with gravel extraction lakes, carr lands, and marshes, pebbledash the map to the north-west. These contrast with the pastoral and agricultural valleys bordered by elongated switchback hills and cloud enhanced ridges to the north-east.

That said, none of the contours could be described by a painter or landscape photographer as visually dramatic. But the changes as one drives towards Bawtry or Doncaster accompany the feeling of having West and South Yorkshire closing in from the north and north-west and the entire county of Lincolnshire beckoning over to the east. East Retford is usually the central town for beginning or ending a day's exploration of this area, for my friends and I at least.

This thriving market town has become merged with West Retford due to building expansion and boundary changes intervening throughout the twentieth century. People nowadays, particularly the young, refer to both simply as Retford.

In Cannon Square one morning I asked a young woman the way to the Tourist Information Centre. She directed me along a series of interconnecting streets and while thanking her, I admitted that I had thought that the town planning department would have allocated a more centralised position for this establishment.

'Oh come now! You're asking too much of a place like Retford sir! And this is the twenty-first century we are living in after all!' laughed my informant who, I admit, had made a valid point.

The young woman behind the counter at the Tourist Information Centre situated on Grove Street could not have been more helpful. She gave me

maps, leaflets and adequate directions, after which I made my way through the park, with its gardens and sports pitches divided by the River Idle. From there I arrived eventually at Cannon Square, which, along with the marketplace is a main centre point for the town. One does not have to walk for long here before one passes a pub that was a former coaching inn and on Bridge Street, a sign adds worthy weight to Retford's past importance as a trading centre. The sign indicates the whereabouts of the Borough Carriage and Motorworks. Historians have agreed that the town was possibly created as a medieval marketing centre in the twelfth century, the first charter having originated in 1246. But when in 1898 the River Idle was dredged, items of Roman pottery were surfaced thus suggesting that the Romans had inhabited the banks of the Idle at least while the Roman settlement of Littleborough was regarded as the main local trading point.

Known in those times as Segelocum, this village had slaves and labourers build a paved ford across the river which further endorses its past importance both to traders and governing dignitaries.

The Saxons in this area described themselves as living in the Kingdom of East Mercia, and due to the settlement being within marching distance of the Trent flood plain, the kingdom was raided and pillaged frequently by the Vikings.

Once the Vikings became established, the area became known as Bassetlaw, to aid in the administrative laws and regulations laid down, I'm told, by both Saxon, Scandinavian and Danish settlers.

After the Conquest, the old Saxon lands were given to William's strongest aide, Roger de Busli, for whom a castle was built at Tickhill. Two churches were then established, St Michael's at West Retford and St Swithin's at East Retford. Like most marketplaces, including that once-busy trading centre in the middle of Nottingham, the name given to this once colourful and intriguing place was 'The Shambles' and the trade stands and stalls may well have extended up to Cannon Square. The recognised market days in present day Retford I should add are Thursdays and Saturdays.

And so to the centralised cannon weighing over 1,000 kilograms. This was used by the Russians in the Crimean War, and was brought back as a token of victory under the guidance of Corporal Charles Piercy, then aged twenty-one. Charles had fought in the Battle of Alma in 1854.

In April 1858, after several years of having been pulled by horsepower, the cannon arrived in Retford by train, all the financial issues having

The centrepiece of Cannon Square, Retford.

been settled as agreed by prominent members of the local community. Robert's father had for long suggested that the cannon be installed in its present position after which trade continued within a few feet of it. Red meat, poultry, game, vegetables, cheeses and other dairy produce were sold from the stalls positioned around the cannon and in the days when the town crier was still the most prominent figure in every market street scene.

During the Second World War, however, a local dignitary suggested that the cannon be put into melt. He explained that he was thinking in terms of the town doing something towards the war effort.

But a local solicitor objected. Moreover, he purchased the cannon, had it removed and 'hidden away' until 1949 when, four or so years after the war ended, it was repositioned in Cannon Square.

If a fair few shop and business fronts appear drab in present-day Retford, the people make up for that drabness with their warmth and friendliness. Anyone seeking a meal of fish and chips to 'eat in or take out' could do far worse than call in at Kenny's, on Carol Gate. The chips are golden and truly delicious and Kenny's 'Thank you lads, I hope you

enjoy them,' persuades you to check your whereabouts in readiness for another visit when you're next in the area.

* * * *

South-west of Retford and returning to the A1, the rivers Maun, Meden and Poulter converge at Elkesey, where the crossroads linking Bothamsall and Gamston meet on the long-established coaching road.

Here the three rivers become one: the River Idle, which burrows relentlessly through the north-eastern sweep of countryside then swings north to Mattersey and Bawtry.

South-east of Retford are such scattered and sequestered villages as West Drayton, Askham Upton, Headon, Stokeham, Nether Headon and the delightfully named Woodbeck.

It was near here one December morning that my exploration of Tresswell Wood was heightened by the gabbling of pink-footed geese, as skein after skein flew west and into Nottinghamshire from the Lincoln drain fields around Kexby and Gainsborough. This countryside to me, with its lush agricultural fields, intersecting dykes and drains carrying the reflections of cloud formations, and open skies, is exciting to say the least.

The rush of adrenaline accompanies me hereabout. I can't wait to see the next village or hamlet, the next dip, next contour of land, the very occasional skyline windmill, and gleam of willow-thicketed water.

The occasional mid-afternoon line of traffic apart, these are deep, open and lonely tracts of land. It is the countryside of the loner and as the years slip uncomfortably by, the more excited about such relatively unspoilt places I become.

North-west of Retford is the village of Blyth divided by the Great North Road, or the A1 as we know it today.

The village and its adjacent acres are formed around a barely recognisable peninsula, with the River Ryton shaping the boundaries but unseen by Blyth's visitors, for much of this narrow waterway borders on to private farmland.

The village green at Blyth is centralised, triangular, and rightly regarded as a conservation area with over twenty of the nearby buildings being listed as worthy of study and architectural interest. The elongated greenbelt that fronts The White Swan Inn displays its April daffodils and

The divided village green at Blyth.

stands of aubrietia or forsythia enhance the garden borders and cottage surrounds.

By mid-May the daffodils have died off, but the lime trees are in full foliage and the cock blackbirds are fluting against a background of crowing cockerels kept in one of the nearby gardens.

Opposite The White Swan on the High Street is the local Co-op which was opened in 1927. A door or two down from the inn is the 'White House'. Here an exterior plaque informs the visitor that the house was built in 1596. Attached and built of red brick and blending well into the village scene are the comparatively recent Whitehouse Mews, built on what was originally stabling for the main house itself. Centralised at the end of the elongated grass area and opposite the village green stands The Red Hart, a coaching inn estimated to be around 400 years old.

Close by is The Angel Inn and the aptly named Four Ways Hotel with road signs indicating the routes to Nottingham, Newark and Retford. Crossing the road to look over the village green, the promoted four ways become apparent when one realises that a road leads to Sheffield in the west, Retford slightly to the south-east, and Doncaster and Bawtry to the north.

The village green bears signs and beautifully carved insignia further informing the visitor that the settlement was originated, or perhaps entered as such, into the *Domesday Book* in 1086. The timespan ends in 1986, when the sign was obviously erected.

Great freightliners and lorries trundle into the centre of Blyth from each direction. But the skills required to drive these vehicles do not by any means overshadow the distant days of the coach-and-four. Between lulls in the traffic, when only the cock blackbirds and chaffinches are fluting, the days and skills nurtured by the coachmen, ostlers and the hustle and bustle of the stablemen and innkeepers seem still relatively close to hand. Anyone gifted with the slightest quirk of imagination can from the village green transform the village to the London-to-York coaching routes in as many seconds as it takes for the next freightliner to come through.

The church stands back from the village green where a parishioner explained to a friend and I the fact that the remains of an eleventh-century Benedictine priory are to be found in the church, but in the form of the splendid nave which is the only indication of there having been a priory in Blyth.

I don't doubt that all the closely built former coaching inns in Blyth are attractive, comfortable and welcoming. But a friend and I chose The Red Hart because it was open at around 11.30 a.m. on that particular morning and we were told to regard the car park as 'the' car park for however long it took us to explore the village. I was expecting to see the mounted head of a red deer stag on the wall of one of the bars here, because 'hart' is the Norman-French term for these magnificent animals. The friendly barmaid informed us, however, that there was no such ornament enhancing the wall but agreed that there might have been in times gone by.

The midday coffee sipped in a window bay was splendid. The interior of the rooms are panelled and the walls, carpets and general decor of that particular bar, as I remember it, was fitted throughout with dark red.

Many social events are staged here, as perhaps they are at the neighbouring inns. We were, in fact, just two days away from the beer festival, which was scheduled to begin on the Friday with a complimentary patio buffet and live music provided by a local group. Saturday was 'traditional fish 'n' chips' day or homemade pie, both served with mushy peas. Sunday food was served from twelve till five

and Bank Holiday Mondays' offerings were freshly grilled food, and live music provided by acoustic guitar in the afternoon.

On returning to the car, the barmaid pointed out that where the vehicle was parked and the adjacent patio stood was the stabling area for The Red Hart in the days of the coach-and-four.

* * * *

West of Blyth sprawl the private housing and council estates of Langold. Signs hereabout direct the motorist to Langold Lake, which I have visited several times. Not surprisingly, and like most park and meadow areas within and around the Dukeries, it has an over-population problem with the Canada geese which have flight lines linking all the waters of central and north Nottinghamshire with the Humber estuary and the Isle of Axholme.

A council notice beside Langold Lake informs the visitor that the parklands were intended to be yet another of the Dukeries estates when a local businessman purchased the land and planned on having a substantial house built there.

The lake was dug out and the woods planted, but the estate failed to materialise. Instead it was given to the local council for use as a public park, which indeed it still is, with swimming and boating having become firmly established summer activities. Part of the lake is also regarded as a nature reserve where waterfowl breed when the local youth population allow them.

From Langold, a short journey north takes one to Harworth, near the Nottinghamshire-Yorkshire border town of Bawtry. I should point out that Bawtry is just inside the Yorkshire border. At Harworth, small village though it is, a mine shaft was sunk by the Northern Union Mining Company in 1913. The company that followed were soon faced with bankruptcy. But in 1923 a rich coal seam was located and business matters improved from thereon. Coal from the Harworth colliery was used to fuel *The Flying Scotsman* when it achieved the London to Edinburgh run of 392 miles in seven hours twenty-seven minutes.

* * * *

The name Gringley-on-the-Hill became familiar to me in the 1960s and early 1970s, when on my regular visits to the Nottingham Natural History Museum, based close to my home, I studied the monthly reports tendered by the Trent Valley Birdwatchers.

From these reports I learned that in the autumn and spring the migratory plover species called dotterel would have been recorded there. In the autumn, dotterel migrate to North Africa and possibly the Persian Gulf. Quite often they fly in small groups known as 'trips' and it would seem that countless generations of these birds travel to and from specific locations, therefore suggesting that like many species they have a homing instinct in the same way as pigeons.

In all probability, 'trips' of dotterel were travelling to and from the fields of Gringley-on-the-Hill when the Saxons and Vikings were making their respective presence known. However, while today a 'trip' of dotterel arriving at Gringley-on-the-Hill is an almost foregone conclusion for the April birdwatcher, they have been reported elsewhere in Nottinghamshire and a century ago were breeding on the hills of Sutherland and spreading down to the Pennines.

The demise of this species occurred through overshooting. Like the woodcock in present times, they were popular with field sportsmen and the Victorian hordes of birds' egg collectors. Although a scant few pairs are sighted today in lower terrain than their normal breeding grounds, the sixty or so remaining pairs nest around the Cairngorm summits. Here, thanks to my son Stuart, who sent me there as a birthday surprise, all expenses paid, I watched pairs indulging in their fascinating courtship rituals or sprinting alongside the ptarmigan which provided equally interesting studies.

At places like Gringley-on-the-Hill dotterel, are by comparison less conspicuous, because they intermingle with the sizeable flocks of green and grey plover and the observer needs a recognition book to hand to tell the species apart, especially as when disturbed they rise in vast clouds from the ploughlands.

* * * *

Of the people who live at Gringley-on-the-Hill I have met only three, none of whom were in the village itself.

The first was a suntanned elderly couple taking their ease on a seat near the Speakers' Corner in London's Hyde Park. All three of us were

seeking the shade and soon got into conversation, largely relating to our natal county.

The third was a farmer looking at the properties and gardens in the older part of Ollerton. Leaving his family in the Mill Tea Rooms, he had, like a friend and I, decided to have a look around the streets of Ollerton in general.

I first regarded the farmer as being an Ollerton man and asked him if he knew how the name of one particular dwelling had originated.

He then told of his whereabouts, and further that, like us, he was interested in the origin and significance of place names.

On the narrow pavement we exchanged information when I suppose we could have propped up a bar at The Hop Pole or The Snooty Fox. But there was no traffic and so we touched upon the subject of place names. This became enlarged through a discussion on field names. There was on his farm at Gringley-on-the-Hill a tract of land known as Withnall Fold. This has been so named and used for grazing sheep since Saxon times. Field names, we both agreed, came into being in around the thirteenth century, if not a little before. Some, like Withern Fold, have remained unchanged, while others have been redefined or renamed according to the parliamentary enclosure interventions. Some fields were named according to their shape, soil content, types of animals best suited to grazing there, owner's identity, archaeological value, boundary references and recreational or folklore associations. We also agreed that remnants of the strip lychet systems may also be still named on maps that are secured for legal reference, and therefore largely forgotten until a dispute arises, which is fortunately not a frequent occurrence.

* * * *

Gringley-on-the-Hill, with its village summit rising to 82 feet, is situated directly off the A1. In what may be termed the village centre is the manorial house and the well-positioned Old Coach House, adjacent to the corner of the church. Opposite the church, with its five stand of trees, beckons the old post office. Next door is a hostelry called The Blue Bell. At what I think of as being the eastern end of the main street is Beacon Hill. From here, the next hill, on which Lincoln Cathedral is built, can occasionally be seen. This is situated some twenty-twenty-five miles away.

Beacon Hill was used, as the name implies, for the purpose of signalling with fire during the Napoleonic Wars. Whether the hill was manmade is still a point for conjecture. Prince Rupert is also believed to have celebrated and camped here after he defeated the Parliamentarians during the storming of Newark Castle in 1644.

Today a beacon, rail protected but suitably conspicuous, stands at the crossroads. This was designed and made by Jack Rennison, the village blacksmith (1915-1995), and was erected in 1988.

Between the street corners of Gringley-on-the-Hill one cannot fail to see on a summer's day, the extensive views of reclaimed fenland stretching away to the Isle of Axholme.

I was in my mid-forties before I discovered that such a place existed. When at the introductory session of a land management course, held at the Gibraltar Point Environmental Centre near Skegness, a genial and weathered man told the group that he came from the Isle of Axholme, the collective question was, 'Where on earth is that?'

When we had a free evening, this fellow student told us that his home county was situated about twenty miles from the estuary of the River Trent, which borders its eastern edge. The original name of this early fenland tract was thought to have been Haxey-holme. Haxey was the name of the village and 'holme' is a Scandinavian word denoting 'a place liable to submergence during a time of severe flooding'.

The Isle in present times embraces some 200,000 acres of agricultural land, but not until it was drained in the seventeenth century by the Dutch drainage engineer Cornelius Vermuyden did its wealth become apparent. In modern times large scale farming and market gardening provide the local prosperity.

Occasional belts of poplar trees can be seen here, especially in late April and the middle of May, when thousands of acres of oilseed rape provide an insetting canvas of deep yellow, which on warm days becomes enhanced by the blue of the sky.

Epworth, the birthplace of John Wesley, the founder of the Methodist Church, is the place where strip lychet farming took hold in the Middle Ages. And at the time of our meeting at Gibraltar Point peat cutting, again originating from medieval times, was still continuing at some of the holdings around Westwoodside and Haxey on the Isle of Axholme.

* * * *

A quiet stretch of the Chesterfield Canal borders the lower climes of Gringley-on-the-Hill but one has to negotiate the narrow winding village street descent to reach it. However, since this chapter primarily deals with my search for the county's old coaching inns, the canal will more appropriately feature in the next chapter.

North-east of Retford and about three miles from Gainsborough is the village of Sturton-le-Steeple. I was told that opposite the church lies The Reindeer, which was once a coaching inn.

When a friend and I drove that way from North Leverton, we discovered that the inn was untenanted. Consequently, I learnt nothing of it, but it was certainly on a crossroads and could therefore well have served as one of the more necessary and outlying coaching inns on that side of Nottinghamshire.

The inn at the time of my visit was billed as being a 'Free House' and the sign, not of a reindeer but of a red deer stag, was one of the finest studies I have seen in years, and had me thinking of the artists who make a living, or close to it, designing and painting pub signs. Alongside the pub is land that I suspect was once used as outbuildings and stables.

There is, within a few feet of the pub doors, now a duck pond. This was created by Spadework Projects, a worthy offshoot of the Nottinghamshire Leisure Services. The island on which the feral mallard and fewer duck call to preen and oil their plumage, is called Edwin's Island, Edwin being the driver of the JCB and who worked so diligently on the project.

There is in the village a post office, a newsagents and a general store. Fresh meat and vegetables are supplied via a mobile shop and a mobile library calls weekly.

The church, built in the twelfth century, lacks a spire, but around the tower twelve pinnacles can be seen, whereas the average Nottinghamshire church, as a local historian quickly pointed out, usually has eight. A mallard duck nesting in one of the churchyard trees left the nest while a friend and I were there, and flew directly to the duck pond. The drakes, which are fertile for ten months of the year, immediately knocked the duck off her feet, but she kept her wings stiffened over her body, thus indicating that she was not going to meet with their demands and was already incubating eggs.

* * * *

The frontage of Ye Olde Belle, a seventeenth-century coaching inn at
Barnby Moor.

The sign Barnby Moor directs the seeker of coaching inns to the locally
famous Ye Olde Bell Inn, which is a favourite venue today of drinkers
and diners from east Derbyshire, north Nottinghamshire and north-west
Lincolnshire.

Ralph Thoresby, a historian and antiquarian from Leeds, wrote in
1680 a detailed account of the pleasantries of this establishment.

By 1727 Ye Olde Bell Inn was *the* coaching inn on the Nottinghamshire-
Yorkshire border and horse breeder and former sportsman George
Clarke, who used the inn frequently between 1800-18, stated that
anyone visiting the castle of a nobleman couldn't ask for more. But as
became the case with the canals, it was the railways that put the venue
out of business, with the stabling extended to house 120 horses being
gradually forced into redundancy.

For sixty or so years Ye Olde Bell Inn was no longer regarded as such
and became a private house while still being kept in relatively good
repair. Only in relatively recent times has the establishment beckoned
again from the roadside and been refitted according to the demands of
those many car owners and bus trippers who still regularly use the Great
North Road.

* * * *

Within a short distance of Barnby Moor are two wetland and wildfowl areas. Just off the A68 and along the B1403 one arrives at the Wetlands Waterfowl Reserve established in a setting covering 32 acres. When I first visited some twenty years ago, the family who purchased the two or three gravel extraction lakes and adjacent belts of woodland were uncertain as to whether their venture would take off.

They were exhibiting ornamental waterfowl species, and free flying wild duck and swans were visiting in the autumn and winter months. In present times, lemurs, wallabies and varied monkey species have been included, along with free-range guinea fowl, storks and turkeys. As well as facilities for the disabled, there are educational staff on hand, a café, a picnic area and two stretches of water stocked with coarse fish which are intended to attract anglers to the site. Much has been made of this delightful place, which now fortunately attracts families throughout each week as well as the weekends. Closer to Torworth are Daneshill Lakes, a country park area bordering the London-Edinburgh train line.

There are stretches of water on opposite sides of the road, one managed by the Countryside Department, the other by the local Wildlife Trust.

I first visited these lakes with Tony Stevenson in the freezing fog that swathed the countryside on Christmas Day 1990.

On our journey up the A1 we had not seen a single car. The first people we saw were a man with his wife and daughter at Daneshill feeding bread to the swans, before going to join their parents at the traditional Christmas table no doubt. Despite the fog, the thirty or forty swans were visible and we noticed, as years earlier I had at Thoresby, that the majority sailed from us with wings arched in the defensive attitude. The majority were, in fact, marshland and drain fields swans, more used to the solitude offered by the wash lands around the Humber estuary than those in the parks and around the villages of mid-Nottinghamshire.

A splendid pair of saw-billed duck, called goosander, drifted alongside the raft of swans and were as equally wary.

Summer visits to Daneshill have been enhanced by birdsong, especially the cock reed warblers, usually unseen but holding territories in the reed beds and willow breaks.

Careful conservation and management techniques have seen many interesting plant and wildflower species thriving in the area and the young trees planted around 1989-90 have foliaged to the extent of them

screening the lakes from the view of the train passengers heading to one or other of those seemingly still distant cities.

The 'middle lake', as it is known locally, now has an established yachting centre close to the car park entrance and on a recent visit in June 2007 I was delighted to see that the woodlands – comprising of willow, alder and silver birch are well grown and screen long tracts of the water's edge from human encroachment.

This, to my eyes, is how a country park and nature reserve should be. There is now a rich habitat and during inclement weather both food and shelter can be found for the resident species and those passing through.

Beside the railway are signs, in high letters, reminding us that Edinburgh is still 250 miles to the north. The trains travel at an estimated speed of around 100-125 mph. But with peace and interests offered by such places as Daneshill Lakes on hand, who wants to hurry?

WHERE THE WINDS SING

On a day of unbelievably strong wind I set off with canal towpath enthusiast Tony Stevenson along the section of the Chesterfield Canal that connects Worksop with Retford. En route we expected to be passing through the delightful countryside around Osberton and Ranby, whose location we had earlier learned from a leaflet map produced by the Chesterfield Canal Partnership.

What we failed to realise was the velocity of the wind which in the time it took for us to travel from Nottingham to Worksop had increased to around 60-70 mph. The surface of the canal was whipped up to proportions that I believe are called by the boating people 'white waters', and we were literally stopped in our tracks so many times we realised that the walk would prove exhausting, at least on that occasion. And so, laughing and shaking our heads in disbelief we retraced our steps and sought shelter in Worksop, the town that is often regarded as Bassetlaw's capital. It is also thought as being the town closest to the Dukeries. Here we settled for a refuelling meal of fish and chips and two pints of bitter in The Canal Tavern. Consequently, as Tony put it, we were 'well out of the wind'.

Straddling the canal is Pickford's old warehouse with the trapdoors, which were once opened for days on end as the wide and narrowboats of bygone times were loaded or unloaded accordingly, now closed.

Leaving the pub and the Worksop Town Lock we then wandered the streets until we came to Potter Street and the tourist information centre.

As the small information pack advised, we had a look at the priory situated by the Prior Well Bridge, with its church dating from the twelfth

century. We learned that this place of worship was partially desecrated during the Dissolution of the Monasteries and that a spire was added into the 'new superstructure' as late as 1970/71.

The building was locked and there was no one around who could admit us inside, for not only paintings are on view alongside the monuments, but a human skull unearthed from the leaf layers of Sherwood Forest. This has the tip of an arrowhead sunken into it, thus indicating that there was at least one bowman with a deadly aim in the forest glades of bygone times. The Duke of Newcastle drew up a trust, which bequeathed a fourteenth-century gatehouse to the priory.

There is a British Waterways warehouse by the canal at Worksop and three pubs (at the time of our visit): The Fishermen's Arms and The King's Head, which served Horne's real ale, and the large French Horn, which advertised the advantages of drinking Stone's real ale. Centred in the bygone coal fields of north Nottinghamshire, Worksop can hardly be described as an attractive town. In fact, to my eyes, quite the opposite. But it is home to generations of coal-mining families and will remain so for years to come, despite the fact that the large collieries have long ground to a halt.

* * * *

The Chesterfield Canal was built and formed with the intention of transporting coal from the Derbyshire coal fields to markets in South Yorkshire and Nottinghamshire.

James Brindley, the engineer whose name is associated with other successful canals, carried out the main surveys, and the canal was dug out by hardworking teams of navvies. The route was officially opened on 4 June 1777.

The Chesterfield Canal Trust emphasise the engineering achievements that included the Norwood Tunnel, which extended for 2,880 yards, and a staircase of lock gates at Thorpe Salvin, which are considered to be one of the earliest forms of waterway staircasing known throughout the history of canal building. Horse-drawn boats and the canal boat people conveyed consignments of coal and other goods, including freshly quarried bricks, along the waterway until its period of deterioration in the early twentieth century caused changes in the stopping and starting points particularly when part of the Norwood Tunnel collapsed in 1907.

As was the case with the Nottingham and Erewash canals, commercial transportation ceased in the 1950s, particularly since the twenty-six miles between West Stockwith and Worksop fell into disrepair and were deemed unnavigable.

The Retford and Worksop Boat Club members of that time however campaigned for the canal to be used as a leisure amenity and were successful in their efforts. Most of the forty-six-mile towpath is open to walkers, according to the leaflets which also emphatically state that due to occasional periods of reclamation work, notices advertising diversions should be adhered to in the interests of public safety. Leaflets giving information on the short circular walks are published by the Chesterfield Canal Partnership and can be located at the Tapton Lock Visitor Centre, which is situated off the A61 at the Tesco roundabout, Lockford Lane, in Chesterfield. These leaflets and information sheets are really high-quality sources of information with colourful illustrations and information on both the Chesterfield Canal Partnership and the Chesterfield Canal Trust if it is required.

From the leaflets one learns of the canal's rise by fifteen sets of lock gates – the Thorpe Flight, close to the hamlet of Turnerwood and the limestone quarries of bygone times. There are intriguing names to be found: Dog Kennel Bridge, Shireoaks, and the comparatively recent New Boundary Lock. Were it not for these leaflets, I doubt that local explorers and wanderers, such as my friends and I, would have been made aware that locally mined limestone, some estimated half a million tons, was from 1840-1844 loaded from a nearby wharf and transported by boat along the Chesterfield Canal to London during the building of the Houses of Parliament.

The Chesterfield Canal was in the eighteenth century known as the Cuckoo Dyke, due apparently to the types of boats known to the local folk as 'cuckoo' or strange boats, and The Cuckoo Way is the adapted name used for the towpath in whichever direction one chooses to walk in present times.

Friends and I have walked the towpath from and around Town Lock in Retford but have noted from the leaflets that Clayworth and Drakeholes are well worth exploring.

* * * *

The lock keeper's cottage beside Chesterfield canal at Grinley-on-the-Hill.

On a glorious afternoon in mid-May a friend, Dennis Astle, and I caught up with the Chesterfield Canal at Gringley-on-the-Hill, under the blue flawless sky, surrounded by fields burning golden with oilseed rape.

Between bouts of birdsong, the welcoming silence welled in. This is quiet farmland country. The canal banks were built up and the waterway not as reeded as I expected. But the towpath was turfed and cushioning.

Cock blackbirds, chaffinches, song thrushes, willow warblers, linnets and white throats were in full song, some of the latter allowing us surprisingly close to their territorial song posts providing that we kept walking. Swallows and house martins dipped above the water surface.

There are three locks, Shaws or Lower Bridge close to the disused brickworks from which bricks were transported to West Stockwith for The Trent Navigation Company. Middle Bridge has a holding or two situated within a matter of yards, and Top Lock or Hewitts Bridge where we encountered but two anglers.

Here, again, I savoured the silence for a time, then photographed the old lock cottage, which appeared derelict but had a rambling garden with creeping plants partially screening the bricks and flowers, particularly roses, flourishing pleasantly out on to the towpath.

Each lock keeper and his wife in times gone by probably cycled along the towpath to do their shopping at Misterton then continued the short distance to West Stockwith, both places at which they would undoubtedly have been known. On most canals, buckets of coal for the cottage fire were exchanged at the lock keeper's cottage for vegetables and perhaps a chicken for the table by the boat people regularly passing by. Gringley and the lovely surrounding countryside can be screened by freezing fog for days in midwinter, as Tony Stevenson and I discovered on at leas two occasions, although in more recent times than those in which I have attempted to describe.

* * * *

On the two Christmas days that Tony and I drove out there, the roads, as previously mentioned, were deserted and freezing fog cloaked the fields.

Yet the villages, Misterton in particular, were brightened, not just by the cottage window trimmings, but by the rich red of the house bricks from which the majority of the farms, holdings and cottages have been built.

Misterton's two pubs are situated in the oldest section of the village which, as expected, was built close to the church. The spire looks awkward, heavy and hastily erected to the unaccustomed eye. From a brief conversation on the canal towpath we learned that this was a rebuilt or reconstructed tower, the original having been struck by lightning in the early nineteenth century.

Due to John Wesley having been born at nearby Epworth, there is, we were told, a 'thriving Methodist church community' in Misterton.

Before making for the canal towpath we located the post office, a village shop, a bank and a garage.

The clattering of hooves caused us to turn as a young equestrian sitting comfortably on the saddled back of a black Shetland pony guided it through a garden gate, held open by her pedestrian friends, and up the path to the front door, presumably to deliver a card or present or accept an invitation to a party.

On the second Christmas Day exploration for Tony and I, the temperature rose and by midday it was mild to the extent of diners at the canalside Packet Inn taking plates, well covered by their respective Christmas dinners, out onto the towpath and eating picnic fashion on

the grass beside the water. Some had their partners bring out chairs and sat with serviettes and plates in their laps while tossing occasional scraps to the ubiquitous moorhens parading like city pigeons around their feet.

The Packet Inn was named to commemorate the boats that, on market days, took villagers along the canal to Retford and outlying holdings that were considered, in those days, to have been within walking distance of a canal bridge, winding hole or lock house moorings.

After walking the towpath to West Stockwith, Tony and I returned to Misterton and met a pipe-smoking sage who told us more about the village history.

There were, in the early 1990s, about 2,000 people living in and around Misterton, which meets the West Stockwith boundary at the Iron Bridge where the canal and the River Idle flow into the Trent.

He confirmed that it was due to Sir Cornelius Vermuyden having drained the once vast marshes of the Isle of Axholme that the village became prosperous in the sense of land reclamation.

'Some of the farms round here date from the sixteenth century. If you know anything about architecture, you will see both Georgian and Victorian buildings still holding prominence, including the public buildings, meeting and civic halls and what have you. The Old Vicarage is timber-framed, dating from the sixteenth century.' He also emphasised the employment offered by the brickyards, where men acquired their skills around the kilns. The canal locks and not a few of the lock keepers' cottages were built from local bricks and the flourishing industry brought prosperity to the surrounding villages.

By the mid-eighteenth century, Misterton was holding an annual or twice-yearly 'love feast', the minuscule equivalent perhaps of a present -day pop festival. There was singing and dancing and slices or loaves of seed bread were handed out to all the feast goers. This was washed down with water served in Misterton's traditional two handled mugs.

In September, during the eighteenth century, a feast and fair was held on the two fields nearest to the church.

In modern times, Misterton has seen the opening and closing of around ten to fifteen shops. There is also a fire station with all the modern rescue facilities installed. Down the towpath, seaward as one might think it, Tony and I then ventured into Christmas-deserted West Stockwith. Here there were once five rope makers' businesses, a chemical works, a flax manufacturing plant and four boat repair yards.

Direction notices along the tidal section of the River Trent, 'where the winds sing.'

Across the Trent is East Stockwith, which is situated in Lincolnshire. Just as the River Severn hosts a tidal wave known as the Severn Bore, so the canal between the Stockwiths takes in part of the local tidal wave which can, apparently, be spelt as 'the aegir' or 'the eagre'. But whichever, this is a tidal wave which surges up the Trent some say 'in the form of a natural phenomenon'. It reverses the normal flow of water and can at times extend to a height of two metres.

Local folk insist that this tidal wave begins in the region of Gainsborough, a Lincolnshire town situated three or so miles downstream. It usually occurs in March and, when, in normal years, the flows of the Trent are at there lowest they're controlled as a preventative measure from causing flooding southwards at Cromwell Lock.

I should add that the Trent at West Stockwith and its adjacent mooring basin is tidal. The mouth of the River Idle here is partially sealed by floodgates. The surrounding and overlooking houses are fine properties, the majority having been built privately by the merchants and ship owners. The wharf is said to have once provided employment and homes for some 5,000 people.

As we came to expect in this part of the country, St Mary's Church, built in 1722, is built from red brick and was financed by William

Huntingdown, a carpenter of ships and eventual ship builder. In his time, there were five boatyards at West Stockwith. On our Christmas visits we located moorings for pleasure craft and two sailing clubs. Thus the basin remains well-used. The main basin lock at the time of our visit was operated by a lock keeper. Although being Christmas, however mild, there was no boating traffic. All the villagers hereabout had closed their doors to the world, leaving Tony and I wandering the village and towpath, darkly clad and obvious strangers.

Lingering at the lock, we learned from a notice that the rise of fifteen locks along the Chesterfield Canal can still take the boats to Worksop.

The keepered lock at West Stockwith, however, is on the Trent and the height of the tide determines as to when it can be operated, although boats can leave the sea behind usually two and a half hours to four and a half hours after high water. The main boatyards closed down in 1948 and after reading the informative notice, we remarked on the sound of the wind pulsing through the overhead wires.

As when travelling through Cambridgeshire one is aware of the openness and formations of cloud, so this Humberside borderland takes on the same character, with nothing to thwart the cruel east winds that sweep across Lincolnshire, many say from the steppes of Russia. Against a build-up of cloud, we watched a singular dark-plumaged bird flying in from the sea. It veered low and settled on the edge of a boatyard. Minutes later Tony and I were watching it preening and rearranging its plumage, a shag, member of the cormorant family, which seemed to have come specifically to preen, thus suggesting that a map of the drains, depths and channels hereabout were lodged into the instinctive workings of its mind. As expected, there were a few gulls – common, black-headed, greater and lesser black-backed – hovering against the cloud formations. I was reminded that common seals occasionally travel up the tidal Trent and are seen particularly around Dunham. The otter that caused a stir when, some years ago, it was seen in the Chesterfield Canal at Retford could also have travelled the same route, although travelling overland, as otters often do, it could have come in from the Lincolnshire drains country, still seaward, and over to the east.

* * * *

My summer visit to West Stockwith was by coach organised by the late John Severn and members of the West Bridgford and District Local History Society.

Several friends and I joined the trip on 13 August 1994 when John informed us there were spare seats. The journey included visits to three locations, the first being at Saundby, a Lincolnshire-Nottinghamshire border village on the west side of the Trent.

Here we were met as arranged by Mr George Dawson, who took us around the church of St Martin. A member of the Guild of Bellringers, he and John pointed out the bell frames, which had recently been saved and repaired. They were considered rare by architects such as John because the pegged frames were made from oak, whereas today they would have been constructed from steel.

The church and its comparatively recent conserved and restored furnishing is now in the care of the Redundant Churches Fund.

By noon we were exploring Gainsborough and with John, who was the author of the Cromwell Press publication *The Dovecotes of Nottinghamshire*, sitting outside a pub enjoying pints of bitter.

After John explained the layout of the wharves and warehouses, of Gainsborough we were given a guided tour of The Old Hall,

At West Stockwith. Turning seawards with the flow.

Gainsborough, then returned to Nottinghamshire by coach and had a look around West Stockwith. John explained again how the wharves and warehouses came to be built according to the course of the River Trent, and also verified the fact that West Stockwith is Nottinghamshire's most northerly village. Here we were met by Mr Albert Reynolds, who took the party to view the Church of St Mary the Blessed Virgin. Built as late as 1722, according to the executors of William Huntingdon the church comprises of local red brick and is of Georgian design.

Pevsner wrote of this being the second of the fifteen Nottinghamshire churches that were built between the Restoration and the early years of the nineteenth century.

In the church hall we joined members of the West Stockwith Local History Society and chose tables for our 'surprise cream tea' welcome. But the term 'cream tea' proved a misnomer because our genial hosts had made sandwiches, cakes, trifles and salads. With urns of tea also to hand, we changed places around various tables and exchanged information on the parishes of West Bridgford and West Stockwith before departing, but not without a well-earned round of applause as a token of appreciation for the time our hosts had put into our visit and day.

In the low evening sunlight I walked with a couple of friends beside a drain, the 'Mother Drain' I think it was called, and along the flood bank grassed over but built to keep the waters in check. We then returned to the coach.

On the evening journey homeward, John directed the coach driver along appropriate routes so that we could see the villages and different styles of church building, in particular Church Laneham. Here, on a late summer evening, and with little wind stirring the hedgerows to speak of, we could, nevertheless, hear the guitar like plucking of the wind in the overhead wires.

There was once a ford and a Saxon church here, which after the Conquest was rebuilt by the Normans. John pointed out the door, made from oak, plain looking, but according to local historians the original door, as one of the few to have survived throughout England.

Local couples who married in the church had had the bellringers inscribe their initials inside a 'wedding ring' situated on a bell tower wall. A romantic gesture, some may say, except that the couple had to pay the inscriber the sum of 5s or present him with a sage cheese.

The Archbishops of York, in the Middle Ages, were designated a palace that was built on or close to the site that is now Manor Farm. Nearby, Jersey cattle made a welcome change as they grazed the fields and I was told that there is a stock breeder of this much-admired strain living locally.

A lane bearing the sign 'Ferryboat Inn' directs the walker to the Trent and its flanking flood bank, now incorporated into the walkers' route known as 'the Trent Valley Way'. There is also a riverside caravan and mobile homes site and, as John pointed out, a three-storey warehouse built in Victorian times. The flood bank extends for about a mile. To the left looms the eight cooling towers of Cottam Power Station. There is also a pumping station as the flood bank loops to meet the entrance to Torksey Lock. This is the first or last lock, dependent on which way the boater is travelling, on the journey connecting the Trent to the cathedral city of Lincoln. It is known as the Fossdyke Navigation and was created by the Romans as a trade and commercial link with both Lincoln, Boston and the Trentside towns and villages. Dating from the twelfth century, it is known to be the oldest navigation route in Great Britain and today stems from the boat users' Mecca and marina of Brayford Pool, situated within walking distance of Lincoln Cathedral.

Back to the land, an interconnecting merger of Ferry Lane and its stiles and footpath enables the explorer to see the remains of Torksey Castle, built in Tudor times of stone and brick. At nearby Cottam stands the Station House, once conducive to the smooth running of the Boston to Sheffield railway line until it felt the descending blade of the Beeching Axe. John, on our flood bank saunter, explained that part of the station buildings have been converted into a public house, which at the time of our visit was known as The Moth and Lantern.

We set off for Nottingham on the coach a little before sunset and at Torksey Lock, from the road, saw the water of the Fossdyke Navigation Canal burning with the redness of the sky and the pleasure boats and narrowboats reduced to dark silhouettes, each of which created a golden wake. A splendid closing scene to a most informative and enjoyable day.

* * * *

Whether driving his comfortably upholstered Suzuki along the A52 from Spondon, Derby, at 1.00 a.m. on a Sunday or seated around a table in

his favourite Mayfair, London pub, The Grapes, in Shepherds Market on a winter Saturday night, John Severn proved a first-rate communicator. He was generous, entertaining and unique in that in this age when people in pubs do little more than discuss television game shows he had a natural flare for keeping alive the dying art of conversation. I had not known John as long as the friends who introduced me to him, but the bond between us was soon that of brothers. Yet only from his June 1998 obituary did I learn that as a young man he was commissioned into the Royal Engineers then joined the Territorial Army as a captain serving in the South Notts Hussars. He then became a magistrate, an architect and a local historian who was eager to save Nottinghamshire's most important buildings and was soon enrolled as a member of the Notts Building Preservation Trust. Other memberships were of the Nottingham Historic Churches Trust and the Nottingham Civic Society, where after serving for some years as a committee member he was elected chairman.

John Severn had much to do with the restoration of three Nottingham projects, these being the original Middleton boathouse at Wollaton Hall, the Wollaton Village Dovecote, and the Ragged School in Sneinton.

A resident of West Bridgford, he was also a member of the diocesan advisory committee and preparing at the time of his death the histories of Nottinghamshire's Anglican churches.

He was a man of integrity, unflagging enthusiasm and warmth, who is survived by two sons, Richard and Andrew. Mention of his name alone recalls his knowledge and efforts to preserve all that was possible within his beloved Nottinghamshire.

TWO LESS KNOWN NOTTINGHAMSHIRE WRITERS

Only by delving around the second-hand bookshops on Mansfield Road, Nottingham, in the 1960s did I learn that a farm labourer called Fred Kitchen had written an autobiography about his life on the land in Nottinghamshire. Born in 1891 in the legendary forest village of Edwinstowe, Fred, when still under school age, moved with his family to the village of Maltby in the West Riding of Yorkshire. The landscape was a mixture of arable farms dealing largely in potatoes and corn, tracts of woodland, and collieries working and developing the many shallow coal seams. His father worked as a stockman for a wage of 17s a week. But the Kitchens lived in a tied cottage belonging to their employer. Consequently, they grew their own vegetables, were allowed two free pints of milk a day, and had no rent to pay.

Fred proved a keen pupil at the village school, but when his father died of diabetes, Fred, who was not by then aged twelve, moved with his mother to a smaller place, from where his mother walked two miles and back for two days a week to The Hall where she was employed.

Fred left school in March 1904 and found work on a nearby farm. When at the age of fourteen, he moved to another farm, Fred took with him a wooden chest in which he had stowed the books he had won as school prizes but never, due to the hard working conditions, had the time to read.

By 1913 he was working in a colliery and in 1915, at the age of twenty-three, he married his sweetheart Helen, to whom he enjoyed reading. He was also able to purchase 'The Dickens Library', a full set of books that joined those in his wooden chest but which he read one by one.

After five years of marriage Helen died and Fred had a young family to provide for. He went back to the land, labouring on a farm near

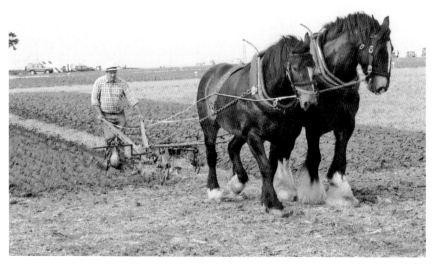

This scene at Flintham Show and Ploughing Match, held at Bingham in 2008, was commonplace in Fred Kitchen's time.

Sheffield. Eventually his duties entailed delivering milk to the houses in the Sheffield suburbs and meeting the different people on his round enhanced those duties considerably.

In February 1927 Fred moved with his children back into Nottinghamshire and obtained a position working for a gentleman farmer near Worksop This educated man loved classical music and invited Fred to join him at the Sheffield opera concerts.

When his employer purchased and moved to Kilton Forest Farm, Worksop, Fred Kitchen moved with him. By this time, I think, Fred had remarried.

In 1933 Fred joined the Workers' Education Association. He studied in his spare time music, economics and literature. He also began writing stories and articles for agricultural magazines. As is the story with every writer, he received many rejections, but in 1939 a London publishing

Fred Kitchen saw the revolution in agriculture. He lived to experience the first Fordson tractors taking over.

company took a well-deserved interest in his autobiographical book entitled *Brother To The Ox*. This became a wartime bestseller.

After the first printing in 1940, *Brother To The Ox* was reprinted in 1944, 1945 and 1947. Fred, due to his best seller, won the Foyles Literary Prize and attended the famous luncheon connected to the event. Moreover, he made a speech without notes, which surprised Fred to the extent of him admitting this to his delighted audience.

Throughout the time that his first book was being reprinted Fred had three more published. *Life On The Land* was deemed successful, but *The Farming Front* and *Jessie And His Friends* not to quite the same extent. Nevertheless, Fred still continued to write.

He moved in later years to a bungalow in Bolsover, living with his daughter, because he was by then widowed for the second time. But he worked the land by way of an allotment and as well as writing became

a preacher on the local Methodist Church Circuit. Fred also wrote a few children's books and a final work for the general reader called *Nettleworth Parva*, based on life in a country village. He died, I believe, in August 1969 never having earned a great deal from his works but having absorbed every subject in which he was interested and lived a life that few of us today could envisage.

* * * *

Journeying south by car through the Idle Valley one winter afternoon, Tony Stevenson and I shared the surprise of arriving unexpectedly in the village of Gamston.

Tony was at that time a resident at the mobile home park at Gamston, near West Bridgford, just south of the Trent and Nottingham. What we hadn't realised was that the county's second village of that name is situated within walking distance of Boothamsall and Elkesley in the Idle Valley.

The Idle at Gamston was on that occasion flooded and on the surrounding fields fed the various breeds of wild duck: waders, including lapwing and grey plover; grey lag and pink-footed geese, probably both wild and feral; and the expected family groups of mute swans.

In recent summers Denis Astle and I have taken that same route homeward and remarked upon the fact that, the gravel extraction lakes and lovely reedy stretches of the Idle apart, those travelling the roads seem to soon have put Gamston behind them.

The Church of St Peter is, we discovered, mainly a fifteenth-century building, although the chancel is thirteenth century. The perpendicular tower is 120 feet high.

Before the *Domesday Book* recordings were entered there were two manors – which eventually became part of the Duke of Newcastle's estate – and two mills.

By 1782 a candlestic-manufacturing business had become established with 100 or so local people working shifts there night and day. This was, however, demolished by 1845.

Near the river bridge a cotton mill provided employment in the nineteenth century. The calico manufactured there was bleached by spreading it out on the nearby water meadow during prolonged periods of summer and early autumn sunlight. When the business tapered into liquidation the premises were used as a flour mill and later a corn mill.

At the time of our visit Gamston could not boast of having a pub, a post office, or a single shop, although I learned from a retired postman that the modern and old houses provided homes for an estimated 300-350 people. 'You need a car or motorbike to be living out this way in the twenty-first century,' the retired man replied ruefully.

There was, however, a daily bus service which linked the shoppers with the surrounding villages and the town of Retford.

* * * *

With its bowering alders, stands of willow and reeded meadows, the River Idle is obviously a birdwatcher's river and it goes without saying that in the past otters have bred there and undoubtedly been hunted by the hounds. But one afternoon, as I studied the course of this river, something stirred from the subconscious archives of my boyhood.

I remembered a monochrome photograph depicting a stretch of river such as I was looking at that day. I also remembered the author's sketch of a lake. Then came the name of the book's author, John Warham, followed by a brief introduction which after his name came the single location: 'Retford, Nottinghamshire'.

In this book were some quite outstanding bird photographs for the time, although Warham never actually revealed the location of the natural studio, a true remaining wilderness described in photographs and prose between the covers of his work *A Birdwatcher's Delight*.

He did, however, describe adequately the terrain of parkland, fields, water and mixed woodland and further that his photography and bird study area covered 'some eight square miles' and was on 'the edge of' what we know today as the Sherwood Forest Country.

There was a map on one of the introductory pages which I have before me as I write today. He mentions no location but describes only the terrain. In his main area chosen for photography and studying birds is a lake to the west and a meandering river leading away from it to the east.

He describes tracts of the terrain in forms of the land, parkland, water meadows, larch and corsican pine, spruce, birch, alder or oaks, birch and beech, scrub oak, sedge and sallow. After it has passed between two roads, the river, which he describes as being far from linear and estimates to be 'about twenty-five feet in width', divides, so that a small land mass

of sedge and sallow stands then rejoins at a north-easterly sweep and a road bridge close to which is a village and two footpaths. He titles the map 'A Happy Hunting Ground' and subtitles it 'A Setting'.

Studying a present-day Ordnance Survey map, I am not surprised to discover that the lake is that in the grounds of Thoresby Hall and that the first of the three roads dividing Warham's map is the A614. His main area of study appears to be Boothamsall and Houghton, after which the Maun passes beneath the B6387 which again fits in with Warham's map splendidly then flows to the A1.

His marked 'village' appears to be Milton or West Markham; I favour the former. Leading off from Milton is the A638 and the village of Gamston, south-west of which is a stretch of river beside a roadside lake between the Elkesley crossroads and Bevercotes.

This is the area to which I was earlier referring and which I gradually realised was on what today might be described as the northerly edge of John Warham Country.

John Warham followed in the tradition of pioneering bird and wildlife photographers John and Cherry Keaton, Frances Pitt and Eric Hosking.

Like Hosking, he climbed trees and set up hides to photograph little owls, tawny and barn owls at the nest feeding the young and in flight. He also photographed kingfishers, stock doves, red polls and the various summer or 'leaf' warblers at their nest.

THE HOMEGOING ROUTES

In the north-west corner of Nottinghamshire is the place I think of as the contrasting corner to West Stockwith and the open countryside intersected by rivers and drains. This contrasting corner, the Derbyshire border coalfields aside, has always attracted people to the limestone 'massifs' of Creswell Crags and local folk from such places as Cresswell, Worksop, Cuckney and Clowne have taken their weekend afternoon walks there since time immemorial. Then, in the Victorian era, the charabanc and organised parties of trippers arrived from Sheffield, Nottingham and Derby. Following the charabancs came the single-decker coaches, particularly after the Second World War.

Situated about five miles south-west of Worksop, the site was at one time popular with railway trippers wanting escape days from the already mentioned large towns and cities.

10,000 years before the tourists arrived, the hunters of the Ice Age located the site and seemingly settled there, as the works of art on the walls of the caves have since indicated. This is, the archaeologists informed me, the only rock art of the Ice Age to be found in Great Britain. Many bones have been excavated from the caves – bison, reindeer, hyena and woolly mammoth – along with the stone tools that were probably used to kill them.

There are caves, woods and water snaking through the limestone gorge to form a small lake. And today there is a museum and education centre. Inevitably, one of the caves has to be linked with the legendary Robin Hood.

The crags are between 30 to 80 feet high and besides the crags there are precipitous rocks, ravines and a tract of meadow, this being behind

Creswell Crags. A section of the terrain known to the early people who hunted woolly mammouth, horse, bison and reindeer hereabout.

the Museum and Education Centre. There are also tours and children can buy activity sheets and crayons from here and try out their own versions of Ice Age art.

I first visited Cresswell Crags when with Ranger colleagues. I drove up to the Welbeck estate timber mill with the Land Rover and trailer to collect lengths of fencing. The head ranger for the Crags site was, I believe, a fully qualified archaeologist. Thus I considered him then to have an interesting job in unearthing, identifying and logging the remains as they came quite literally to light, although long after the first archaeologists moved in.

It was on this overcast, early autumn afternoon that I was approached by the driver of a parked car; a small, bespectacled, middle-aged woman who introduced herself as a medium.

'And while you were checking the trailer security just now, I received vibes as I studied you of trees and forestry and animals and birds, and what have you. Am I right? Are you really interested in these things to do with the great outdoors?'

Surprised, I admitted that she was. 'I'm particularly interested in forest and woodland fauna – yes. And I'm also interested in breeding deer for

good "heads"; their genetic antler formations. But how could you know that?' I queried good-naturedly.

'Well, as I have said, the vibes came through as I studied you. I should think you know something about animal tracks and signs too?'

'Yes, I've made a point of studying them in the field,' I told her.

'So, I am right. Your ancestry stems from the peoples of the old forest country. People who had to know about animals and study signs in order to survive.'

'Well, that's interesting. And as a matter of fact I feel quite at home here at Cresswell and yet I've never been before,' I told her.

'There you go.'

She then offered to read my palm and which request I refused. 'No thank you. I don't want to go as far as that because some things are better left unsaid or unread.'

My ranger colleague also refused but, nevertheless, I was grateful to the woman and realised that there are people out there who have such gifts that surely border on spiritualism and the occult.

＊ ＊ ＊ ＊

The past concerning the site known as Cresswell Crags embraces a considerably longer period than the era of 'the old forest people' as the people of the post-Norman Conquest era may have been known. At the present-day visitor and education centre, one learns that some 250 million years ago limestone formed as rock on the bed of an inland sea. 20 million years later, rivers gorged paths through and between the rocks, thereby creating the relatively narrow gorges and caves.

Excavations in comparatively recent times have revealed that the Neanderthal people found and camped in the caves some 50,000 years ago. By this time the majority of them spent their lifetimes hunting and butchering. Bison, hippopotamuses, red deer, reindeer, the giant deer or 'Irish elk', and horses grazed the surrounding plains in good number and besides Neanderthal man, there were bears, wolves and hyenas preying on them.

Different peoples left and returned according to the climate, for, in cold periods, the animals probably moved south and the human hunters with them. Then when warmer periods evolved the reverse situations occurred.

Some groups of hunters used Cresswell as a winter camping place and others a summer site. On my first visit when plans were afoot to open the first visitor centre, I learned from the leading archaeologist that the crags and gorge at Cresswell were immersed in ice several times over the past two million years.

Looking at the terrain this is difficult to believe, but there is sufficient evidence to prove that these dramatic changes occurred.

My visit also coincided with the first modern-day excavations of the locally known 'Pin Hole Cave' where earth layers were being removed by archaeologists millimetres at a time. I am referring now to the mid-1980s. The cave was so-called because local people from such villages as Welbeck and Cresswell visited the site, perhaps regularly, in Victorian times and it became the habit of the girls and women in the groups to each drop a hat pin in the pool, glistening invitingly at the rear of the cave. I learned also that limestone and sand layers were removed and the pre-Ice Age fossils of bats, birds, shrews, voles, lemmings and various fish came to light, but only by careful and sophisticated sifting.

The cave also served as a hyena lair and intriguingly from the dung, still preserved after some 38,000-50,000 years ago, the researchers and laboratory technicians found minute grains of pollen, which when identified gave them a further picture of the plants that were growing in the terrain at that time.

People of the Stone Age also lived and camped in the Pin Hole Cave, as their unearthed tools and possessions have proven.

The first known, official and ultimately fully interpretative excavations of Cresswell Crags occurred in 1875.

There had for some years been a mill and waterwheel in operation. But the shooting and fishing gentry attached to the Welbeck estate also used the watercourse and its inflows and outflows as a duck decoy. Consequently, game shooting days took place here but to the millers and duck decoy man, who probably lived in a cottage nearby, this site must have seemed an awesome and lonely place in the bygone midwinters.

Then to this land tract, owned by the Duke of Portland, came Thomas Heath, the curator of Derby Museum, and his companion the Reverend Magens Mello.

Prior to these visits, the Committee for the Archaeological Exploration of Derbyshire Caves was formed around 1920, with Leslie Armstrong serving as their field archaeologist. It was he who set about excavating

Pin Hole Cave and the orifice now known as 'Mother Grundy's Parlour'. In those times they used sieves to aid in the process of close excavation.

Mention of Derby reminds me that we are just over the Nottinghamshire border in parts here, but on the west side of the Welbeck Estate, thus the museum and education centre are listed as being on Crags Road, Welbeck, Worksop, Nottinghamshire. But country boundaries regardless, there were reports of the caves being filled 'wall to wall with animal bones'. The spoil excavated from the cave entrances exists to this day but the managing authorities have created rail-sided flights of wooden steps to the cave entrances, which are gated and barred, although guided tours take place at certain times of the year.

Armstrong and his team of workmen removed the bones of woolly mammoth, horse, bison and reindeer from these caves – all prey species may I point out – and so one gains the impression of certain caves here being used for centuries as larders and food preparation chambers, as well as homes and shelters. But bones in good quantity had also been chewed by generations of spotted hyenas, which seem also to have been well-established.

'Robin Hood Cave' is the largest, with four chambers leading off. The 'Church Hole Cave' is so called because its naturally evolved inner roof or ceiling resembles the vaulted interior of a church. 'Mother Grundy's Parlour', like 'Pin Hole Cave', contained some of the archaeological finds the site has so far yielded.

In present times the Cresswell Crags site museum and education centre is open from February until October. In the winter months of November to January it is, understandably, a Sundays only opening venue.

On the Sundays prior to Christmas, children are catered for by way of a visit from Santa Clause for which events there is an entrance fee. And there are some splendid and highly informative books, booklets and information sheets at the centre, along with museum displayed bones of the animals that were once found to be at this unique and quietly awesome site.

Journeying back from Cresswell and north-west Nottinghamshire in the spring or early summer is interesting, for the river that appears intermittently through the towns and villages hereabout is the Medan which eventually enters the lake in Thoresby Park.

The place we make for is Church Warsop where by the Church of St Peter and St Paul is a car park, and there is an interesting walk or two from the millpond.

The Church of St Peter and St Paul, Church Warsop.

The ancient church was partially rebuilt by the Normans and is beautifully sited, even with a mixture of buildings and a busy road, the A60, partially skirting it.

Situated on and a half mile back from Welbeck, and three and a half miles from Budby, Church Warsop is embraced by the Parish of Warsop and Sookholme.

On a radiant May morning the church porch echoed with the songs and sub-songs of a cock blackbird to the extent of Denis Astle and I deciding there was a nest close by. This particular nest was, however, not in the expected laurel or deep hawthorn thickets, but on the lowest rung of an angle support above the church door.

The hen bird, incubating the egg clutch or newly hatched young, was yellow-billed like her mate, and remained on the nest for as long as we were in the porch below. Here we studied the cross keys and sword design of the door while admitting that we would need a local parishioner or a copy of Arthur Mee's *Nottinghamshire* to explain the origin and meaning to us.

Behind the church, at the picturesque crossroads, we saw pink campion in flower, yew and horse chestnut trees, and the expected lane bank umbellifer.

Partially screened by bowers of laburnum out to our left stands a Tudor barn with blocked in windows and doors. We pointed out to each other the differences in brickwork and building materials. One of the doorways faces the road that is today the B6031, and across from which the green recreational acres of Carr Park stretch into the distance.

Returning to the church front and the car park, we walked a section of the Medan footpath while noting from the signs that the district of Warsop Vale was a little to the south-west and Market Warsop to the south-east on the home-going A60.

From a local council notice board we learn something of the adjacent land tract known as the Warsop Carr. Carrland comprises of pools or small ponds holding stands of willow and alder. There are several such carrs in north and north-east Nottinghamshire, but this is the only tract of carrland that I am aware of to the west.

The council information notice explains that the Abbot of Welbeck, in 1534, paid the landowner, the Earl of Rutland, an annual fee for grazing rights hereabout. It also explains the benefits of pollarding willows – always difficult to manage – and refers to the black poplars that were once used as field boundary trees along with the expected oaks, but which now are becoming rare and difficult to propagate.

Playing fields and sports pitches border the millpond and beyond the 'hills and holes' pitch a brook enters the River Medan, close to Herrings Farm and the village of Sookholme. The Medan can be followed again at Pleasley between the road leading to Mansfield to the Common Lane bridge near Mansfield Woodhouse.

The riverbank exploration begins at Pleasley post office, where there is a footpath sign that links up with the river, despite the underpass and T junction.

Here is a left turn and a currently rail surrounded or fenced off building. To the right of this the river the path continues. The path is way marked with diversions through slender tracts of sycamore woodland and a motorcycle prevention barrier.

Local botanists list golden rod, columbine, bellflower and autumn gentian here and geologists point out that the trackway of the once-busy railway is laid in, and intersects, a layer of Magnesian limestone.

Birdwatchers link the wagtail species, linnets, greenfinches, goldfinches and the occasional breeding pair of kingfishers with this linear walk and the summer visiting warblers, swallows, and house and sand martins

will swell their lists. The railway cutting exposed cave system is thought to have resulted due to a land slip. And interestingly, the bones of wolf, lynx and wild boar have been recovered from them.

Tracts of the Medan were from 1847 to around 1986-87 serviced in the manner of millponds, the water power being originally used to drive the machinery of the mills, which at the time of writing belong to the Bolsover District Council and are being converted into industrial units.

The Pleasley Vale mills were used for the production of textiles and are described by modern day industrial historians as 'impressive'.

The first mills, water-powered and used for grinding corn, were built here in the thirteenth century and remained thriving within this capacity until one mill, which fell into disuse, was in 1784 converted for the production of textiles by Cowpe, Oldknow, Siddon & Company. The locally based industry of the then future dynasty was founded here when Henry Hollins joined the partnership.

In 1847 a waterwheel was installed as a standby at the mills, which in the nineteenth century became steam-powered. Still improving, the company then installed electricity and created steam turbines, which ran, but were termed redundant in around 1962-63.

The railway was used for transporting the coal, thus ensuring a supply of steam power. The secondary use was in sending out the finished products to the company's many customers.

There were a number of company name changes, but the best-known was the flourishing William Hollins Company, which traded under that name from 1846 until the 1980s. It was then that the entire company became the Coates Viyella partnership, although the Pleasley Vale Mills had by 1987 ceased production.

* * * *

On the Derbyshire border, close to the green undulating parklands of Hardwick Hall, are the once busy industrial parishes of Teversal and Fackley. Teversal is to be found directly off the B6014. The original village of Old Teversal is considered by many to be picturesque. There are certainly some fine trees. To the east winds the River Medan by Coppy Wood and through Moorhaigh, as near a natural stretch of river as can be seen in this quarter of the country, with fields sloping either side to form a deep agricultural valley and a watercourse relatively free

from human encroachment. There is, in the village, a visitors' centre. Here the visitor learns how well the area was served by the Midland Railway, which was the first of the companies extending eventually from Teversal to Pleasley and Mansfield Woodhouse.

The Great Northern Railway Company became linked to the Silverhill Colliery, and that particular line linked to Worksop via Shirebrook.

This really is old established coal mining country, which began with bell pits. These were operated by baskets attached to the ropes which lowered them down into the bell-shaped dugout, from where miners filled them with lumps of coal then proceeded to dig for more.

The really deep coal mining as we knew it in the nineteenth century began at Teversal Colliery in 1868, Pleasley in 1871, nearby Silverhill in 1875, and Sutton in 1884.

To meet the demands of market and transport, the surveyed railways were laid on until the Rowthorne line closed in 1938, and the last length of track connecting Pleasley with Teversal was faced with redundancy forty years later.

Today walking routes or 'trails' have been devised that connect collieries with railway workers' cottages, places like Teversal station, and the intriguingly named Coppy Wood, which was probably called Coppice Wood and managed as such before the nineteenth-century coal mining magnates moved in.

North-west of the coal measure belt, the already mentioned parklands of Hardwick Hall beckon the rambler over the county border and into Derbyshire. In the eastern corner, off Newbound Lane, stands the imposing Norwood Lodge, which became the last home of my friend the conservationist, Bernard Harling.

To Norwood Lodge I was invited several times by Bernard and his wife Joan. They were the 'you have only to pick up the phone' type invitations and in all seriousness Jean and I intended to accept one or other of them. But as often happens there was so much family life taking place around us that, regrettably, we never made it.

Bernard and his wife were, I learned from our phone conversations, delighted with their new surroundings, having only several years before moved out of their equally spacious house in a respectable Nottingham suburb. So it is with a feeling of guilt nudging me on the shoulder that I pass Norwood Lodge, as admittedly I have in recent years, en route for the grassy contours and chains of lakes and ponds that are to be found beyond.

A splendid sculpture of a miner and his lamp at Silverhill, which is now recognised as being the highest point in Nottinghamshire.

Returning to the route just west of the Medan Valley there is a second visitor centre interpreting the work and lives of the people who were so much a part of the bygone industrial scene thereabouts. This visitor centre is to be found at Fackley, near Teversal station.

The entire area of walkable trails and grassed-over colliery tips is similar to those that now provide recreational assets around Williamsthorpe and Sutton Scarsdale, as well as the interesting and recently converted Poolsbrook Country Park at Staveley, near Chesterfield.

Leaving Teversal or Fackley, the B6011 directs my explorative friends and I on to the M1, between junctions 28 and 29. From there the direct route takes us through the ever-intriguing mixed forest country that strays to the edge of the motorway from Underwood to the west and Annesley the east. After coming off the M1 at junction 26, there is then, so far as I am concerned, only three or four miles to go before I reach the housing association flat that currently serves as my home and writer's garret. And seldom do I arrive without having discovered something new about my native county.

RECOMMENDED READING

My present copy of *Lady Chatterley's Lover* is the Penguin Lawrence edition. It contains a preface and is edited with an introduction and notes by Michael Squires, who has published several acclaimed books on Lawrence and his manuscripts. The chronology of the book was researched by John Worthen, who in 1991 published a biography, *D. H. Lawrence: The Early Years 1885-1912*. This relatively new Penguin Awareness edition is fully comprehensive and extends to some 365 pages which include chronology, notes and texts, editorial notes, appendix, etc. and last but by no means least a glossary of dialect forms. Much work has gone into producing this edition and the Lawrence veteran reader or newcomer could not ask for more.

As for dialect forms in Chapter XVI of *Lady Chatterley's Lover*, Hilda questions Mellor's dialect, which he describes as Derby (or 'broad' Derbyshire as we know it today). I was about to hastily add here that few, if any, of Eastwood's residents use this vernacular, if indeed it was used in Lawrence's time.

By stating Derby, it was the now-pretty village of Teversall to which I think Mellors was referring, or at least the coalfields around there. And yet, while writing I have heard in a less than immaculate café Eastwood referred to as 'Oistwood' and someone walking over a bridge described as

'Ozz gone ovver 'ump.'

So what is one to think?

BIBLIOGRAPHY

The Dukeries and Sherwood Forest, Sissons & Son, Worksop (Date unknown).

Nottinghamshire, Pevsner, Penguin Books, 1957.

Byron, *The Flawed Angel,* Phyllis Gross Kurth, Hodder & Stoughton, 1997.

The House of Byron, Violet W. Walker, Quiller Press, 1988.

D. H. Lawrence, The Life of an Outsider, John Worthen, Allen Lane, 2005.

Bygone Nottinghamshire, Stevenson, Frank Murray, 1893.

The History of Retford, John S. Piercy, 1828 (Reprinted for Notts. Leisure Services 1994)

A Brief Recorded History of Blidworth, W. Wild, Newstead and Clipstone 1972.

Tourist Information outlets and interpretative centres in Retford, Teversal and Clumber Park suggested and helped by pointing out the relevant leaflets appertaining to the walking and leisure trails.